Will Barnet:
A Timeless
World

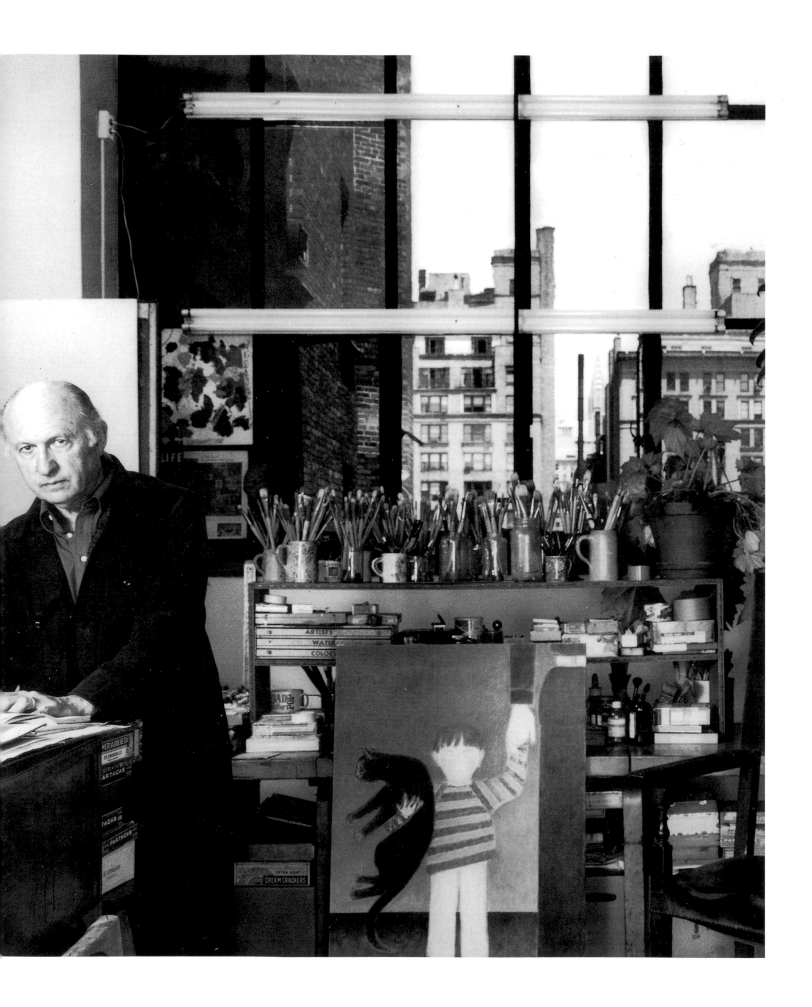

Will Barnet:
A Timeless World

BY
Gail Stavitsky

WITH ESSAYS BY
Twig Johnson and Jessica Nicoll

ORGANIZED BY
The Montclair Art Museum

ISBN 0-8135-2834-8

Library of Congress Catalog Card Number 00-132121

© 2000 The Montclair Art Museum

3 South Mountain Avenue

Montclair, NJ 07042

(973) 746-5555

www.montclair-art.org

Distributed by Rutgers University Press

Design: Rich Sheinaus, Gotham Design, NYC

Electronic Pre-Press: TBC Color Imaging

The Montclair Art Museum
May 14 - August 20, 2000

Boca Raton Museum of Art
September 20 - November 5, 2000

Portland Museum of Art
December 21, 2000 - February 18, 2001

Arkansas Arts Center
March 22 - June 3, 2001

Previous spread:

Will Barnet
in his studio,
July 18, 1985
© Hans Namuth,
1985

TABLE OF CONTENTS

Foreword and Acknowledgements
by Ellen S. Harris 2

Will Barnet: A Timeless World
by Gail Stavitsky 5

Will Barnet and Native American Art
by Twig Johnson 61

"A Certain Slant of Light":
Will Barnet and New England
by Jessica Nicoll 69

Plates . 77

Selective Bibliography 109

Selective Chronology and
Exhibition History 112

Exhibition Checklist 120

Appendix– A Statement for
Lawrence Alloway, 1960
by Will Barnet 123

LENDERS TO THE EXHIBITION

Arkansas Arts Center

Will and Elena Barnet

Brenda and Hartley Bingham

Dr. and Mrs. John C. Bullard

Irene and Philip Clark

Sylvan Cole Gallery, New York

David David Gallery, Philadelphia

Farnsworth Art Museum

The Samuel S. Fleischer Art Memorial/
Philadelphia Museum of Art

Grey Art Gallery and Study Center,
New York University Art Collection

Mr. and Mrs. William Y. Hutchinson

Mr. and Mrs. Woody Klein

Frank and Katherine Martucci

Tom and Remi Messer

Liza and Michael Moses

The Metropolitan Museum of Art

Museum of Fine Arts, Boston

National Museum of American Art,
Smithsonian Institution

Neuberger Museum of Art, Purchase
College, State University of New York

Mary Ann and Bruno A. Quinson

Frank K. Ribelin

Mr. and Mrs. Richard E. Salomon

The Snite Museum of Art, University of
Notre Dame, Indiana

Tibor de Nagy Gallery, New York

Tweed Museum of Art, University of
Minnesota, Duluth

Frederick R. Weisman Art Museum at the
University of Minnesota

Dorothy and Herb Vogel

FOREWORD AND ACKNOWLEDGEMENTS

It is with great pleasure that The Montclair Art Museum presents the first comprehensive retrospective of Will Barnet's highly accomplished career. Although his work is well known and admired, Barnet has, surprisingly, never received the thorough, critical attention that he so justly deserves. In exhibiting Barnet's work within the context of a substantive reappraisal, the Museum is proud to continue its ground-breaking tradition of originating retrospectives for under-recognized American artists, including Morgan Russell (1990 and 1998), Hananiah Harari (1997), and Steve Wheeler (1997).

The exhibition has been organized by the Museum's Chief Curator, Gail Stavitsky, who has greatly enjoyed her work on this project. A longtime colleague and friend of Mr. Barnet, Gail is a specialist in American modernism who first met the artist when she was preparing her dissertation on the Gallatin Collection at New York University some years ago. True to form, the unfailingly generous Mr. Barnet spoke extensively with the young graduate student. He was also, characteristically, very helpful with many other projects, especially the Steve Wheeler retrospective. On behalf of the Museum, I would like to extend our heartfelt gratitude to Will Barnet, whose prodigious aesthetic accomplishments, keen intelligence, compassion, and humanism have greatly informed this entire project. We are also particularly grateful to Elena Barnet, who ably assisted with all aspects of the research conducted for this exhibition.

A special expression of deep gratitude is owed to Abby Leigh, a former student of Mr. Barnet and an accomplished artist, who has provided the primary funding for this exhibition

through The Abby and Mitch Leigh Foundation. Their exceedingly generous leading gift was complemented by greatly appreciated additional support from Frank and Katherine Martucci. Philippe Alexandre, a director of Tibor de Nagy Gallery, New York has been exceedingly generous in his support of the exhibition and Mr. Barnet.

We are also extremely grateful to the lenders of the exhibition listed on the facing page. This exhibition and catalogue could not have been produced without their cooperation and assistance.

Many others assisted Gail with her vital, scholarly organization of this show. Catalogue essayist Twig Johnson, the Museum's Curator of Native American Art, sheds new light on Barnet's fascination with the "first American art." For the first time, Jessica Nicoll, Chief Curator, Portland Museum of Art, Maine discusses the critical legacy of Barnet's New England heritage. Dr. Nicoll was also an early supporter of this show and we are very pleased that *Will Barnet: A Timeless World* will travel to the Portland Museum of Art. Our heartfelt thanks are also extended to the following individuals at the other venues to which the show is traveling: Joseph Borrow, Executive Director and Courtney P. Curtiss, Curator of Exhibitions of the Boca Raton Museum of Art, as well as Townsend Wolfe, Director and Brian Young, Curator of Art, Arkansas Arts Center.

We would also like to thank the following individuals who greatly assisted with the research aspects of this project: Pamela Koob, Curator, and Stephanie Cassidy, Archivist, The Art Students League of New York; Traci Parnell, Museum intern and Rutgers University graduate student; Robert Yahner; Judith Throm, Archivist, Archives of American Art; Anna Langstaff, Assistant Director, Beverly Public Library; Sarah Malakoff, Library Associate, Boston Museum School; Sylvia Yount, Chief Curator, Cheryl Leibold, Archivist, and Thomas Clyde, School Registrar's Office, Pennsylvania Academy of the Fine Arts; Joann Moser, Senior Curator, Graphic Arts, National Museum of American Art; Kathleen Kienholz, Archivist, American Academy of Arts and Letters; Andrea Bayer, Assistant Curator, European Paintings, The Metropolitan Museum of Art; Carol Salomon, Archivist, Cooper Union Library; Suzanne H. Freeman, Librarian, Virginia Museum of Fine Arts; Helena E. Wright, Curator of Graphic Arts, National Museum of American History, Smithsonian Institution; Ann Stewart, Administrative Assistant, American Art and Decorative Art, Dallas Museum of Art; David Dearinger, Chief Curator, National Academy of Design; Nancy Malloy, Reference Specialist, Archives of American Art; Anna Indych; and Maria Balderrama.

The Museum's staff was also crucial to the successful realization of this project, especially Mara Sultan, Associate Registrar; Susanna Sabolcsi, Librarian; Anne-Marie Nolin, Director of Communications; Brandi Marchini, Curatorial Assistant; Thomas Shannon, Exhibits Designer/Assistant Facilities Manager; and Charles Cobbinah, Art Handler.

We also thank the New Jersey State Council on the Arts/Department of State, a partner agency of the National Endowment for the Arts, PNC Bank, and Museum members.

Ellen S. Harris, Executive Director

Will Barnet:
A Timeless World

by Gail Stavitsky

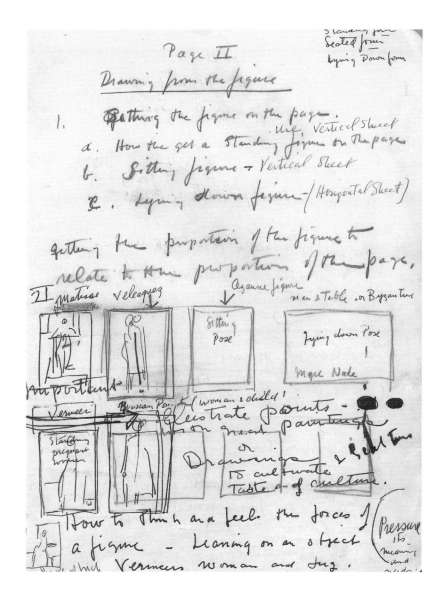

Will Barnet,
Teaching Notes,
c. 1956, "Drawing
from the Figure "

Ars Longa; Vita Brevis
(Art is Long; Life is Short) [1]

INTRODUCTION

As painter, printmaker, and teacher, Will Barnet has made uniquely significant contributions to American art for seven decades. Barnet's work reflects his ongoing participation in certain vital currents of American art, from the social realism of the 1930s to abstraction in the 40s and 50s, followed by a renewed concern for figuration from the mid-1960s onwards. Although the range of Barnet's accomplishments is vast, his entire body of work is unified by the artist's sacred devotion to classical principles of order, stability, harmony, and grace. A master of architectonic pictorial organization, Barnet has been a devotee of art history, engaged with modernizing figurative traditions of portraiture and genre.

Since his earliest days, Barnet has chosen the subjects with which he is most intimately acquainted as the vehicles for his paintings and prints. Thus the domestic life of the family is the most prominent recurring theme in Barnet's work, which explores the human condition, as well as relationships between man and nature. The artist's own family members are transformed into symbols of the universal family unit as the timeless essence of civilization. Finding that abstraction comes more naturally with forms that are so familiar, Barnet gradually pares his subjects to their essentials, without sacrificing their expressive complexities. Eliminating illusionism, Barnet achieves a total unity of simplified form and seamless space. The resulting compelling synthesis of content with the formal demands of pure painting is the foundation of Barnet's achievements.

Although Barnet's work has been extensively exhibited and published, it has, surprisingly, never been the subject of a full-scale critical and art historical appraisal. Furthermore, his work has not been included in most of the standard survey books on American art. The vital connections between his abstract and realist works have not been fully examined. Additionally, he is often regarded primarily as an independent artist who has ignored the vagaries of the art world. This lone wolf perception is an oversimplification of a highly sociable individual's life and career which has been enriched by a wide circle of friends and colleagues. Thus Barnet remains a somewhat misunderstood and relatively under-recognized artist, despite his multiple roles as a leading American modernist painter,

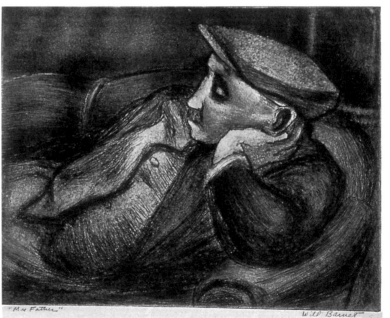

Cat. No. 6.

My Father, 1937
Aquatint
11 3/4 x 14 3/4 in.
Collection of Will and Elena Barnet

pioneering printmaker, and widely respected teacher who has generously nurtured the development of countless students. Therefore, for the first time, Barnet's entire life and career is approached in this book from a variety of scholarly perspectives. It is hoped that this multi-faceted approach will inspire future studies.[2]

THE EARLY YEARS IN BEVERLY AND BOSTON:
1911-1929

Born in Beverly, Massachusetts in 1911, Will Barnet developed a strong interest in art on his own at a very early age. As the last child who was much younger than his two sisters and brother, Barnet was left to his own devices and brought himself up by observation of the world around him. His father Noah, a Russian immigrant, was a machinist who worked long hours for the local United Shoe Machinery Corporation. Although too busy to encourage his youngest son, Noah set a healthy example for Will who inherited his father's strong work ethic, sense of duty, as well as his love of nature and animals. Dogs, talking parrots, and cats were collegial members of the household who would later recur as symbols of childhood and the family in Barnet's art work. Trees, flowers, and a garden with a fish pond were part of this stimulating environment created by Noah who also built their family home.[3]

Furthermore, Barnet was "brought up in a liberal kind of background without any political [or strong religious] identification" by Noah, who forbade his son to work in a factory which "destroyed a man's soul."[4]

Will's mother Sarahdina, also of Eastern European heritage, transmitted her sensitivity to people to her youngest son with whom she was particularly close. An introspective individual prone to melancholia, Sarahdina supported her son's endeavors to be a creative person.[5] One of her brothers, Will's uncle Harry, a building contractor based in Boston, possessed "intellectual feelings about life and art" and encouraged his nephew's budding interests.[6] A liberal socialist who believed in justice for the underprivileged, Uncle Harry also nurtured Will's awareness of class problems and tolerance for others in his mixed community.

According to Barnet, his hometown, Beverly was "a model of a New England town," with beautiful Colonial revival homes, wide streets, elm trees, and an extremely picturesque shoreline animated by great clipper ships with masts "in full bloom."[7] Living next door to one of the oldest cemeteries in New England, his family was very much immersed in this New England environment which is such an important aspect of Barnet's vision. As he has recalled, "something about Beverly and its isolation, its old colonial history" gave him a sense of living "a lot in the past...part of this American heritage."[8]

Thus at an early age, Will Barnet developed a sense of the fragility and transitory nature of life, compounded by the first World War and the terrible influenza epidemic of 1918. The young artist soon found that his only relief from this temporal burden "was to liberate oneself by enveloping one's feelings into some kind of creative form...something which a lot of other people couldn't do."[9] Projecting himself into the immortal, universal world of art, Will has recalled that his earliest exposure was through his independent readings of illustrated fairy tales by age six or seven. He particularly enjoyed the illustrations of N.C. Wyeth and Howard Pyle. His love of Robert Louis Stevenson's adventure tales, William S. Hart's westerns, Edgar Rice Burroughs' Tarzan stories, and French authors like Balzac, Stendhal, Voltaire, and Guy de Maupassant was nurtured by a sound education in the classics at McKay Grammar School where he also had some art classes. Another formative experience occurred in junior high school when he starred in a Japanese play for which he created stage sets which stimulated his interest in Oriental art. His studies of art in high school were complemented by reading the literature of such favorites as James Fenimore Cooper, Henry James, Nathaniel Hawthorne, Joseph Conrad, Edgar Allen Poe, and others who

offered "profound values in life…experience and depth."[10]

By ages 6-8, Barnet was creating many drawings at home of cats, dogs, birds, and people. He soon drew the seashore, as well, and by age 12, he set up a studio in the cellar of his home, having decided "that it was the second coming of Rembrandt."[11] Thus early on he established what would become a lifelong tendency to locate his studios in his living quarters. Before long, the Beverly Public Library became Will's second home when the librarian Marjorie Stanton gave him the key to the upstairs Art Room filled with portfolios and a substantial collection of books on artists and art history. Having been previously exposed only to Maxfield Parrish calendars, magazine, newspaper, and fairy tale illustrations, Will Barnet now discovered the old masters that would later influence him profoundly: Rembrandt, Watteau, and Daumier. Turning to the history of art for his "other relatives," Barnet has recalled how "psychologically moving" were the portraits of Rembrandt which "spoke to future generations."[12] Developing an early desire to emulate the great immortal painters of the past in order "to produce paintings that would last," he began to copy their work at an early age.[13] He also looked at the work of English watercolorists, especially Turner, Constable, Blake, and the Pre-Raphaelites. Studying the entire history of art, Barnet also looked at reproductions of Greek art and dreamt a lot about classical Greece. As a teenager in the 1920s, he absorbed Elie Faure's four volume series (1921-1924) which served as an important foundation for his convictions about art's timelessness, universality, symbolic properties, and synthetic sense of unity. Agreeing with Faure's emphasis upon the necessity for "harmony between the intelligence and the heart," Barnet has also recalled how the reproductions in these art history books made such an impression as well, notably the "beauty, grace, structure, and simplicity"of a Watteau drawing of a nude woman.[14]

Concurrently in the 1920s, Will began to familiarize himself with the collections of the Peabody Museum of Salem and the Museum of Fine Arts, Boston. At the nearby Peabody Museum, he was especially impressed with the "abstract, almost classic feeling" of the carved female ship figureheads and also admired objects from Japan, China, Polynesia, New Guinea, and New Zealand, as well as Native American art.[15] Encompassing all of world art, The Museum of Fine Arts, Boston provided many seminal viewing experiences. On class trips to the Museum, he urged his friends to skip the work of Gérome as slick "artificial stage sets," of only superficial inter-

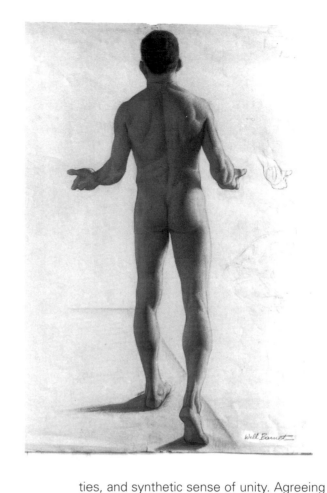

Cat. No. 1.
Lifestudy, Boston Museum School, 1929
Charcoal on paper
25 x 19 in.
Arkansas Arts Center Foundation Collection: Promised gift of Will and Elena Barnet, 1992

est and to seek the monumental, painterly vitality of Daumier.[16]

Since an early age, the young artist was free to spend romantic, idyllic summers swimming at the beach, dreaming about paintings at the Museum of Fine Arts, and painting the Beverly Beach, rocks, and trees in a *plein air* Impressionist style as he studied the work of Millet, Courbet, Dupré, Rousseau, and the Barbizons.[17] In 1928, feeling increasingly isolated in the relative provincialism of his hometown, Barnet enrolled in the Boston Museum School, beginning his formal art education, rooted in the French academic tradition. Much time was spent during the first year creating meticulous charcoal drawings of works in the collection of plaster casts of Greek, Roman, and Italian Renaissance sculpture. Subsequent studies encompassed perspective, design theory, illustration, composition, anatomy, and eventually working with live models. Excelling in all classes, as indicated by his masterful *Lifestudy* (Cat. No. 1), Barnet nevertheless felt frustrated with the academic emphasis upon the figure in isolation, rather than in compositional context to its surroundings.[18] He recalls challenging his instructor in Life Drawing and mentor, Philip Hale, an Impressionist and leading member of the Boston school.

Commenting that Hale had never really discussed how "to organize the visual world," the young artist had already discovered what would become a central objective: "the art of organizing the world in terms of plastic structure...what really makes pictures work, what makes them live...what gives them power to exist."[19] Hale, however, wrote a book on Vermeer (1913) that made quite an impression on Barnet who similarly aspired to be another link in the great tradition of the old masters admired by his teacher—Velasquez, Titian, Ingres, and David. Vermeer's elimination of inessential qualities and achievement of serene pictorial unities would emerge as attributes of Barnet's work as well.[20]

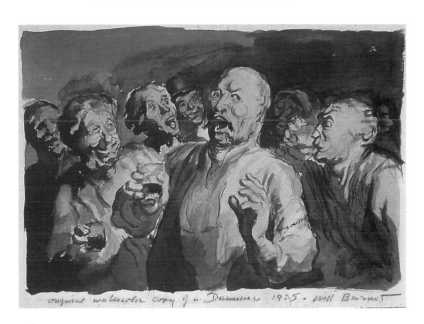

Copying extensively the works of the old masters, Will Barnet found himself drawn to the works of Daumier, Rembrandt, and also Millet (especially well represented in the Museum of Fine Arts), all of whom reinforced his socially conscious interests in the human condition.[21] Rebelling against his academic training, he began to explore different areas of Boston (such as Scollay Square) and Beverly, drawing and painting subway and factory scenes, vendors, parks, backyards, his father, and family animals. These largely Daumier-inspired works executed on site and from the imagination were much more modern and loose than his work done at school. Around 1925 he copied Daumier's *The Drinkers* (Fig. 1), embracing the master as a "god" who "spoke of the common man" in powerful aesthetic terms.[22] For Barnet, Daumier was a "wonderful role model who translated Michaelangelo's monumentality and physical energy into his own terms,"

Fig. I
Will Barnet, *Sketch after Daumier's "The Drinkers"*, c. 1925, watercolor on composition board, 11 x 15 in., Collection of Will and Elena Barnet

transcending narrative elements by translating them into harmonious works of art.[23] The young artist's struggle to forge his own identity was also shaped by extensive readings of Friedrich Nietzsche and Benedict Spinoza, both of whom gave him the strength and sustaining philosophy to overcome rejection and pursue his own creative goals without the expectation of material reward.[24]

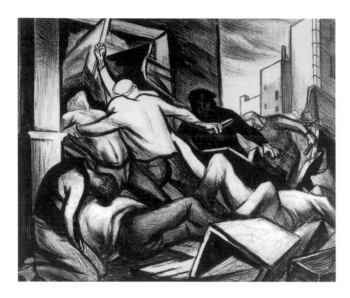

Fig. 2
Will Barnet, *Conflict*, 1934, lithograph,16 1/4 x 19 1/8 in., Collection of the Ogunquit Museum of American Art, Maine (photograph courtesy of Will Barnet)

In Boston, Will also became gradually aware of modernist tendencies, as he haunted bookshops and saw reproductions of work by Cézanne, Modigliani, and other French artists. He also saw the actual work of Puvis de Chavannes, Rodin, and Maillol. His visits to exhibitions of work by Massachusetts post impressionists William Littlefield and Frank Carson were reinforced by a significant friendship with John Hussian, fellow painter, Van Gogh devotee, and cousin of Arshile Gorky. He was also familiar with the older generation of American modern artists' work—John Singer Sargent, George Bellows, and the Ashcan School—although he had reservations about what he perceived to be a certain slickness, virtuosity, and illustrative superficiality in their work. During his student years, Barnet also had his first teaching experience, instructing settlement children in drawing at Salem's House of Seven Gables made famous by Nathaniel Hawthorne.[25]

NEW YORK:
THE 1930s

Valuing the solid technical education that he had received at the Museum School, Barnet nonetheless was ready to move on, having rejected "the staged quality of the Boston school of painters which lacked a strong formal frame."[26] Already informed as to the more cosmopolitan New York art scene through his reading of *The Arts*, *Creative Art*, *International Studio,* and other publications, he resolved to move there after finishing his course work in 1931. Indeed in 1929 he traveled to New York to see the landmark opening show of the Museum of Modern Art, *Cézanne, Gauguin, Seurat, Van Gogh*. Deciding that he wanted to attend the famous Art Students League which offered a more liberal education, he applied for the out-of-town scholarship which he won with the support of one of the judges, Reginald Marsh. Barnet had hoped to study with the influential School of Paris modernist Jules Pascin whose paintings and drawings of Parisian harlots he admired for their sensuality of line, sensitivity, and simplicity. Unfortunately, he found out soon after his arrival in the summer of 1931 that Pascin had committed suicide. He then resolved to study with Stuart Davis and enrolled in his class in October. This decision was most likely related to his interest in the "eclectic, Picasso-Cubist style" works of Arshile Gorky whose studio Barnet began to frequent upon his arrival in New York. Davis's Cubist street scenes of Paris created in 1928-1929 were of particular interest to Barnet who admired the modernist's elimination of perspective, tonality, and modeling—his ability to simplify the three-dimensional complexities of the outside world into two-dimensional art. Furthermore, Davis was a role model in terms of being an internationalist who was also very American in his outlook.[27] Nevertheless, Barnet was not

yet ready for modernism in his own work. Enrolled for only a short time in the class of Davis, who taught briefly at the League, he transferred to the afternoon lithography class of Charles Locke, a lithographer and instructor at the League since 1923 when he inherited the position of Joseph Pennell.[28]

Already aware of Pennell while studying in Boston, Barnet had also read books on graphics and Daumier's lithographic stonework techniques. His embrace of printmaking was therefore a natural evolution for an artist, in the midst of the Great Depression, wishing to make a living, to "do prints that would reach many people."[29] Barnet wanted to follow in the footsteps of his idol as a social commentator who knew, however, "the difference between telling a story and making a work of art."[30] He therefore appreciated Locke's tendency to emphasize aesthetics over technique in his many discussions about Poussin, music, and the geometric organization of pictures.[31] Essentially self-taught as a printer, Barnet printed for Harry Wickey, George Picken, and Harry Sternberg.

At the League he also met instructor Thomas Hart Benton and fellow student Jackson Pollock. Although Benton encouraged him, Barnet rejected the regionalist teacher's art and stance as "illustrative…nationalist…completely anti-modern" and could not understand why Pollock had chosen him.[32] Aware of the short-lived tenures of such modernist instructors as Hans Hofmann and Jan Matulka, Barnet began to involve himself actively as a member of the League in order to attract "more modern men" as teachers, including the great satirist George Grosz.[33] In 1935 he became the League printer and

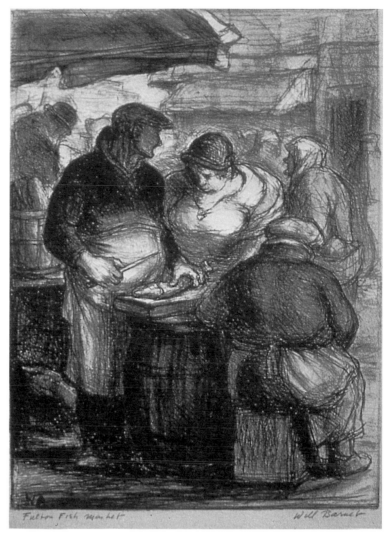

began teaching workshops in printmaking the following year.[34]

Although he would develop a reputation in the 1930s as an interpreter of the human condition, Barnet has always distinguished his work from the "half-starved social painting" of that era.[35] Decrying the Social Realist/American Scene illustrative emphasis upon subject matter, he preferred the powerful work of the Mexican muralist and printmaker José Clemente Orozco. Having first seen his work at the Museum of Fine Arts, Boston in 1930, Barnet appreciated the unified, dynamic thrust of massively constructed forms in Orozco's socially engaged work which served as the model for such prints as *Conflict* (Fig. 2) and *Workers* (1935). Referring to Orozco

Cat. No 2.

Fulton Street Fish Market, 1934
Lithograph
15 1/2 x 11 in.
Collection of Will and Elena Barnet

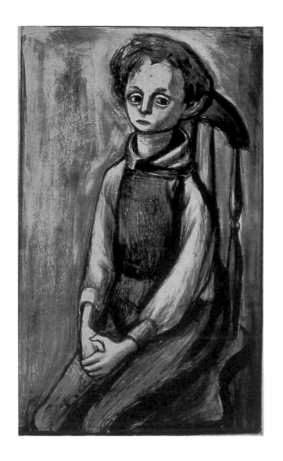

as the Mexican Giotto, Barnet also related to the Mexican master's appreciation of the Byzantine and early Italian artists' conceptualization of form.[36]

Orozco was an influential and prominent figure in New York as a result of various exhibitions, his 1931 murals at the New School for Social Research, and his association with the American Artists Congress. Barnet belonged to this socially conscious organization of artists united against impending war and the spread of fascism.[37] As a politically aware proponent of the New Deal, Barnet worked for the Federal Art Project of the Works Progress Administration (WPA) in 1936 as a technical advisor and printer for the Graphic Arts Division.[38] Nevertheless, he was not a joiner or extremist by nature and did not participate in labor demonstrations or other progressive groups with which he might have had sympathies, such as The Ten and the American Abstract Artists, founded in 1935 and 1936, respectively. Both of these mod-

ernist organizations, formed in opposition to the dominant American Scene painting, included artists with whom Barnet was friendly, such as Joseph Solman of The Ten, as well as studio mate and geometric abstractionist Albert Swinden, a founding member of the AAA. Furthermore, he shared a house in Queens with AAA member and pioneering follower of Mondrian, Burgoyne Diller.[39] Indeed Barnet recalls that Diller looked at some of his earliest prints and remarked that his young colleague was "thinking kind of abstractly" in terms of the strong spatial/perpendicular relationships of horizontal and vertical forms.[40] Declining to become a follower of any school of thought, Barnet strove to make an aesthetic, humanist statement about figurative imagery that stirred his imagination.

In 1931, Barnet issued his first lithograph, *New England Town.*[41] In 1934 he created *Fulton Street Fish Market* (Cat. No. 2, see previous page). Referring to this work as "a Michaelangelo-esque version of a street scene," Barnet has recalled his fascination

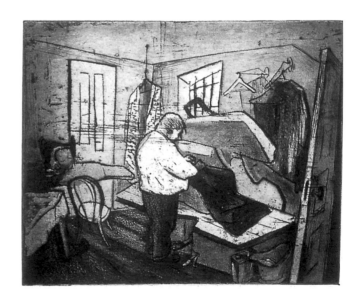

with sketching immigrant life in New York's Lower East side and his appreciation of Glenn Coleman's views of Greenwich Village.[42] The solid volumes and monumental-

ity of carefully organized forms reveals the strong continuing influence of Daumier. The lithograph of *Little Joe* (Cat. No. 3) was drawn freely and directly onto a heavy stone that Barnet carried up four flights of stairs to his apartment and propped up on a chair. This son of a coal miner posed for the artist after having met him in Central Park. The stylized elongated treatment of the subject evokes both the hunger of the child and the impact of Modigliani whose work was frequently exhibited in New York in the early 1930s. Barnet appreciated "the fact that [Modigliani] could take a head and create a sense of the head having geometry and not losing its humanity."[43]

Approaching lithography as an experimental painterly medium, Barnet would wash in a stone, as if he were making a ground for a painting and "draw into it [with a lithographic crayon or pencil] while it was wet, then scratch out and put in tones."[44] Convinced that all the great graphic work had been done by painters like Rembrandt, Barnet felt that he was much freer in his approach than most printmakers. Working also with the mediums of aquatint and etching, he created *The Tailor* (Cat. No. 5), based upon sketches of another Lower East side subject which were transferred to the etching plate (for other works he drew directly on the metal plate). His lyrical, intimate approach suggests Barnet's appreciation for the work of Pascin and also Vuillard. The latter's *Mother and Sister of the Artist* already in the collection of the Museum of Modern Art by 1934 and on view, forms an interesting comparison with Barnet's lively watercolor of his mother (Cat. No. 4).[45] This work, which also

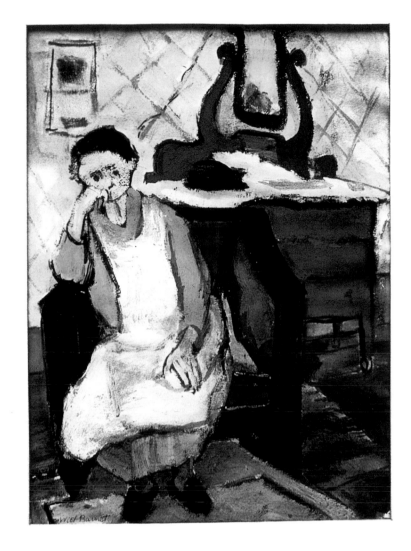

suggests Barnet's awareness of Matisse and Fauvism, is a portrait of his mother in her bedroom, a typical intimate study which evokes the artist's strong, emotional ties with his mother.

Barnet also created many intimate studies of his father during his return trips home. *My Father* (Cat. No. 6, see page 6) is a monumental, timeless image based on an outline drawing of his father resting, which was the only way that he would pose. The work that truly memorializes the 1930s is *Idle Hands* (Cat. No. 18, see page 77) which exists both as a rare extant early painting and as a lithograph. Having little money for paints and moving around a lot, Barnet focused primarily at this time on doing his own prints at the League.[46] This iconic image was based on the experience of encountering a homeless

Cat. No. 4.
Artist's Mother,
1934
Watercolor on
paper
15 1/2 x 11 1/4 in.
Collection of Will
and Elena Barnet

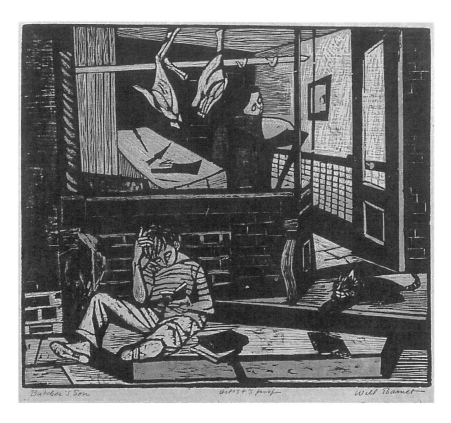

Cat. No. 7.
The Butcher's Son, 1939
Woodcut
13 3/8 x 15 in.
Collection of Will and Elena Barnet

ing symbolically addressed the "red-hot issue [of] slum clearance" in his prints of depressed industrial sections of Norwalk, Stamford, and Bridgeport, Connecticut.[51] One of the reproduced prints, *Factory District, Norwalk, Connecticut*, had been featured in the American Artist's Congress first show devoted to contemporary graphics in 1936. Barnet's feature article and inclusion in *America Today* signaled his significant role in the national renaissance of prints as accessible art works "that can be reproduced cheaply and without loss of pictorial power."[52] His

person on the Bowery. Leaning forward, his face buried, this man has been transformed into both "a historical monument to this period and a universal statement that is not propaganda" as it transcends specific time, place, and situation.[47] Differentiating his work from the "political statements" of Ben Shahn, Barnet has recalled initially exhibiting his graphic work when this leading Social Realist's series on Sacco and Vanzetti was on view at the Downtown Gallery in 1932.[48] Barnet's first one-man show of paintings and drawings at the Eighth Street Playhouse in 1935 was well-received by critics, especially Emily Genauer. She praised his "first-rate debut" of works such as *Cotton Pickers*, "designed with a splendid sense of rhythm and integral movement."[49] She also chose to reproduce Barnet's portrait of his wife Mary Sinclair as "another example of Barnet's rhythmic design and free, strong brushwork."[50]

In 1938, a feature-length, illustrated article on Barnet's work appeared in the *Herald Magazine* with the title "Art That's Not for Art's Sake Alone." He was credited with hav-

prints were already being included in important surveys at the Art Institute of Chicago, the Philadelphia Print Club, the Los Angeles Museum, and other venues, including the New York World's Fair of 1939.

In 1938, Barnet's second one-man show of lithographs, etchings, aquatints, and drawings at the Hudson Walker Gallery received considerable coverage (included were Cat. Nos. 3, 5). Credited with preaching "No 'Angry Propaganda,'" Barnet was praised as a consummate technician who imbued his direct, unsentimental work with a full expressive range and "a humorous appreciation of makeshift living, as well as a tender sympathy with its unfortunate practitioners."[53] In addition to his work at the League as "the craftsman printer to whom the most famous printmakers trust their work," the 27 year old Barnet also became technician and instructor in etching and lithography at the New School for Social Research in the spring of 1938.[54] As the Art Students League printer, Barnet made lithographic impressions for Louise Bourgeois, Minna Citron, William Gropper,

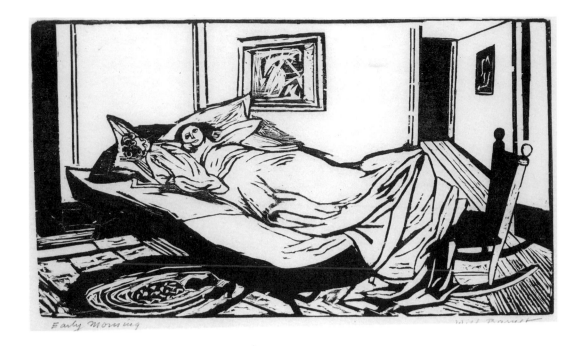

Early Morning [signature]

Louis Lozowick, Harry Sternberg, Charles White, and even his idol José Clemente Orozco.[55]

The late 1930s and early 40s constituted a turning point for Barnet in his personal and professional life. With the birth of his son Peter in 1938 (followed by Richard in 1941 and Todd in 1944), Barnet turned increasingly to his home environment as the subjects for his work.[56] This natural tendency was reinforced by his love of Vermeer about whom he would have long arguments at the League with social painter and colleague Harry Sternberg: "I used to say if Vermeer can take the corner of a room and make a work of art out of it why bother to run around painting lynching scenes and coal miners?"[57] Furthermore, he began to consciously develop a modernist vocabulary of form as a result of his years of looking at modern art in New York galleries and muse-

ums—"it took me ten years to break away from a very academic point of view."[58] He has recalled frequenting the Weyhe Gallery where he bought books on Cubism, and seeing the work of Kandinsky and Klee at the J.B. Neumann Gallery.[59] One of his favorite places was the small, intimate Gallery of Living Art at New York University which offered a choice selection of works by Picasso, Braque, Léger, Gris, Arp, Mondrian, and others. Furthermore, the Museum of Modern Art presented a highly influential, large-scale Picasso retrospective in the fall of 1939.[60]

Created in 1939, Barnet's woodcuts *The Butcher's Son* (Cat. No. 7) and *Early Morning* (Cat. No. 8) suggest the artist's thorough, almost subliminal assimilation of these modernist sources. The stylized figures and indoor/outdoor Cubist conflation of space in *The Butcher's Son* can be related to the work of Picasso, Gris, and

Cat. No. 8.
Early Morning,
1939
Woodcut
9 x 15 3/8 inches
Collection of Will and Elena Barnet

Fig. 3
Unknown (late XIII century),
Italian (Florentine) Madonna and Child Enthroned
The Metropolitan Museum of Art,
Gift of George Blumenthal,
1941, 41.100.21

Modigliani—the latter continuing to be "always in the back of [Barnet's] mind, a spiritual father haunting [him]."[61] The pivotal print that marked his transition away from scenes of society at large into the modernist, psychologically engaged, family-oriented work of the 1940s was *Early Morning.* This haunting image of his awakening wife reclining in bed with their infant son in their cramped railroad flat was drawn directly onto the woodblock. Striving to organize all of the visual elements and enliven the picture plane, Barnet swept aside all modeling and conventional perspective, embracing synthetic cubist spatial principles. Although this work is often linked to German Expressionist woodcuts which Barnet appreciated, he instead attributes the enormous stretching of the abstractly conceived, flattened figure of Mary to his strong interest in Byzantine and early Italian art (see Fig. 3, see previous page).[62] This desire to assimilate the best from various cultures of the past and present permeates Barnet's teaching as well.

THE 1940s & BEYOND:
WILL BARNET AS A TEACHER

Barnet stresses the importance of structural design and the understanding of the formal elements of drawing and composition plus the techniques of the graphic arts. A sound understanding of the Old Masters; their influence on, and their relationship to the Modern Masters, is the basis on which we work.[63]

When I say to my students be true to nature, I mean be true to the structural meaning of nature rather than its appearance.[64]

Spirit of Form the important thing— not the style.[65]

During the 1940s and 50s, Barnet generally shifted his attention away from printmaking to painting, relinquishing his teaching position at the League in the graphic arts to become an instructor of painting—a position he held

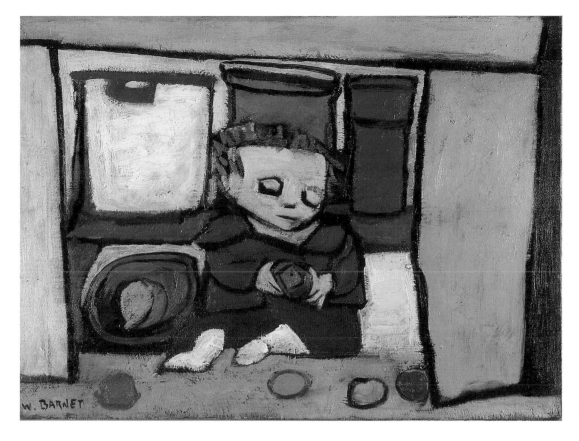

until 1980. (Fig. 4) Nevertheless, he continued to teach printmaking there and also at Cooper Union starting in 1945, as well as the New School for Social Research, and later at the Pennsylvania Academy of the Fine Arts. From the start of his long, busy teaching career at many colleges, universities, and professional art schools, he believed that the fundamentals for painting and graphics were the same. "what do I want to say and how shall I express it plastically?"[66] Taking his students to museums and galleries, Barnet emphasized the connections between vital art forms of all ages, wishing to instill "a certain reverence for art and the desire to emulate your best ancestors…to absorb [one]'s past, not to rebel against it, and to move it into the discoveries of [one's] time.[67] Barnet felt that his responsibility as a teacher was "to help students find the larger forms and themes—the permanent values."[68] He communicated his enthusiasm for the purity, simplicity, stylization, monumentality, and spatial compression—"fundamental principles"— of

Egyptian, Romanesque and Etruscan sculpture, the Byzantine artists, Cimabue, Giotto, the Italian primitives.[69] For Barnet, these and other early masters predated the overly refined decadence of the High Renaissance and constituted "the birthplace of Western Culture."[70] He has recalled that the Italian primitives, in particular, were "a great influence on my work as I was struggling to understand modern painting" because they "taught me about the flat surface I was working with."[71]

Barnet equated the classic achievements of these Western primitives with the strengths of Native American (early Pueblo, Hopis, Central Plains), African, Aztec, Mayan, and other early civilizations. He has recalled that modern artists like himself were among the first to appreciate and communicate the aesthetic principles of these aboriginal art forms which he defined as "the ability to take a figure, disassociate it and re-create it while expressing a certain kind of dynamism through imagination."[72] Barnet was especially

Cat. No. 19.
The Cupboard, 1944
Oil on canvas
18 x 24 in.
Lent by the Frederick R. Weisman Art Museum, Bequest of Hudson Walker from the Ione and Hudson Walker Collection

Fig. 5

Will Barnet Painting Class, Summer 1950. Collection of the Art Students League of New York. Photograph by Alfred Gescheidt. The artist is lecturing in front of reproductions of works by Cézanne, Seurat, and Ingres, especially the latter's *Vicomtesse Othenin d'Haussonville, née Louise-Albertine de Broglie* (1845, The Frick Collection, New York).

familiar with the articulation of these principles in the book *Primitive Negro Sculpture* by Paul Guillaume and Thomas Munro, first published in 1926. He copied by longhand entire sections of this book, devoted to such subjects as "The Mask as Sculptural Form" in which "the entire face becomes an organic whole in which contrasting elements are harmonized, in which lines and planes echo and reverse one another, flowing or sharply jutting together to form a closely interwoven whole."[73] Barnet also shared his enthusiasm for the "multiple forms" and "simultaneous relationships" of Incan art and Peruvian tapestries.[74] Delivering pioneering lectures at the League, the American Museum of Natural History, and the Museum of the American Indian, Barnet emphasized the pictorial integrity of primitivist pure forms that were metaphors for forces felt in nature, as well as the melding of positive form and negative space into a continuous "all over" composition.

He also articulated his expectations for great art of all cultures and ages as that which is beautiful, ennobling, and uplifting, with a fundamental respect for all living things. The disparate masters he admired share "a com-

mon devotion to 'honest structures'…a rejection of 'illusionism and emotionalism;'" nevertheless, the artist's emotional feelings about what is seen constitute a reality that is as important as that of the canvas.[75]

Furthermore, Barnet has, over the years, developed an art collection ranging from early archaic Greek sculptures to such contemporary artists as Louise Bourgeois, Henry Pearson, Robert Blackburn, Louise Nevelson, Peter Busa, Dennis Cossu, Seymour Lipton, and Richard Anuskiewicz. His collection encompasses Mayan, African, Cambodian, and Eskimo art, Italian drawings of the 16th-17th centuries, as well as works by such French artists as Fernand Léger, and Ignace-Henri-Jean-Théodore Fantin-Latour.

Regarding the past as providing "solid roots" for the present, Barnet taught "the relationship of the Old Masters to modern abstraction."[76] Analyzing "the model as a source of abstract inspiration," he compared the work of Velasquez and Matisse.[77] Though "separated by several centuries," he observed, "both these painters show a rigorous concern for the structural forces that are so organic and timeless in the history of painting."[78] Barnet frequently discussed the work of such favorite classic masters as Poussin, Vermeer, Ingres, Cézanne, and Seurat whose work exudes eternal order, clarity, and tranquillity. (Fig. 5) Drawing upon a treasured collection of color reproductions, he often analyzed such masterpieces as Ingres's *Vicomtesse Othenin d'Haussonville, nee Louise-Albertine de Broglie*, 1845 (The Frick Collection, New York)—"an excellent example of Ingres at his peak."[79] Transcending mere description, Ingres gave "a tremendous, horizontal expansion" to this vertical picture; this anchoring "stretch, vitality, tension" is the "only means of [pictorial] life."[80] Barnet also analyzed Ingres's *Odalisque*, pointing out "how he stretched that…one curve [from the shoulder to the tip

of the toe]…like an elastic band" to create "the idea of tension between forms—one of the great lessons."[81] Addressing misinterpretations of Ingres's work and the classical tradition as overly intellectual, Barnet informed his class that the master's forms "are welded with passion" for "the hottest part of the flame is the white part, not the red."[82]

Another favorite was Juan Gris, whose essay "On the Possibilities of Painting" was a critical text for Barnet who appreciated the painter's reflections on the "architecture of picture-making" and the elaboration of "formal elements into a coherent unity."[83] Gris's essay was translated into English in 1947 by the great Cubist dealer and critic Daniel-Henry Kahnweiler whom Barnet invited to speak to his students at the League. Delivering lectures on Gris as a "master of interlocking forms," Barnet asked his students to make copies of the Spanish master's *Dish of Grapes* in the Gallatin Collection.[84] Favoring the "close values… compactness [and] dynamic movements"of Gris's work which attained a "climactic serenity,"Barnet stressed his ability and that of other masters to structurally interrelate visual elements which was deemed more important than their choice of subject matter.[85] He also emphasized the need to find "the essence, the basic character of an object" and to avoid getting involved with details.[86] The basic visual element is form, defined by Barnet as "a plane which begins to describe the position of an object."[87] Defining the canvas or paper in planar terms, Barnet stated that all of his thoughts have been centered on how to work within the limitations of this fundamental plane. Thus, planar "form is the very essence of painting and color the final binder."[88]

This "anatomy of a two-dimensional surface" is a recurring theme of Barnet's writing and teaching.[89] He regards the limitations of this flat, quadrangular surface as an asset with "a clear and concise beauty" with "life-giving properties…in terms of two-dimensional movements"and proportions.[90] Thus Barnet emphasized the dynamic equilibrium of horizontals (across) and verticals (up or down) as "more than just a method or a theory but a living and natural organic force."[91] Discussing the expansion and contraction of forms to achieve tension and balance, he also advocated the elimination of distracting atmospheric effects (shadows, modeling, textures, highlights, vaguely defined, floating forms) which contradict 20th century modernist thinking, creating "a world of illusion and chaos."[92] (Fig. 5) Barnet has also stressed the interchange of positive and negative form, stating that he is "as vitally concerned with the air and space between forms as…the forms themselves."[93] Unifying relationships of color and form, horizontal and vertical movements create "a spiritual vitality" and leave nothing "to chance or illusion."[94] Thus Barnet has avoided employing diagonals which disrupt the vertical-horizontal structure of the canvas. He has also warned against the use of the word "composition" as suggestive of artificially contrived designs, preferring instead to talk about deeply felt, life-affirming horizontal and vertical forces.[95]

Barnet is commonly regarded by his many students as a highly effective, humane teacher. Gentle yet tough, determined, and demanding, he has been praised as a very articulate, encouraging individual who has been generous and helpful to many artists in the development of their careers. One of the best and most influential teachers in America, Barnet has had many prominent pupils, including Mark Rothko, Audrey Flack, Tom Wesselman, Paul Jenkins, Donald Judd, Eva Hesse, Henry Pearson, Cy Twombly, and James Rosenquist, as well as the master printer Robert Blackburn.[96]

THE 1940s & 1950s:
MODERNISM, INDIAN SPACE, AND ABSTRACTION

During the early 1940s Barnet was pushed to the limit with the heavy demands of his teaching schedule, wartime work in a printing plant, and home life. Nevertheless he recalls this period as a time when a lot of his ideas began to mature because he "had all of his models in [his] own home."[97] He made many prints and paintings of his wife and their children. Especially interested in capturing "the spirit of children in action" and in different stages of development, Barnet created such seminal works as *The Cupboard* (Cat. No. 19, see page 17), *Soft Boiled Eggs* (Cat. No. 20, see page 79), and *Go-Go* (Cat. No. 9). His abiding interest in the children's proportions and perspective of the world around them is evident especially in *The Cupboard* which features his three year old son Dickie (Richard) playing with fruit. The large-headed toddler is juxtaposed with two vibrantly colored pots and a white basket which looms above him to the left. The bright, unmodulated palette and even illumination brings to mind Barnet's later comment about Matisse who taught him "to paint the model as if it were in full light with every form clearly indicated, the shapes not disguised by shadows."[98] The carefully coordinated, simplified, stylized, planar forms typify what Barnet has called his "conceptional thinking" with regard to "trying to create a concept of things that were fragmentary into things which became organized…complete."[99]

Synthetic Cubism played an important role in this abstract presentation of lively

forms. Indeed Picasso's *Three Musicians* (Fig. 6) in the Gallatin collection served as the acknowledged prototype for Barnet's *Soft Boiled Eggs*. Adapting the diamond pattern of the Harlequin's costume for the central figure, his wife Mary, Barnet also worked with the Cubist idea of the compression of space to relate the figures to the table and their surroundings. Describing at length the considerable genesis of this painting from hundreds of sketches, Barnet has recalled its origins in a family birthday party. (Fig. 7) Seeking to unify the mother and child sprawled under the table, he brought the mother's body forward and painted the son's hand touching her slipper. The final resolution came with the removal of an obtrusive birthday cake, and substitution of soft boiled eggs (seen one morning at breakfast) which enhanced the planar horizontality of the table. *Soft Boiled Eggs* was featured in Barnet's well-received one-man show of early 1947 at

Fig. 6
Pablo Ruiz Picasso, *Three Musicians*, 1921, oil on canvas, 80 1/2 x 74 1/8 in., Philadelphia Museum of Art, A.E. Gallatin Collection, 1952-61-96.

Cat. No. 9.

Go-Go, 1947 Serigraph 12 x 9 5/8 in. Collection of Will and Elena Barnet

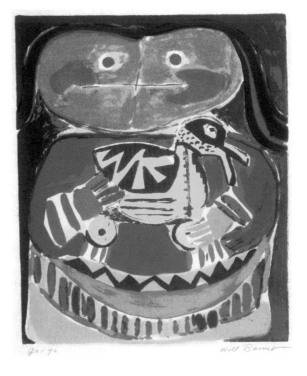

Bertha Schaefer Gallery. He was praised at that time as "the only painter in the child-like idiom we have seen in a long time who hasn't looked too long at Picasso."[100]

Although primarily a natural outgrowth of his own experiences, Barnet's interest in the vitality and energy of children and their essential concepts of the world can also be related to the work of Paul Klee whom he regards as a "very strong link."[101] Klee's belief that "children, the insane, and primitive peoples all still have—or have rediscovered—the power to see" had become a commonplace notion among modernists by the 1940s as a result in part of such books as Robert Goldwater's *Primitivism and Modern Art* which, as Barnet recalls, was very much "in the air."[102] Like Klee, Barnet was fascinated by children's drawings and in 1947 he organized an exhibition of drawings by his sons Peter and Dickie at the Carlebach Gallery in New York. Furthermore, he admired Chardin's depictions of children for their "clarity of organization" and insight into character.[103] Barnet shared his interests in Klee, Picasso, the modernist appreciation of the tribal, and primitivism with such fellow artists as Peter Busa and Steve Wheeler whom he had befriended in the late 1930s. They all frequented the Native American collections of the American Museum of Natural History where their friend Robert Barrell worked on a WPA project in 1939 and 1940. Barnet was especially impressed with the pioneering work of his friend Steve Wheeler who by the early 1940s had forged an original, all-over style of complex, linear painting rooted in his appreciation of the work of Miró, Klee, Picasso, and Northwest Coast

Indian art. By 1944 Barnet had even acquired an example of Wheeler's work, *The Halogens II*.[104] Nevertheless, Barnet was already moving in his own direction and achieving recognition for having developed a personal expression.

Focusing increasingly on creating and exhibiting his paintings, Barnet temporarily abandoned printmaking from 1943 to 1946. Writing about Barnet's one-man exhibition in 1943 at the Galerie St. Etienne, critics took the opportunity to comment on his paintings as being "crude in comparison to the sensitivity of his prints"[105] Nevertheless he was deemed "a good designer with color as with black and white" whose paintings show promise, as well as "the same touching quality long noted in his prints."[106] It was observed that Barnet's "luster" in the field of graphic arts still "eclipsed his claims to being a painter."[107] Indeed Barnet's first solo museum exhibition at the Virginia Museum

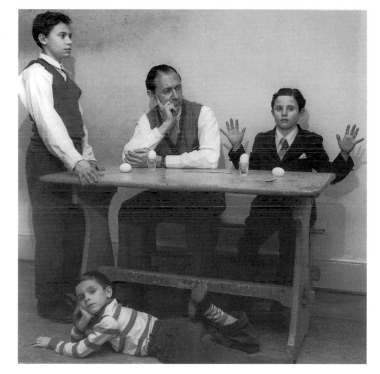

Fig. 7

Recreation by Will Barnet and his sons of *Soft Boiled Eggs* (Cat. No. 20, see page 81), 1952. ©Alfred Gescheidt.

of Fine Arts in 1942 had been devoted almost entirely to his prints. Nevertheless by 1946 when Barnet had his next one-man gallery show, he was acknowledged to be

"getting away from influences previously appreciable in his canvases and arriving at a more personal expression."[108] Praised for the "higher key of his color…virility of statement," and intricate compositions, Barnet also received approbation for depicting his young subjects with fidelity and a lack of sentimentality.[109] Reminding her readers that Barnet had "long been a painter of substance and maturity," Emily Genauer detected "a new freshness, crispness, stylization and tenderness. Others related the work to "the formalism of a mosaic" and, in the case of the Native American-inspired *Boy with Corn*, "an Indian Kachina."[110] His "remarkable growth" was observed by another critic who noted that Barnet had "gone far beyond the skillful, though derivative Post-Impressionism of his earlier canvases."[111] Having replaced "loose contours…muted color [and] expressionist bravura" with "boldly crystallized" design, Barnet "transcends the specific and makes a universal commentary on human relations."[112]

In 1946, Barnet also had a ten-year retrospective of his graphic work at the U.S. National Museum in Washington D.C.[113] That year some of his colleagues and former students, including Oscar Collier and Gertrude Barrer, exhibited their work in the landmark show *Semeiology or 8 and a Totem Pole* at the Galerie Neuf in New York. One of the exhibiting former pupils, Howard Daum, coined the term "Indian Space" to characterize the Native American-inspired integration of organic and geometric, pictographic forms within a flat, seamless space. For the Indian Space painters, the nonillusionistic pictorial structures of Native American art "exhibited formal power…profound insights" and universal interpretations of "man's perception of his environment."[114] Furthermore, American Indian art provided an indigenous heritage for these artists as they sought to "give a new expression to American art" and to "be truly American."[115] Barnet recalls

their common bond as they sought a new concept of visualizing multiple, hard-edge planar or linear imagery:

> Some of us felt it wasn't enough to be a pure abstract painter nor a social painter. We felt there had to be something else beyond the form concept that came through Cubism, Malevich, and Mondrian. We were looking for some other aspect to form… re-realized in a fresh way.[116]

Stimulated by the work of Picasso, Miró, and Klee, they began to find their own voices by investigating the primitive art sources of these European masters. This exploration led them to their own aboriginal art traditions of Native American art—an interest in mythic origins that pervaded the New York avant-garde of that time.[117] Although Barnet sympathized with the aims of his colleagues to go "beyond Cubism in a search for American values," he did not choose to exhibit in the 1946 show.[118] Nevertheless, by 1947 he was incorporating the structural and iconographic principles of Indian Space in a highly original group of works.

In 1947 Barnet returned to printmaking. *Go-Go* (Cat. No. 9, see page 20) is a tender, playful silkscreen portrait of Barnet's youngest son holding a duck. The compression of forms and oval-shaped format suggest the profound impact of Native American ceramics of the Southwest. This influence of prehistoric Hopi pottery designs from Arizona is also evident in the humorous lithograph *Strange Birds* (Cat. No. 10, see page 63), rooted in his experiences of a bird chasing a cat on a farm in the "primitive countryside" of upstate New York in Webatuck.[119] There he immersed himself in the lively behavior of the farmyard animals, just as he had studied his own children. Other works from the late 1940s, such as *Old Man's Afternoon* (Cat. No. 22, see page 81) are regarded by Barnet as being on "the bor-

derline between Cubism and Indian Space."[120] The earlier, more literal version of *Old Man's Afternoon* (Cat. No. 21, see page 80) is a Synthetic Cubist composition of Barnet's father with a parrot affectionately perched on his head and his grandson Dickie playing with the family cat under a table. In the second version, the son is joined to his black cat; his mask-like head is completely merged with the table, as is the parrot with Barnet's father. A vast sense of scale is suggested by the extension of the central elderly figure and the transformation of the sunlight streaming in from the window into a yellow patchwork quilt that unifies the composition. It is enlivened by the colors and textures of the tablecloth, a painting of roosters leaning against the window, and a Klee-like cat face suspended above a rainbow band. Barnet has also referred to the combination of "almost Miróesque humor and serious formal ideas" evident in this painting.[121]

Barnet's brief interest in Surrealism (i.e. the work of Miró and Masson), shared by many other artists in the 1940s, including his closest friends Wheeler and Busa, is also manifested by *Family and Pink Table (Mary and Sons)* (Cat. No. 23, see page 84). The surreal element of Todd playfully torturing the cat is a psychologically charged motif that epitomized Barnet's desire to communicate his life experiences in a contemporary language of his time.

Nevertheless, the treatment of Mary as a hieratic Byzantine madonna typifies Barnet's conception of Indian Space as "a merger of many cultures, past and present."[122] This notion of assimilation and adaptation is also evident in the transitional painting *Summer Family* (Cat. No. 24, see page 83), created when Barnet acquired property outside Danbury, Connecticut. Interested in integrating his family members with the surrounding landscape, he developed "a mysterious link, an interplay of figurative forms out in the

open or contained by tree-like forms."[123] Attempting to merge the compartmentalized figures with the atmosphere and shifts from hot light to cool dark, Barnet evoked the different personalities of his family members: the shy figure of Peter to the left, the more exuberant Todd holding the cat with which he is thoroughly integrated, and the haunted figure of Dickie between the trees to the right. The figure of Mary is an intensely private abstraction whose personality is unfathomable. An inherent sense of tension suggests the growing stresses in a marriage that would end in divorce in 1952.

The stylized, mask-like faces of all the figures in *Summer Family* evoke Barnet's notion of Indian Space as a synthesis of the tribal and modern. Wishing to surpass Cubism in his desire to create an authentic American modern art, Barnet achieved "a provocative spatial ambiguity" and "totemic verticality" in *Summer Family*.[124] Nevertheless, his concepts of Indian Space would be more fully developed in a major group of paintings from the 1950s.

In 1948, the year that *Summer Family* was completed, Barnet had another one-man show at Bertha Schaefer Gallery. The exhibition's short catalogue essay was written by the critic Dorothy Seckler who would become one of the artist's most articulate and sensitive supporters. Referring to his work as "deceptively informal," she commented on "the interrelationship of structure and idea," monumentality, and life-affirming qualities of his work.[125] Other critics commented on his lack of sentimentality, "effective spatial relations," "flat, decorative ribbons and bars of color reminiscent somewhat of Stuart Davis," gaiety, and "strong, sense of color."[126] Barnet's solo exhibition of 1949 at the same gallery, featuring *Summer Family* and other recent works, was also well received. Critics compared aspects of the work to Picasso's portraits of his own children, as well as "the

awkwardness…of an infant by an early American limner" and the "touching solemnity of a daguerrotype."[127] This exhibition was accompanied by an excerpt from the introduction to the first monograph on Barnet's work, published in 1950.

Published by Press Eight for which Barnet, Busa, and Wheeler served on the editorial board, this monograph featured a selection of 36 paintings completed during 1939-1949. In his introduction, James T. Farrell emphasized Barnet's focus on American "life in humanized terms…seen freshly, with deep affection and sympathy."[128] Through "the firm construction" of Barnet's scenes and his skill, "the ordinary becomes a new visual world."[129] In 1950 he was also the subject of Dorothy Seckler's article in *Art News*, "Can painting be taught? Barnet answers." As a result of this first feature-length article, Barnet received many calls from universities, especially Josef Albers at Yale, and embarked upon a very active career as a visiting instructor all across America and in Canada.[130]

Seckler characterized Barnet as "a nationally-known leader in the graphic arts, as well as an established painter."[131] She defined his aesthetic as possessing two sides: one "anchored in the perception of the concrete…the other soars into an Emersonian transcendentalism, which is expressed in the poetic and philosophical meanings he constantly imputes to these phenomena."[132] Referring to Barnet as "ordinarily mild mannered and soft spoken," she noted his vehemence "when he speaks against illusionistic painting 'which has obscured and corrupted the great tradition of art,' or when he inveighs against 'bellyache art' in which he includes almost all expressionist and neo-romantic painting."[133] This statement seems to reflect the mounting frustration of Barnet, as well as his friends Wheeler and Busa with the growing dominance of Abstract Expressionism.

As an example of the peculiar divisions among painters of this period, Barnet has recalled his inclusion in the large-scale landmark show *American Painting Today* in 1950. This diverse national competition is primarily recognized today as the launching pad for the Irascibles, namely the fifteen New York abstract painters (including Pollock, Reinhardt, Gottlieb, and Rothko) who boycotted the show and were featured in *Life* magazine.[134] Represented by one of his finest paintings, *Awakening* (1949, Private Collection, see back cover), Barnet regarded this protest against the Metropolitan Museum of Art as the unwarranted rejection of tradition: "If you encompassed tradition, you were not progressive enough."[135] For Barnet, the 1950s was a difficult decade in which he felt himself to be an outsider whose hard-edge abstractions were rejected by the museum and art world year after year. Nevertheless, he persisted and was supported by teaching as an outlet for his ideas: "I used to teach the history of classical painting in the midst of terrific expressionism."[136]

Searching for a sympathetic critic in what they perceived to be an increasingly intolerant environment, Barnet, Wheeler, and Busa befriended Gordon Brown, a lecturer in art history at Hunter College. They worked closely with him on the important article "New Tendencies in American Art" which was published in Winter 1951-52.[137] Noting a tendency to view abstract expressionists as the only ones "following the right path," Brown credited Barnet, Wheeler, and Busa with being the first to take the "important step of consciously eliminating…the distinction between background and foreground…since the forces exerted by each are equalized.."[138] Furthermore, they are praised for "combining the modern color technique [of unmodulated, contrasting colors] with a thorough-going elimination of all other illusionistic factors, including linear perspective, overlapping, and

chiaroscuro."[139] Brown contrasted the work of Barnet and Busa to that of Wheeler, citing the elimination of lines from their work based upon the strong pictorial tensions of "contracting and expanded shapes, placed side by side without overlapping, which push and squeeze in interaction with one another."[140] He also distinguished their "new point of view, from inside the object" (as opposed to Wheeler who "symbolizes not only what the object is, but what it was and will become.")[141] The work of African sculptors, Peruvian weavers, Northwest Indian painters and Polynesian carvers were cited as ancient precedents in which "the tensions created by the voids are as important as the figures."[142] Brown also cited Barnet's own article of 1950, "Painting without Illusion" in which the artist articulated his definition of structure as a dynamic system of mass and color reactions which preserves the integrity of the quadrangular picture plane.[143]

Seeking other vehicles as well for his ideas, Barnet became involved with the organization of a series of panel discussions, the Four O'Clock Forums from 1953 to 1956. Barnet has recalled that this organization was conceived as a counterforce to Abstract Expressionism at a time when he and his colleagues received no real press. Barnet, Brown, Busa, and Wheeler were sponsoring members of the Forums, along with Louise Nevelson who often hosted the sessions in her home. Attracting a diverse roster of speakers, the Forums included such sessions as "The Crisis of Form in Modern Art," for which Barnet served as moderator. This meeting of March 14, 1954 provides a fascinating glimpse of Barnet's convictions at that time and those of his colleagues. Believing that "the contemporary artist…must break fresh ground within the context of …classic pictorial elements, " Barnet and the sponsoring artists stated that they were "faced with the task of creating a present equal to the

grandeur of the past."[144] As moderator he summarized the evolution of the American art world from an emphasis on social content in the 1930s to a sense of interiority in the 1940s as artists "began to look within themselves and…to think in terms…more involved with personal feelings."[145] Observing that works of art are rarely discussed today in terms of color and form, Barnet stated his desire to open the discussion up beyond "just inner expression" and "one group."[146] Similarly Wheeler asked panel speaker Ad Reinhardt about "this conspiracy of silence… as if abstract expressionists were the only thing."[147] Barnet concluded the meeting with the statement that "form is still a problem that exists for the artist" and for future generations who, if they "see that what has gone on has lacked form in the sense that history has known form," will regard his contemporaries in the same light as the masters of superficiality, Gérome and Bougereau.[148]

Later in 1954 Will Barnet restated his early negative reactions to Gérome as panel speaker in the session on "The Synthesis of Idea and Technique in Art Today." Engaging in a dialogue with the abstract expressionist Willem de Kooning, he observed that "there is a terrific prejudice today against conceiving a thing precisely."[149] Noting that positive, clean-cut colors and forms are not appreciated, he declared "that it is possible to make a positive statement today, not a tentative one."[150] He discussed at length the contributions of Ingres and especially Vermeer to "giving the [picture] plane the life that it demanded" through precise organization and conception of form.[151] Observing that today "it is wrong to make absolute statements," he concluded that "art is a great aesthetic experience, and not necessarily an emotional one alone."[152]

Barnet's ideas about the shapelessness of present day art and the need for clarity of form were also channeled into another organ-

ization with which he began to exhibit regularly, the American Abstract Artists. In 1954, "looking for structure in a period that was destroying structure," he joined the AAA which had been co-founded in 1937 by his colleague and fellow instructor at the League, George L.K. Morris.[153] A prolific critic and contributor to AAA publications, Morris had articulated the "quest for an abstract tradition" rooted in the classical, architectonic traditions of "Cézanne, Seurat, and their Cubist heritage."[154] Barnet and Morris shared many aesthetic convictions which they articulated in the 1956 publication that they co-edited, *The World of Abstract Art.* Barnet's essay "Aspects of American Abstract Painting" serves as the foundation for understanding the development of his work during the past decade as well as the evolution of his thinking in relation to the history of American art.

According to Barnet, the "major movement of abstract art in America began in the 'thirties with a strong direction towards a more structural quality, the elimination of impressionism and atmosphere and a general clearing away of realistic painting surfaces and textures."[155] This "striving towards a purer and more architectonic quality," reflected by the work of Morris, Swinden, and others, led to the development of the AAA.[156]

Barnet praised Morris and Davis as "classic examples of painters who...have understood the context of classical pictorial order."[157] Finding that today "the sensuous part of painting [is] more highly appreciated than the structural...because of a general prejudice," Barnet observed that many "attribute emotion only to a painting which has a kind of painting verve and surface manipulation."[158] Thus paintings with "clear form and...color" are mistakenly interpreted as "intellectual and cold."[159] Regarding the word "freedom" as a "very misused word in painting today," he inveighed against Abstract Expressionism

as a "non-communicative approach" whereby "the painter paints suggestively, allowing the observer to read into the painting."[160] For Barnet, the abstract expressionist approach, as epitomized by certain works of Pollock and de Kooning, was too involved with the personal act of painting and the relief of inner tension through projection of the self onto huge canvases "by the sensuous impact of...paint."[161] He also observed that this approach, incorporating the use of accident, "did not exclude certain atmospheric, illusionary...qualities," often outstripping "regard for the flat plane, the borders of the canvas, the scale, scope, and proportion."[162] Barnet stated his preference for a more premeditated aesthetic whereby "the painter develops the painting through to an exactitude and allows the observer to see his vision clearly."[163] Instead of "depending upon...an all-over immediacy, the all-over quality of [Barnet's] painting came about through a searching and a long period of meditation...so that the central core of excitement came near the end rather than the beginning" in a process equivalent to "the creation of the world...how it functions."[164]

Deploring this "climate that relies so heavily on surface seduction and tentative form," Barnet stated that "[t]rue freedom lies in the understanding of one's limitations—as realized in primitive art and the work of Gauguin, Kandinsky, Miró, and Klee through the use of "formal symbols aimed, not at expressionism, but at giving order and meaning to life."[165] Cubism "opened the road" to this "greater pictorial imagination... and...plastic meaning" by liberating the painter from "the fixed position, the stage set and...the world of the outer eye...allow[ing] a larger recording of the whole of life."[166]

Barnet's concluding remarks provide a sound basis for understanding his concurrent body of Indian Space work in the 1950s.

Observing that the "inspired independent painter searches today for the meaning that lies hidden beneath things seen and felt," Barnet affirmed the goal of finding "concrete shapes that express... [one's] feelings" and stated in "fresh, vital painting terms."[167] For Barnet, this was possible only via the "conspicuous elimination of the subject and its replacement by symbolic imagery."[168] He

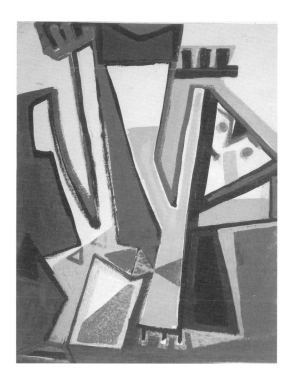

characterized the accomplishments of such contemporaries as Wheeler and Busa in terms that applied to his own Indian Space paintings: "The plane flattened out, the whole canvas active, the human form taken apart and put together again."[169] Proclaiming man's "physical symmetry" to be of enduring interest, Barnet stated that the human form had "assumed a new place in painting, more direct, more dynamic and closer to the peculiar quality of our time with its particular tensions."[170] For Barnet, it "becomes the structure of the picture, and the structure of the picture becomes the human form."[171]

Barnet's Indian Space concepts of human form were fully developed in his monumental *Self Portrait* (Cat. No. 25, see cover) of 1953-

54.[172] The long gestation of this primitivistic painting from around 1948 until its completion in 1954 is a testament to its pictorial complexities. Barnet has transformed imagery of himself scratching the top of his head and smoking a pipe into pictographic symbols and patterns evocative of Northwest Coast art, Mayan totem-glyphs, African masks, and Peruvian textiles. He regards this work as a combination of Western and Indian Space, in terms of the Byzantine formality of the head, the dispersal and expansion of interlocking planar body parts across the surface, and the cubist treatment of the pipe (in simultaneous front and profile view). The color scheme is also a fusion inspired by the earthy colors of Peruvian and American Indian textiles, as well as the varieties of blue in Western art. Eliminating distinctions between figure and ground, Barnet has created a dynamic composition of interlocking organic and geometric forms that take on different aspects as they intersect. The inherent tensions of tightly woven form serve as metaphors for the human condition during what Barnet has referred to as "a period of self-investigation."[173]

Recalling the 1950s as "a big psychological period," Barnet sees his work in part as "a formalization of the Rorschach idea."[174] More importantly, however, he brought European classicism into psychological terrain by going beyond his immediate feelings and initial impulses into a broader, constructive, universal vision. For Barnet, the decade was a time of intuitively questioning his feelings about his life and relationships. From 1950 to 1952, Barnet resumed printmaking, concentrating on the production of an innovative series of color lithographs. Executed roughly and with great immediacy, these semi-abstract images of children conveyed nostalgic psychological feelings, especially of solitude.[175] Regarding painting as a much more arduous process requiring calmness and stability, Barnet did

Fig. 8
Peter Busa, *Untitled*, c. 1942, gouache and ink on paper, 20 x 20 in., The Montclair Art Museum. Gift of Sandra Kraskin, 95.31. Photo by Peter Jacobs, 2000

not create many oils at this difficult time in his personal life, the year of his divorce. In 1952, Dorothy Seckler published a feature article on Barnet and his approach to color lithography; later that year the American Federation of Arts circulated an important show on his work in this medium. He was also featured in the Brooklyn Museum's exhibition of 1955, *14 Painter-Printmakers*.[176] Conceived as independent works, his prints nevertheless served as an important transition to the Indian Space work for they contained expressive images that became part of the abstract paintings. The evocative titles of these works emerged during the creative process.

The Cave (Cat. No. 26, see page 87) is a symbolic portrait of Barnet, now a bachelor living alone, and his youngest son Todd with whom he enjoyed a very close relationship of mutual support and love. As the father figure, Barnet portrays himself confined by the forms of the cave and reaching out to his son, a brightly colored figure who seems to function as a beacon of optimism.[177] Barnet has also equated the compression of the pictorial space with the pressures of modern urban life. The planar orientation of this Indian Space painting and its family theme can be related to the work of Barnet's friend and colleague Peter Busa. (Fig. 8, see previous page) In such works as *Children's Game* (1940) and *Children's Hour* (c.1948), Busa similarly drew upon Native American sources to integrate symbolic human forms within a flat, seamless pictorial space.[178] Barnet's *Fourth of July* and *Creation* (Cat. Nos. 27, 28, see pages 88, 85) are pictorial metaphors for the next stage in the evolution of his family.

In 1953, Barnet was introduced at the League to Elena Ciurlys, a modern and folk dancer from Lithuania who later worked in the cancer field. They soon married and embarked on a honeymoon abroad, despite Barnet's protests that "Europe is finished!"[179] *Creation* was begun in 1954 when Elena was expecting their daughter Ona, whose identity was as yet unknown. Universal female (green) and male symbols are held by the hand of God whose organic form suggests the voluptuous torso of such prehistoric fertility figurines as the Venus of Willendorf. According to Barnet, the embryonic figures of male and female are enveloped within the womb as "the inner and the outer come together" through the merging of vibrantly colored form and ground.[180] Inspired by Michaelangelo, Barnet transformed the Renaissance master's conception of creation "in a very primitive way."[181] The exuberant *Fourth of July*, completed on Independence Day,1954 has its origins in free, improvisational sketches of Barnet's three sons with sparklers. As the work evolved, "the figures became the fireworks symbolizing the freedom of childhood exploding in different directions."[182] The intuitively developed patriotic colors took on a life of their own, with red "spreading like wildfire," blue as a containing force, and white relieving the intensity of both.[183]

Janus and the White Vertebra of 1955 (Cat. No. 29, see page 89) epitomizes Barnet's "highly successful synthesis of the spiritual aspect of mood and the physical structure in the creation of a painting."[184] The conception of this work grew out of "a figure glimpsed in the shadowy background of a woods…the firm, upright silhouette…turned towards" Barnet.[185] The white vertebra—emblematic of the central nervous system—forms the structural backbone of the painting, heightening the impact of the double-sided head and the weight of the pelvic region (supported in turn by the compressed rectangle at the bottom). Anchored and unified by a static warm green background, the red, white, and black schematic figure of Janus has two heads; the purple one in shadow and the yellow-green one in light. These geometric heads, balanced by the organic curves of the arms

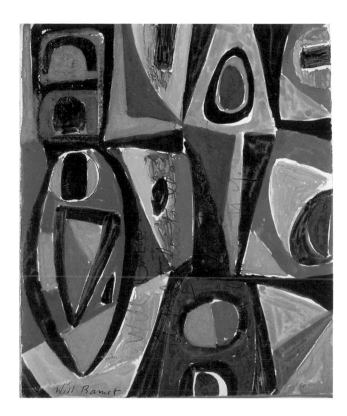

and torso, evoke the inward and outward duality of existence and what Barnet's friend and fellow painter Cameron Booth has referred to as the two sides to this artist's personality and creative process:

> Will Barnet is a painter skilled in contrasting opposites and making them complement and enhance each other through their very differences. He balances emotion with reason, automatism with control, enthusiasm with restraint, sensibility with affirmation and realism with abstract relationships. This profound search into the meaning of opposites produces powerful pictures as only Will Barnet can paint them.[186]

The choice of Janus, the double-headed Roman god of all beginnings and animistic spirit of doorways was particularly appropriate for Barnet at this juncture in his personal life and career.

In 1955 Barnet introduced his new body of paintings in another one-man show at Bertha Schaefer Gallery, having had his first solo show of watercolors there in 1953. The critical response was positive and the connections to primitivism were stressed. Lawrence Campbell, a former pupil and colleague at the League for many years, observed that Barnet's "use of geometric ornament and symbol recalls the tattooings and paintings of 'animist' civilizations."[187] He also emphasized the dualism of Barnet's art as a representation of the spiritual presence that is behind "the phenomena of everyday life…by means of a concrete symbol."[188] Observing that Barnet's "frontiers are large enough for several cultures," he characterized the work as encompassing both abstraction and figuration, textured or anonymous surfaces, European and American Indian derivations. Nevertheless, "the overall approach remains consistent, formal, serious, and intellectual."[189] Prominent critic and art historian Robert Rosenblum observed that Barnet's bold and assertive canvases compel the spectator not only by virtue of their firm, simple patternings of shape and color, but by their subtle and evocative imagery."[190]

Cat. No. 11.
Untitled, c. 1954
Watercolor and ink on postcard
6 x 5 in.
Collection of The Montclair Art Museum, 1999.6
Gift of Cherry and Lloyd Provost
Photo by Peter Jacobs, 1999

Cat. No. 12
Untitled, 1957
Gouache and watercolor on paper
7 x 4 7/8 in.
Collection of Mr. and Mrs. Richard E. Salomon

Regarding *Fourth of July* and *The Cave* as among the best, Rosenblum noted that the artist's "ostensibly abstract forms, architectonically ordered along approximately vertical and horizontal axes, are eminently suggestive."[191] He also stated his appreciation for a small group of studies which were "at times, even more rewarding than these large canvases, which occasionally appear oversized for their formal and imaginative content."[192]

During the mid-1950s, Barnet made numerous small improvisational abstract sketches. Some of these "exciting inner images" were studies for paintings; others (including Cat. Nos. 11 and 12, see previous page) were independent works—"fleeting moments, playful formal exploration for its own sake, complete in themselves."[193] Barnet referred to his studies as "embryos trying to emerge," as well as "scripts of one's personality," employing an epithet of James Joyce.[194] Working from memory and the subconscious, he drew spontaneously on a variety of recycled scraps of paper. Executed on an announcement postcard from the New School of Social Research, *Untitled* (c. 1954, Cat. No. 11) typifies the Indian Space concept of integrated color and form, as well as a sense of power and massive scale.[195] *Untitled* (1957, Cat. No. 12) exemplifies "the simultaneous presence of calculation and spontaneity" so characteristic of these freely rendered, carefully orchestrated works.[196] Using a postcard's stamp, postmark, and cursive handwriting as points of spontaneous departure, Barnet has transformed them into a bold mosaic of interlocking forms in earthy colors. Although particularly fond of these intensely personal works, Barnet rarely exhibited them at the time of their creation, with the exception of his one-man shows of 1955 and 1957. In a review of the latter show, Irving Sandler characterized them as "embryonic notes" pervaded by a "delightful spontaneity."[197]

The painting *Black and Gold* (c. 1955, Cat. No. 30, see page 32) is related to these studies as a purely aesthetic experience in which Barnet was playing with color and semi-figurative forms to create a balanced composition unified by an ochre band expanding across the picture plane. Barnet sees *Black and Gold* as a transition into the late 1950s when he created the monumental abstraction *Singular Image* (Cat. No. 31, see page 90). Rooted in Barnet's appreciation of the symmetry of the human form, *Singular Image* was inspired by the artist's urban environment. Having observed his shadowy presence in the cracks of an illuminated sidewalk, Barnet developed this large-scale work which is in harmony with his own lanky height. Wishing to avoid the easy identification of this work as a crucifix/cruciform, Barnet regards *Singular Image* primarily as a cryptic self-portrait, as well as "an eternal image played with for thousands of years."[198] In the top upper right quadrant, Barnet employed gold leaf to suggest light trying to break through and has acknowledged the sublimated impact of Byzantine painting in his choice of this medium. As a major example of what Barnet described as "a formal approach that gave equal attention to positive and negative space," *Singular Image* was the culmination of "an intense period of searching which led to radical aesthetic innovations."[199] It served as the foundation for a major series of abstractions created in the early 1960s.

By 1960 Barnet had been recognized as "one of the most original abstractionists of our time" in a number of retrospective exhibitions of the late 1950s.[200] His earlier paintings of domestic scenes were seen as containing "a germ of the significance which is now developed in unmistakable terms" in the latest works that display "a widening of visual and mental horizons…power of formal organization."[201] Although one critic attempted to pigeon-hole his production as a "member of

the jigsaw school that Stuart Davis has raised to glory," he also acknowledged that Barnet's "American-Indian-cum-School of Paris style by which he is most easily recognized…finds [its] quality in [clearer] constructed color [and] simpler forms."[202] Barnet's first full-scale retrospective was held at the Tweed Gallery, University of Minnesota at Duluth in 1958. Surveying Barnet's work over the past 23 years, catalogue essayist Orazio Fumagalli concluded that the artist now distilled the essence of his subjects, setting "them down in icons which encompass and evoke the myriad associations connected with them."[203] Furthermore, he "constructs his paintings, prints, and watercolors as carefully as an engineer designs a bridge."[204]

Barnet's residence in Duluth where he conducted the 10th annual University of Minnesota at Duluth summer workshop in advanced painting was a pivotal experience for him. Living in a house on the shore of Lake Superior, Barnet immersed himself in the visual splendors of his new surroundings. The groundwork for Barnet's renewed appreciation of nature had already been laid several years earlier when he spent the summer of 1956 in Provincetown, Massachusetts. His large-scale painting *Provincetown by the Sea* (1957, Collection of Mrs. Anne Luce) evoked humanity's relation to the natural strata of expansive sky, ocean, and horizon. Part of an entire series, it captured Barnet's appreciation of the luminosity and atmosphere of Provincetown which had attracted his colleague Hans Hofmann and many other progressive artists.[205] Barnet's series of landscape paintings created in Duluth represented a new direction that served as the foundation for his last major abstractions of the 1960s, as well as his figure compositions of that era and beyond.

THE 1960s:
ABSTRACTIONS

Enthralled with the expansive, rugged landscape of Duluth, Barnet reveled in the natural beauty, imposing height, and cool, northern lights of this Midwestern city. He found himself wanting "to tackle the landscape in a new way…[not] impressionist…[not] realistically… [not] semi-abstract."[206] Seeking abstract poetic imagery with which to convey his feelings about nature, Barnet began a series of hundreds of sketches in 1959 (Cat. Nos. 13, 14, see page 33) which culminated in *Big Duluth* (Cat. No. 32, see page 91), painted upon his return to New York.[207] The circular forms in the evening sky symbolize the spectacle of northern lights seen by Barnet through the big picture window of his house overlooking Lake Superior and evoke a variety of other planetary/cosmic associations as well. The divisions of the canvas suggest natural strata of sky, sea, and land that are unified by interlocking shapes and muted, earthy colors. There is also a gravitational sense of a downward movement of interrelated human and natural elements, as characterized by Barnet:

> …the slight curve supports the big planet coming down. So you have a wonderful association of elements that are in the sky…that sink lower into the body of the water. I projected human forms into these two big forms. They are enclosed within it.[208]

The absolute clarity of biomorphic forms is reminiscent of Jean Arp's work (especially his collages and relief constructions which Barnet admired.[209]

Barnet's communion with nature as an overwhelming, ancient force was renewed during his travels out West. Having found a new way to symbolize a landscape, he continued to explore the range of possibilities in works such as *Impulse* (Cat. No. 33, see page 92).

Living in Spokane, Washington to fulfill a teaching assignment, Barnet was impressed with the mountainous terrain of this city, as well as a nearby waterfall. This "fantastic waterway with huge forms of water rushing down a whole mountainside" was the subject of *Impulse*.[210] The pressure of tremendous natural forces has been transformed into powerful pictorial tensions of attenuated geometric forms whose massive movement downward is contained by two black, block-like forms. This effect of compression is relieved and balanced by the airy flotation of the symbolic cloud above and the circular pool below. The title *Impulse* has been interpreted as suggesting both "the seeming randomness of nature but also an id-like spontaneity associated with human nature."[211] Furthermore, it also implies Barnet's desire to go beyond the initial impulse prompted by his subject to create a carefully constructed composition as eternally vital as nature itself.

Another major work in the Spokane series is *Eden* (Cat. No. 34, see page 93), which is related to the large, horizontal *Great Spokane* (1965, University Art Museum, University of California, Berkeley). Striving to capture the expanse of the West, Barnet stretched the horizon line—"the band of life"—almost to the breaking point in *Great Spokane*.[212] In *Eden* he took a vertical segment of the previous painting and, in his words, "tried to make

it a singular image that had the power of the larger one."[213] Inspired by the height, expansion, and containment/contraction of the mountainous landscape bathed in soft sunlight, Barnet transformed the forms of nature into one of his purest abstractions. A curved sky form surmounts a white asymmetrical triangular shape with a delicate tip—"strong and yet fragile, it looks as if it could topple over."[214] Precariously balanced, the light-filled forms project a sense of the sublime glories of nature that is reinforced by the choice of title. Thus *Eden* has been discussed as a work that allies Barnet's ambitions with such transcendentalist modernists as Marsden Hartley and Arthur Dove. Barnet owns a watercolor entitled *Down the Road* by Dove whom he appreciates for his ability to trans-

late his profound reverence for nature into skillfully organized, bold, symbolic forms. Furthermore, he relates the subject of *Eden* and its light-filled palette to the work of the late 19th century American luminist Martin Johnson Heade—"one of the great spiritual artists of his time."[215] Barnet's creation of visual metaphors for the sublime events of nature also brings to mind his great interest in the work of the Romantic visionary painter Albert Pinkham Ryder (also a coastal Massachusetts native)—"transcendental painting at its zenith."[216]

Upon initial examination, the hard-edge, basic geometric forms of *Impulse* and especially *Eden* may seem comparable to the work of such contemporaries as Burgoyne Diller, Leon Polk Smith, Ellsworth Kelly, and Myron Stout. Indeed Barnet was friendly with Diller, and Smith for years; he met Stout, with whom he shared a mutual admiration, in Provincetown. Barnet himself played a significant role in this development of American geometric abstraction as an instructor to such hard-edge painters as Al Held and Henry Pearson. Nevertheless, his work is

clearly distinguished by its active format of pictorial tensions based upon symbolic interpretations of landscape and the human form. The poetic, meditative mood and quiet serenity of the work is generally yet another distinctive factor. The static forms and resolute non-objectivity of his contemporaries' work are more commonly associated with the tradition of geometric abstraction in America since 1945.[217] This may be why Barnet's work, which transcends categorization, has not been included in many surveys of abstract art. An exception to this rule was the Whitney Museum of American Art's *Geometric Abstraction in America* in 1962. Barnet's *Singular Image* was exhibited alongside works by Albers, Bolotowsky, Davis, Diller, Calder, Hartley, Smith, Kelly, and many others to demonstrate that American geometric abstraction "has been a strong and dedicated movement...though somewhat obscured by other movements more in the public eye."[218]

Barnet has commented on the resurgence of hard-edge and geometric painting in the 1960s as a "delayed reaction" to Abstract

Cat. No. 13.
Study for Big Duluth, 1960
Gouache on paper
7 1/2 x 4 3/4 in.
Courtesy of Tibor de Nagy Gallery, New York

Cat. No. 14.
Study for Big Duluth, 1960
Ink on paper
7 3/4 x 4 3/4 in.
Courtesy of Tibor de Nagy Gallery, New York

Expressionism—"already something that I have gone through."[219] Thus Barnet felt little kinship with the key movements of this decade—Minimalism, Conceptual art, and especially Pop which he deplored as a literary and totally commercial phenomenon. Furthermore, Happenings and Conceptual art "left [Barnet] with a feeling for the fragility and obsolete qualities of life" which contradicted his goal of "bringing out the beauty of the human form in an abstract sense [to] elevate the idea of man."[220] Aligned with the AAA, he continued to pursue his own fully developed independent course. In 1960 Barnet had a well-received one-man show of recent abstract paintings at Bertha Schaefer Gallery. Dorothy Adlow observed that the artist "has conceptualized the naturalistic" as he "strives for a mood of dignified and somewhat mystical character" in his abstractions with "a clean-edged outline which imparts a sense of impassivity, of detached objectivity."[221] Another critic, Bennett Schiff, championed Barnet's work as an anti-abstract expressionist statement by "a superbly able craftsman" who imposes "conscious creative order upon emotional reaction."[222] James Mellow characterized Barnet's analytical approach to painting as "a classical aesthetic, somewhat out of fashion recently."[223] Lawrence Campbell observed that *Singular Image* and other recent works were the "best of his career," with simplified massive forms that "work in several ways at once" in ambiguous image-ground equivalences.[224] *Singular Image* was also featured in Barnet's one-man exhibition in Rome at the Galleria Trastevere. In a review, François Hertel praised Barnet as "*un grand plasticien qui allie en lui la serenité d'Auguste Herbin et le coloris aux tons chauds de Piet Mondrian* (a great plastic artist who allies in himself the serenity of Herbin and the coloring of hot tones of Mondrian.)"[225]

In 1961, Barnet had a major retrospective of his work at the Institute of Contemporary Art in Boston which was a very fulfilling experience for him as he returned to "the place where all my dreams were laid."[226] The brief introduction to the catalogue was written by Thomas M. Messer, future director of the Solomon R. Guggenheim Museum who aimed to "reassess an art that has often been misunderstood and, through misunderstanding, neglected."[227] He detected in Barnet "a lone-wolf quality" that may have accounted for this need.[228] Distinguishing the evolution of Barnet's "severe and controlled manner" from the "triumphant…breakthrough of abstract expressionism," Messer also contrasted his work to that of "the minority opposition—among them hard-edged painters."[229] Barnet's art "betrays essentially organic qualities—a warmth and dynamism that stand in jarring contrast with the geometric brand of contemporary painting."[230] Having escaped classification, Barnet had thus far evolved from "early figurative work…toward abstraction through a gradual and often painful process of simplification."[231] Nevertheless Barnet remained "content-bound in his art…submerging and locking it within pure form in various degrees of recognizability, but never abandoning it."[232] Although Messer emphasized the abstractions, the exhibition actually included works ranging in date from 1940 to 1961. Among these was *Mother and Child (Elena and Ona)* (Cat. No. 35, see page 94), a seminal recent figurative work which received no commentary in the catalogue. Barnet himself wrote short summary statements about his oeuvre, observing that his "early work, which has recognizable images, actually contains most of the ideas that I am working with today."[233] Returning to the subject of his family in 1960, Barnet felt ready to "use the abstract concepts [he] had developed in the 1950s to achieve new and vital human forms."[234]

THE 1960s:
FIGURATIVE COMPOSITIONS AND PORTRAITS

Until 1965 Barnet worked simultaneously with abstraction and figuration in his series of landscapes and portraits. He regards *Mother and Child* as well as other figurative work of the 1960s as a continuation of the abstract work. According to Barnet, *Singular Image* (Cat. No. 31, see page 90) set the stage for these figurative compositions based on "similar flat, powerful shapes, as well as open and closed forms in perpendicular arrangements."[235]

For Barnet, his renewed focus on the human figure was a fulfillment of his earliest desire "to emulate Rembrandt…a subconscious drive which became conscious."[236] This humanistic vision was naturally centered on his family, however, Barnet wanted to present a contemporary, unsentimental version of a mother and child. Working on *Mother and Child* for an entire year, Barnet arrived at the concept of his wife and daughter sitting on a couch which is so abstract that it merges with the similarly colored background. Elena has her arm extended over Ona; the two are "not connected in the sense of the old-fashioned picture with the mother holding the child and nestling it."[237] Appreciating "Raphael's wonderful madonna and child," Barnet nevertheless perceived Elena and Ona as "two distinct personalities," conjoined yet isolated—"a contemporary view [in that] each individual has its own identity."[238] As Robert Doty has observed, the psychological aspects of *Mother and Child* are strengthened by the formal clarity of the composition in which the figures have been translated into flat, unmodulated earth-colored planes in a seamless, compressed space. Barnet has referred to this body of work as "hieroglyphic art" in which family members, though recognizable as individuals, are also universal "abstrac-tions—symbolic images" as well as "an organizing idea, a way of making order out of chaos."[239] He has also employed an architectural metaphor to refer to the tight knit integration of the forms: "The entire composition is vital to me. It is like someone who wants to build a house that is solid, and will last for their children."[240]

Mother and Child was a conceptual breakthrough for Barnet who was affirmed in this direction by the example of Ingres—"one of the greatest abstract painters of all time."[241] The stretching of Elena's arm over the couch—"like a ledge grabbing another ledge"—and the monumentality of form are aspects of *Mother and Child* that are clearly related to Ingres' work.[242] He has also drawn inspiration from the tremendous solidity of Hans Holbein's 16th century portraits, ancient Egyptian sculpture, and Persian painting Furthermore, the silhouetted, planar, organic forms of *Woman and Cats* (Cat. No. 36, see next page) suggest Barnet's longtime appreciation for such 18th century Japanese masters as Utamaro and Sharaku. Barnet had earlier written about their woodblock prints as examples of "space conception in its most modern sense—figures and spaces structurally created to form an enduring monument."[243] This relationship, which would be exaggerated in later criticism of the artist's work, is especially evident in relation to the color woodcut of the same subject, *Woman and Cats* (1962).[244]

The close relationship of Barnet's paintings and prints of the 1960s and beyond is also exemplified by the painting *Woman Reading* (Cat. No. 37, see page 95) which Barnet recreated in 1970 as a color serigraph and as a poster for his one-man exhibition at the Pennsylvania Academy of Fine Arts.[245] The pyramidal monumentality of this image of Elena reading in bed with the family cat has appealed to many women who regard it as a personification of their feelings. The formal

clarity, neutrality, and symbolic quality of these paintings of Elena (who is not identified in the titles) constitute their universal appeal. Barnet soon turned to creating abstract portraits of other people around him such as colleagues and family friends Thomas and Remi Messer. The Messers' request became the occasion for Barnet's realization of two of his finest portraits which intuitively capture the spirit of each person.[246] Remi Messer's poise and reserve are evoked by the cool blue tonality of her face, clasped hands, and crossed legs. Her dress and white shawl have been transformed into contrasting, interlocking organic planes of light and dark which further reinforce this impression of her personality and also anchor the monumental formality of the composition. (Cat. No. 38, see page 96)

On the other hand, *Portrait of R.N.N.* (Cat. No. 39, see page 97) projects the restless, entrepreneurial spirit of Roy Neuberger, prominent patron of the arts and founder of the brokerage/money-management firm Neuberger & Berman. Friends with Neuberger since the 1940s, Barnet created several portraits of which this work came closest to his ambitions to make a painting "like Titian who made people into mountains."[247] The frontal, massive form of Neuberger draped in a black coat and seated in a rich, rust-red chair suggest the legacy of the Venetian master. Posed in Barnet's studio on the West side of Manhattan, Neuberger is presented as an elegant man of the world whose restless intelligence is evoked by his facial expression and slightly fidgety hands. Furthermore, the somewhat rakish tilt of his

body, accentuated by the angular shifts in the opening of the black coat draped over his suit, enlivens the upright perpendicular quality of the chair and balances the entire composition. Like his other portraits, the figure is defined entirely in terms of unmodulated flat planes with purely delineated facial details and hands created by means of a sharp pencil to eliminate any vestiges of illusionism. Barnet has tellingly contrasted his approach to that of his purist colleague and friend Ad Reinhardt in his non-objective paintings of that period: "He left out everything [and] my idea is to be able to put in everything and keep it pure."[248] He has also observed that painting portraits of figures "became my way of preserving culture, of stopping time, of making the moment timeless."[249]

Kiesler and Wife (Cat. No. 40, see page 98) is a testament to Barnet's great skill in harmonizing complex human psychology and interactions with the aesthetic requirements of his abstract style. The renowned visionary architect and longtime friend Frederick Kiesler requested this portrait of himself in relation to his younger wife Lillian. The massive frontal figure of Mrs. Kiesler with her elongated arm extended across the top of the couch is reminiscent of Ingres's portraits of women. Furthermore, she is holding a symbolically suggestive apple which further underscores the impression of her dominance over her husband who is smaller in stature. The simultaneously playful and sinister presence of the cat, however, also suggests that the apple will become a toy ball. The rich yet subtle psychological interplay and dualities are anchored in the formality of the unified composition and muted palette.

In 1966 Barnet began working on a monumental self-portrait at mid-career which went through many stages before its completion a year later. He regards Self-Portrait (Cat. No. 41, see page 99) as similar to Eden in terms of its close values, spare clarity of form, and subtle light-filled palette. In an extensive essay on this portrait, Barnet has commented on its origins in an emotional response to the death of his father-in-law. Originally painted in somber colors, the painting featured Barnet in the same pose, however, the cat was not yet present. Dissatisfied with the structure of the canvas, Barnet decided to begin anew, choosing a canvas several inches longer. As the work evolved, the "color mood" lightened and "there were also structural changes in the head and expression of the features from a piqued mood to a more robust one, so that the painting now assumed a more affirmative statement about life."[250] The prominent inclusion of the beloved family cat forms an intimate, organic counterpoint to the upright formality of the painter, as well as the severe geometry of the canvas pushing him back and asserting the planarity of the picture plane. Thus "all of the changes were developed slowly and with great consideration to the formal relationships that were needed in order to create an integral whole and to achieve [his] desire for a sense of monumentality."[251]

Barnet considered his self-portrait to be "one of the best examples of my use of the figure, both as an abstract concept and as an idea of a person in its most intense and essential aspect."[252] It is a work that seems very closely related in gravity of spirit and formality of frontal pose to Barnet's contemporaneous portrait of his longtime friend Ruth Bowman (Cat. No. 42, see page 100). Like Barnet, the art historian Bowman (known at that time as Ruth Gurin, curator of the New York University Art Collection) was an articulate teacher whose activities as an educator provided the key to her pose as she holds an apple, cut open to demonstrate principles of symmetry and design in nature. Like Barnet's self-portrait, the emphatic verticality and simplicity of silhouetted form in Ruth Bowman evokes his interest in Colonial American portraiture.[253] Among his

longtime favorites is the painting of Abigail Gerrish with her grandmother, painted by John Greenwood around 1750 (Fig. 18, see page 72). This double portrait has fascinated him in terms of the artist's ability to structure the composition according to his profound insight into human relationships in Puritan society. The grandmother is an erect, powerfully elongated figure who towers over her granddaughter as an omniscient older person commanding total respect. Thus Barnet has characteristically bridged the colonial past and modernist present in his compelling portraits of the 1960s which stand out as unique contributions to the development of figure painting during this era.[254]

Cat. No. 48.
Eos, 1973
Oil on canvas
58 x 58 in.
Collection of
Frank K. Ribelin

Although Will Barnet was certainly not alone in his renewed focus on the human figure at this time, his work is very different from that of such contemporaries as Philip Pearlstein, Audrey Flack, and Alex Katz. Longtime colleague Phillip Pearlstein employs the conventions of three-dimensional modeling and unusual cropping of form in his portraits and paintings of nudes which are objectively treated as extensions of his artistic ego. As a Photo-Realist at that time, Audrey Flack, a former student of Barnet, also worked with illusionistic traditions, albeit filtered through her use of photographs as the basis for her work. Even Alex Katz who, like Barnet, has created many simplified, modernist portraits of family and friends, has developed a somewhat more impersonal approach to the figure through the enlargement of his pictures to a scale suggesting that of billboards. Barnet's figurative work was increasingly recognized as a singular achievement in exhibition reviews of this decade and beyond.[255]

In 1961 Barnet introduced the public to a group of his recent figurative and abstract works in his one-man show at Bertha Schaefer Gallery. Some of the critics understood the connections between the two bodies of work, observing that Barnet "uniting realism and abstraction…brings to this task the skill of the experienced formalist" by "simplifying forms, confining pattern within the area of realistic shape, eliminating background and foreground."[256] Yet others such as Brian O'Doherty and Natalie Edgaa misinterpreted the "unavoidably academic" work as "sitting uneasily on the fence between abstraction and representation."[257] In 1963 Barnet had a well-received show of works on paper dating from 1952-61.[258] He

began a new association with gallery dealer Dick Waddell in the mid-sixties, receiving good reviews for the "positive energy" of his 1965 show of Spokane and Duluth abstractions.[259] The following year, Barnet's abstract portraits were featured at Grippi Waddell and *Arts* magazine cited them as the work of a maverick "veteran American painter" whose oeuvre "has always been characterized by restraint, modulation, order, a devotion…to content, and a stubborn independence, perhaps the result of his New England upbringing."[260] His 1968 exhibition at the Waddell Gallery was praised for its "new collection of his witty, sophisticated portraits," even though this type of painting was "not exactly today's most swinging genre."[261] Barnet's own self-portrait (Cat. No. 41, see page 99) was singled out for commentary by Gordon Brown as an example of his "almost frightening seriousness of purpose" and his pioneering ability to make "what would ordinarily be called negative space play a positive, active role."[262]

The decade culminated in a one-man show of Barnet's work from the sixties at the Pennsylvania Academy of the Fine Arts where he was a greatly appreciated member of the faculty from 1967 to 1992. In an essay for the exhibition catalogue, former student Richard J. Boyle surveyed the artist's career, referring to Barnet as one of the early pioneers of hard edge abstraction which remained the base of his recent figurative work rendered with "warmth, understanding, and skill."[263] He credited Barnet with developing a strong personal approach to portraiture, consisting "in his combination, carefully balanced, of a delicate Ingresque handling of the face and hands with elements of "clear-edge" abstraction, unified by his refined and graceful style."[264] Several years later, Boyle wrote another appreciation of Barnet's work, characterizing the new directions of his work in the 1970s.

THE 1970s:
FIGURE COMPOSITIONS—MAINE

In 1973 Boyle, now Director of the Pennsylvania Academy of the Fine Arts, observed that Barnet's recent work represented "a more complete synthesis…of the past and present, of style and idea," noted for its "pure poetry" and "emotion recollected in tranquillity."[265] He was referring to a group of paintings inspired by Barnet's return, in his words, "to the visual heritage of my youth—the sea and the transcendental history of New England."[266] In the early 1970s Barnet's family began to spend summers in Maine. Situated right above the sea, their home was in Chamberlain near New Harbor, overlooking Monhegan Island, an area known for its primordial, rocky coastline. The rugged terrain and constant roar of the dark-colored ocean brought back ancient thoughts to Barnet who dreamt about being a cave man. Furthermore, he began to realize, "Maine is to me what Rome was to Nicolas Poussin."[267] There Barnet found an ancient civilization that reawakened memories of various trips to Italy, including a recent voyage. Especially memorable were the Greek columns of ancient architecture in Paestum and Positano, Roman bronzes seen in Naples, and the Villa of Mysteries in Pompeii. Like his admired ancestors Poussin, Ingres, and Seurat, Barnet was especially moved by "the monumentality, profound structure, organization, and craftsmanship" of the superb Second Style frescoes of the Villa of the Mysteries.[268]

The Maine series was launched with the image of Elena standing alone on the porch of their summer house at dusk, her figure silhouetted against the vast sea. *Woman and the Sea* (Cat. No. 44, see page 105) epitomizes Barnet's desire to "come to grips with the radiant light found in the atmosphere without being realistic or literary…to give the

sense of great distances, yet keep the paintings two-dimensional."[269] The subtly simplified figure—evocative of Seurat's women— is imbued with a sense of strength, grace, monumentality, and universality that is anchored by the strong perpendicular organization of the porch architecture, contrasting values of light and dark, as well as the horizon.[270] There is a sense of timelessness generated by the contemplative mood and endless expanse of sky and sea. Nevertheless, a specificity of time and place is suggested by the cool greys and weighty blues of Maine, as well as the solitary figure's scarf shielding her from the coldness of the sea and the atmosphere. Thus Barnet is able to simultaneously evoke his initial experience and the transformation of this reality into an aesthetic, metaphysically charged statement.

In *Early Morning* (Cat. No. 45, see page 102) the smaller figure of Elena is part of a total landscape/ vista seen at another time of day as the morning light is just about to break. The radiant quality of light, subtle atmospheric effects, quietude, and vast, boundless space of this work suggest the impact of the 19th century luminist painters in America. In this regard Barnet has felt particularly close to Martin Johnson Heade whose work he may have first encountered at the landmark exhibition *Romantic Painting in America* at the Museum of Modern Art in 1944. In Heade's renowned Northeastern maritime and salt-marsh paintings of the 1860s and 70s, Barnet finds a structural tension, harmonious balance, "a distillation of sensation— poetry visualized."[271]

Named after the Greek goddess of dawn, *Eos* (Cat. No. 46, see page 38) conveys the loneliness of the human condition, as well as Barnet's fascination with Maine as an ancient civilization. Like an antique statue or column set against a timeless landscape, the solitary, anonymous figure of a woman is subordinated to the vast expanse of sky and ocean—an entire universe supported by the solidity of the rocky coastline. For Barnet, these eroded rocks were "like ancient carvings" and "just as exciting as the Amalfi Drive."[272] Originally a sunset, the sky was darkened to accommodate the characteristic overcast weather of Maine. Along with many preparatory sketches, different versions of *Eos* exist with varying numbers of women, suggesting Barnet's tendency to work on several of these slowly evolving paintings at a time upon his return to New York. He applied the colors heavily in many layers, employing clean, dry brushes for each color and removing the excess paint while still wet—a technique that reveals the texture of the linen. Thus the canvas had a sense of solidity and luminosity as it was allowed to breathe underneath the meticulously applied, thin, opaque layers.

Infinite (Cat. No. 47, see page 103) and *Vigil* (Cat. No. 48, see page 104) feature multiple images of anonymous women who function as archetypal symbols rather than individuals. They have often been interpreted as historical allusions to the steadfast endurance and calm fortitude of New England women waiting for their seafaring husbands or sons to return, ready for any eventuality.[273] Although Barnet has encouraged and even offered these interpretations, he is more involved with the development of the composition and spatial concepts: how to convey a tremendous sense of space and weight without destroying the picture plane. Notions of spirituality and meaning reside in the creative process itself as figures and nature are wedded together to form a monumental, harmonious, aesthetic statement. In *Infinite*, a mood of reverence is established by moonlight transcending the rocky landscape crowned by a starkly silhouetted tree. The architecture of early colonial New England inspired *Vigil* in which columnar women, "perhaps waiting within themselves for something," are juxta-

posed in simple yet complex spatially ambiguous relationships with the widow's walk above a clapboard home.[274] For Barnet, the *Women and the Sea* series constituted "an effort to create a visual epic of America, one rooted in symbolism rather than realism."[275]

When the Maine series was first exhibited in 1973 at the Hirschl and Adler Galleries, Boyle, in his aforementioned essay, characterized its mood as close to Emersonian transcendentalism. Others have similarly interpreted Barnet's solitary figures in communion with infinite nature as signs of his self-reliant, transcendentalist New England heritage.[276] Barnet briefly acknowledged his awareness of Transcendentalism in a lecture presented at the Vatican in 1976 entitled "A Personal Reflection on the Spiritual Aspects in American Art." Reviewing his Puritan heritage embodied in the severity of the natural New England elements, Barnet referred to American literature, "the transcendentalism of Emerson, Hawthorne, and Melville—just as Ryder depicted it in his painting…with all of the elements…becoming as one universal force…completely reliant on each other."[277] Having always regarded art as an ethical, universal pursuit, Barnet also gravitated towards Unitarianism which he chose as an appropriate moral religion for raising his children that stresses individual freedom of belief, the free use of reason, a united world community, and liberal social action. For Barnet, the spiritual, transcendentalist aspects of art reside in the beauty, strength, and construction of form.[278]

In addition to painting, Barnet continued to play a major role in the American printmaking renaissance through the creation and exhibition of his work, as well as his advocacy for others. By the seventies, his widely admired prints, created in larger editions and translated at times into posters, helped him to reach a broader audience, further establishing his renown and finally providing a measure of financial security as well.[279] In 1972 a catalogue raisonné of his 147 editioned prints was published, followed two years later by a book of 27 master prints. Closely related to his paintings, the closely supervised prints often consisted of as many as 30 layers of color in order to "keep the picture plane flat and yet at the same time create a sense of limited depth."[280] The body of critical literature reflected the impact of this growing attention with feature-length articles becoming more of the norm, such as Winthrop Nielson's "The Complete Individualist" at the time of his 1973 exhibition at Hirschl & Adler.[281]

In 1976 *Vigil* and *Infinite* were exhibited at Hirschl & Adler Galleries in Barnet's one man show. In the catalogue preface, Daniel Catton Rich associated the artist's "fastidious relationships" of color and form with "something Oriental…full of an unstressed poetry…a fitting New England austerity."[282] He also commented that the grouping of figures "may remind you of a suspended moment in the ballet, 'Dances at a Gathering.'"[283] Barnet's most important exhibition of this decade was a survey of the past twenty years of work which opened at the Neuberger Museum in 1979. The exhibition was curated by Bert Chernow, Director of the Housatonic Museum of Art, who characterized Barnet as an uncompromising artist who "focuses on a utopian order….a state of equilibrium…seen against the foil of a troubled twentieth century."[284] He also stressed the unifying aesthetic sensibility underlying Barnet's abstractions, figure compositions, and portraits as "images of graceful reserve which provide insights into the positive side of the human situation while exploring the ambivalent path of our common experience."[285] Referring to Barnet's growing audience, Chernow saw "the increased attention being afforded his work" as "part of a renewed interest and re-examination of recent figurative painting."[286]

Furthermore, Will Barnet's major role as an instructor at two of the oldest and most important schools in America—The Pennsylvania Academy and the League— was examined in the exhibition catalogue by devoted student Richard J. Boyle.[287] The third essay was an appreciation by longtime friend and former curator of painting and sculpture at the Art Institute of Chicago, Katherine Kuh. Referring to Barnet's images of women as "archetypes of the introspective spirit," Kuh stated that his work "is more involved with timeless content than daily events."[288] She also observed that Barnet's models did not conventionally pose for him; the work emerged from his intimate knowledge of them through observation and sketches. Furthermore, the fact that Barnet "interviews his sitters at some length before a brush stroke is applied to canvas explains why his portraits transcend routine amenities."[289] A case in point is Barnet's portrait of Kuh herself created in

1982, *Homage to Léger, with K.K.* (Cat. No. 43, see page 101).

Later recollecting the origins of her portrait, Kuh recalled Will's invitation to paint her during a visit to her Wellfleet home in August 1981. Eight months later in New York "after countless sittings and innumerable carbon pencil sketches" she saw the "not quite finished work" for the first time.[290] For Barnet, the sketching period was a learning process during which he was engaged in conversation with her to gain additional insights. Among their favorite topics were art and artists. Several conversations revolved around the mutually admired Fernand Léger who had been the subject of a major retrospective organized by Kuh in 1952. When she confessed that Léger's *The Mechanic* (1920, The National Gallery of Canada, Ottawa) was "the one [she] found most conclusively and indigenously his own," Barnet changed his course.[291] Discarding his former choice of Kuh at a desk with a background

window view of Cape Cod, Barnet incorporated *The Mechanic* into her portrait (or, as Kuh has exclaimed, "he incorporated me into *The Mechanic*.")[292] Barnet has captured the essence of Kuh as a person whom he described as "a very strong, sharp character" with a fidgety habit of pulling at her choker.[293] Kuh's pose, her black gown, and forceful presence complement the cigarette-holding gesture, weight, and dark palette of Léger's *The Mechanic,* regarded by Barnet as among the French master's most powerful works. Feeling that Barnet depicted her as "a total person," Kuh concluded that "for his sitters these thoughtful characterizations can have the sharp edge of a mini-analysis."[294]

A number of Barnet's portraits were included in his Neuberger retrospective of 1979, including *Remi, Kiesler and Wife, Self-portrait, Portrait of Henry Pearson* (1966, The Metropolitan Museum of Art), and *The Collectors* (Cat. Nos. 15, 38, 40). The latter is a drawing of Dorothy and Herbert Vogel. Having observed his longtime friends in galleries and his own studio, Barnet completed the drawing from his imagination. Ending his work with this drawing, Barnet felt that it was sufficient for giving a sense of their characters and accomplishments. Intensely involved with contemporary art since the 1960s, the pioneering Vogels built a major collection of Minimalist and Conceptual art within their limited financial resources as civil servants. Familiar with the many works on paper in their collection based on what he refers to as "simplified elements," Barnet felt that a drawing would be the most appropriate medium for the Vogels' portrait.[295] Full of action, this drawing conveys the essential aspects of each collector's personality. Leaning forward and intently gazing at a picture, Mr. Vogel suggests a more aggressive persona while the more reserved Mrs. Vogel sits back with her index finger raised thoughtfully to her throat. Barnet's focus

upon the Vogels' act of looking captures the spirited integrity of these avant-garde collectors whose interest is in art as an aesthetic experience, not in the public reputation of the artist or art as an investment.[296]

Barnet's show at the Neuberger Museum received strong reviews, particularly from John Russell who observed that the artist "can set up an atmosphere of ambiguity and suspense, both physical and psychological, that we should be glad to experience more often."[297] This exhibition set the stage for increased acclaim from critics, curators, and collectors during the 1980s and 1990s. Barnet's elections to full membership in the American Academy and Institute of Arts and Letters and the National Academy of Design in 1982 are among the highlights of the many awards and other forms of official recognition that he has received in recent years.

THE 1980s AND 1990s:
RECENT WORK

During the past two decades, Will Barnet has been the subject of numerous exhibitions and articles, as well as an acclaimed monograph published in 1984. Many of them constitute a summing up of his life, career, and convictions about his art which deals with "the very essence of being a human being and living in a world in which there are certain cosmic things that keep you alive."[298] In 1980 he was honored on his native turf with a retrospective at the Essex Institute in Salem (followed by shows at other Northeastern institutions), deemed "an apt forum for Barnet, with his career re-focused on what he terms 'New England values.'"[299] Searching for new subject matter, Barnet often found inspiration during his visits in New England with his daughter's family, returning again to the fundamental importance of human relations as the essence of civilization that has guided him throughout his

refined, mysterious presence underscore the almost symbolic solemnity of the children engaged in timeless play. One holds a globe-like ball; the other blows bubbles which is an activity reminiscent of Chardin's great paintings of this subject that capture and preserve a transitory

Cat. No. 50.
The Three Windows, 1992
Oil on canvas
30 1/8 x 34 1/2 in.
Courtesy of Tibor de Nagy Gallery, New York

life.[300] A variety of leisure-time activities taking place on the beautiful grounds of Ona's waterfront inn Rock Gardens Inn near Bath, Maine became the source of such paintings of the 1980s as *Croquet* (Cat. No. 49, see page 106). Resembling Byzantine royalty in their height, frontality, and regal poses, Ona and her former husband, Neil are silhouetted against the vast expanse of the sky and distant rocky coastline.[301] The pure monumentality of these figures is enhanced by the environmental elements, as well as the strict geometry of the croquet mallets and wickets. Figures and their surroundings "form an architectonic whole which dominates the image."[300] When *Croquet* was exhibited in 1987 in a one-man show at Kennedy Galleries, John Russell referred to it as "a classic of the late-20th-century sporting picture."[302]

Barnet's visits with Ona's family also inspired *The Grandmother* (Cat. No. 51, see page 107) which was completed in New York. Elena is seated with her grandchildren Will and Ellie, as well as their cat Minou, in front of Barnet's soaring, two-level studio windows in the historic National Arts Club at Gramercy Park where he has resided since 1982. The grandmother's stately elegance and the cat's

moment for all time. Barnet's natural concerns with eternity, mortality, and the enduring values of personal relationships came to the forefront in another series created during the early 1990s.

At this time Barnet returned frequently to Beverly, Massachusetts to take care of his sister Eva who, along with his sister Jeannette, had resided her entire life in the family's home. *The Three Windows* (Cat. No. 50) shows Eva contemplating the death of Jeannette who had been incorporated into the original composition and then removed. The spectral presence of her original image is faintly visible and evocative of Eva's illness-induced hallucinations of conversations with her deceased family members. A devastating sense of silence pervades this work which tenderly conveys the reality of a reclusive individual living without radio, television, or human companionship. The rigid geometry of her cloistered environment is a subtle evocation of prison bars—not a literal imprisonment but a self-imposed impoverishment of the imagination on the part of siblings who never ventured away from their home, as their brother did. Filled with feelings of profound loss, Barnet created over a dozen

pictures that came to be known as the Beverly series which, in his words, "capture the interior emotions of my family's existence, my relationship to them, as well as the atmosphere of the house, rooms, and abstract sense of light."[304]

Bearing a relation to the solitude of Barnet's *Women and the Sea* series, the Beverly paintings also bring to mind his series of drawings based upon the reclusive life of native New Englander Emily Dickinson with whom he has long felt a strong affinity. Entering into a collaboration with Dickinson, Barnet created a group of drawings in response to her poems. Inspired by Dickinson's reductive imagery, classical restraint, and use of framing devices, Barnet also appreciated her search for meaning in her loneliness. A select group of Dickinson's poems and Barnet's drawings were featured in *The World in a Frame* published in 1989.[305] Barnet's exploration of Dickinson's poems led not only to drawings for the book but also a series of oil paintings and prints, including

the lithograph *Between Life and Life* (Cat. No. 17). Executed for the Print Club of New York, this recent print features a woman resembling Emily Dickinson, who is gazing into a mirror and raising a wineglass in a toast to herself. *Between Life and Life* was inspired by Dickinson's poem:

> *Between the form of Life and Life*
> *The difference is as big*
> *As Liquor at the Lip between*
> *And Liquor in the Jug*
> *The latter—excellent to keep—*
> *But for ecstatic need*
> *The corkless is superior—*
> *I know for I have tried.*[306]

Barnet's lucid integration of real and reflected forms suggests the stark simplicity with which Dickinson carefully crafted her vivid, unified imagery. The pictorial framing device of a mirror is also the subject of such earlier works as *Reflection* (Fig. 9, see next page), one of Barnet's classic interior scenes; like Dickinson, Barnet worked within the seemingly narrow confines of his home (at that time a stately brownstone on Manhattan's Upper West side) to create images of universal appeal.[307] The serenity and stability of Elena and Ona is enlivened by their counterbalanced poses, the ornate mantlepiece, and the mysterious, off-kilter reflection in the mirror. Furthermore, the mirror is featured prominently in another recent print (Cat. No. 16, see page 47). Commissioned by a prominent print collector, Leslie Garfield, *The*

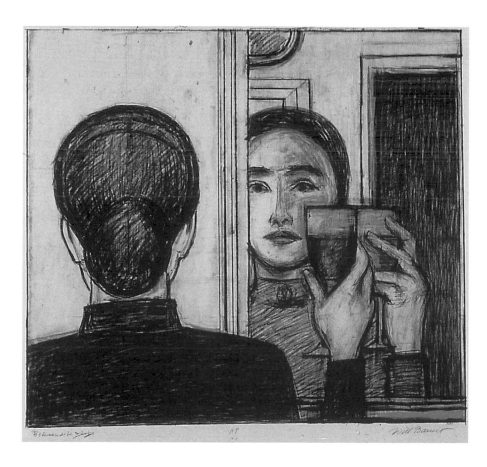

Cat. No. 17.

Between Life and Life, 1998
Lithograph for the Print Club of New York
28 x 29 3/4 in.
Courtesy of Tibor de Nagy Gallery, New York and Sylvan Cole Gallery, New York

Mirror brings to mind Barnet's longtime interest in Japanese woodblock prints. Exploiting the rough texture of the block to unify form, Barnet portrays a woman in the intimate act of combing her hair. She does not bear any literal relationship to her reflected image which is also unified into a classic interplay of curvilinear and geometric forms.

Among Barnet's most important print projects of the 1990s was the commemorative portfolio of prints for the American Academy of Arts and Letters by artist members in celebration of this organization's centennial. From around 1992 until 1998, Barnet was the driving force behind this monumental project of 50 prints in all media by himself, Jasper Johns, Chuck Close, Philip Pearlstein, Jacob Lawrence, James Rosenquist, and many others. With his characteristically "personal persuasiveness and tireless enthusiasm," Barnet enlisted skilled printmakers and supervised others who had never made prints before.[308] In 1998 Barnet also had an important retrospective of his prints which by that time numbered over 240 editioned works.[309]

Other highlights of the decade included his first major retrospective of drawings organized by the Arkansas Arts Center in 1991 in honor of his eightieth birthday. Revealing a virtually unknown body of work dating from c. 1928 to 1990, this exhibition offered "new insights into the process, development, and flowering of his unique artistic sensibility."[310] The formal invention and assured draftsmanship of these works demonstrated how Barnet left nothing to chance as he "steered his way through the tricky shoals of both

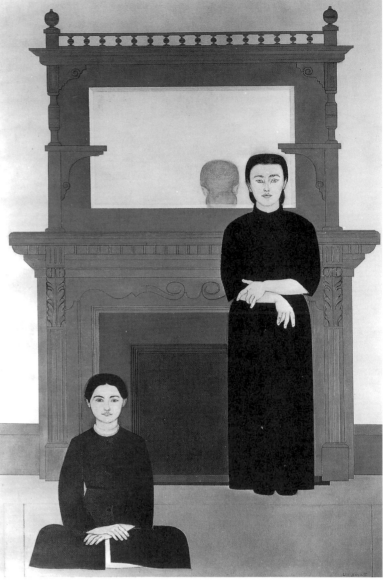

classical tradition and innovative modernism to achieve fulfillment as a valued and successful twentieth century painter."[311] Another important show of the decade was *Will Barnet: The Abstract Work* at Tibor de Nagy, in 1998, which was pronounced a "revelation" by one critic who regarded the artist as having "for some years...pursued a stylized, sweet breed of realism that deals with hearth, home and figures set in landscape."[312] Missing the vital aesthetic connections between the abstract and figurative work discussed in the catalogue, this critic proclaimed that "it is these canvases, [including Cat. Nos. 25, 28, 33, 34] one hopes, for which Mr. Barnet will be remembered."[313]

Another prominent critic asserted that Barnet"s little known "very remarkable abstract paintings" demonstrate "an incisive gift for formal invention that few other Indian Space painters could match."[314] He regarded the show as "an interesting contribution to [the] revisionist history" of American art during an era dominated by Abstract Expressionism.[315]

Barnet has also been a very active member of the National Academy of Design, having served in a variety of capacities, including vice president, and organized a major exhibition there in 1997 entitled *The Artist's Eye*. For the first time in this series of shows organized by prominent members of the National Academy, Barnet reviewed the entire range of work collected since the institution's establishment in 1825. Believing that "everything I do is in a large sense a portrait," Barnet decided to focus upon the Academy's vast collection of portraiture by members of themselves and other subjects.[316] The breadth of work selected by Barnet reflected Barnet's vast knowledge of American art and his willingness to embrace a "variety of approaches to self-definition…some of which…will stand the test of time."[317] Barnet's selection of works by Cecilia Beaux, George Bellows, Richard Diebenkorn, Thomas Eakins, Jacob Lawrence, Robert Rauschenberg, and others was complemented by his choice of ten of his own portraits (including Cat. No. 42, see page 100). At the time of these shows at the Academy, a critic remarked that if "the United States named its elder artists National Living Treasures as they do in Japan, Will Barnet would certainly be one."[318]

In conjunction with an exhibition of *World Artists At The Millennium* in 1999, Barnet ruminated upon the nature of his aesthetic inspiration:

> *By now my work has become so much a part of me, it is hard to pinpoint what inspires me. My work evolves in relationship to my own growth as each day of life offers new experiences: When art can transform nature and everyday events, they become symbols of a timeless world.*[319]

He also completed one of his most recent paintings, *The Purple Bottle* (Cat. No. 52, see page 108) which demonstrates his ongoing vitality as a mature master seeking new forms of plastic and emotional expression. Barnet began work on this painting in 1989 as a more conventional double portrait of himself and Elena together in Maine on the grounds of Ona's inn. Dissatisfied with the old master references of the composition, he abandoned the painting for a long time. Upon his return, Barnet transformed the work into a studio painting with a portrait of Elena on an easel which provides a strong geometric shape. He had experimented with the concept of a painting within a painting in *Now and Then* (Fig. 10, see next page), also begun in 1989, featuring a small photo of an adolescent Elena held by her mature counterpart of that year, in turn

Cat. No. 16.
The Mirror, 1996
Woodcut
22 x 20 in.
Courtesy of Tibor de Nagy Gallery, New York and Sylvan Cole Gallery, New York

juxtaposed against a large abstraction of Elena at midlife. However, with *The Purple Bottle* Barnet has achieved a breakthrough to a new idea with a surrealistic double edge. Paintbrush in hand, Barnet depicts himself in the act of creating and tenderly embracing the image of his wife. As Barnet's longtime muse, the idealized Elena holds a purple bottle; this graceful, enigmatic gesture is pregnant with open-ended symbolic allusions. The startling interplay of temporal reality and timeless illusion in *The Purple Bottle* is reinforced by the presentation of Barnet at his current age of 88 and Elena at a younger, indeterminate age.

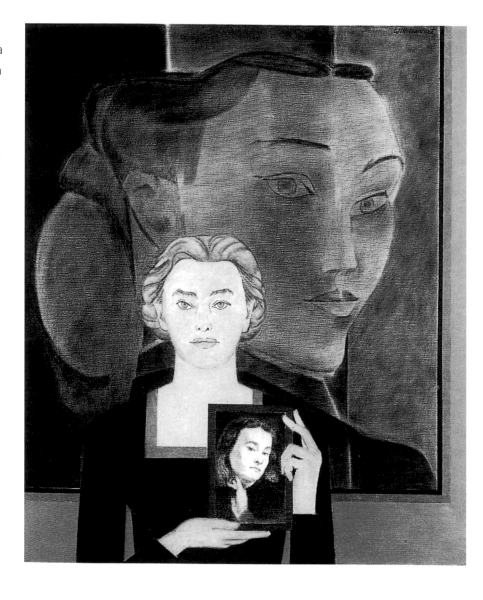

Fig. 10
Will Barnet, *Now and Then*, 1989-90, oil on canvas, 52 x 44 in., Collection of Will and Elena Barnet

Thus in *The Purple Bottle* Barnet has incorporated many of the elements that have established his unique contribution to the history of twentieth century American art. Achieving a rare, integral relationship of universal form and individualized content, Barnet engages the benefits of tradition and art history without sacrificing either the expression of his modern personality or the possibilities of pictorial innovation. In a quiet voice, his art proclaims the endurance of the human spirit and a metaphysical feeling of being connected with the world in an orderly, meaningful fashion. Solidly built, precise structures, Barnet's evolutionary pictures constitute a timeless world of harmony, stability, serenity, and balance.

FOOTNOTES:

1. Richard Brown Baker, interview with Will Barnet, January 20 and 29, 1964, Archives of American Art, Smithsonian Institution, Reel 1, p. 37, hereafter cited as Baker interview ("art was long and life was short").

2. The following is a partial list of major surveys which do not, surprisingly, even mention Barnet: Samuel M. Green *American Art/A Historical Survey* (New York: The Ronald Press Co., 1966); Daniel M. Mendelowitz, *A History of American Art* (New York: Holt, Rinehart, and Winston, Inc., 1971); John Wilmerding, *American Art* (Middlesex, England: Penguin Books, Ltd., 1976); Milton Brown et al, *American Art* (New York: Harry N. Abrams, Inc., 1979); Wayne Craven *American Art: History and Culture* (New York: Harry N. Abrams, 1994), and Matthew Baigell, *A Concise History of American Painting and Sculpture* (New York: Icon Editions, 1996). Barnet was, however, included in Baigell's *Dictionary of American Art* (New York: Icon Editions, 1982), 26.

3. For overviews of Will Barnet's early years, see Peter Barnet, *Will Barnet: Artist and Teacher. A Study of Will Barnet as Painter and Teacher*, New York University, Ed.D., 1975, Fine Arts, pp. 1-12, hereafter cited as Barnet diss.; Baker interview, Reel 1, pp. 31-38, 50-108, Reel 2, pp. 1-46; Paul Cummings, interview with Will Barnet, January 15, 1968, Archives of American Art, Smithsonian Institution (hereafter cited as Arch. Am. Art), pp. 1-25, hereafter cited as Cummings interview. Kitty Gelhorn, interview with Will Barnet, October *1975* to June 1976, Oral History Research Office, Columbia University, pp. 1-88, hereafter cited as Gelhorn interview; entry in *Current Biography*, 46 (June 1985): 3, and non-transcribed interview with Gail Stavitsky, December 7, 1999 (all interviews with the author hereafter cited as Stavitsky interview).

4. Baker interview, Reel 1, p. 102-3 and Reel 3, p. 32.

5. Ibid, Reel 1, p. 80.

6. Ibid, Reel 1, p. 64.

7. Ibid, Reel 1, p. 83. See also Reel 2, p. 12 and Cummings interview, p. 3.

8. Ibid, Reel 1, p. 99. See also pp. 60,100-1, Reel 2, pp. 18-19.

9. Ibid, Reel 1, p. 84. See also pp. 34,37 and Cummings interview, p. 10.

10. Ibid, Reel 2, p. 24. See also Reel 2, pp. 1-4, 22-23, and Cummings interview, pp. 7,9,11. Barnet was also very impressed with the Norwegian novel *Hunger*(1890) by Knut Hamsun, a semiautobiographical chronicle of the physical and psychological hunger experienced by an aspiring writer in late 19th-century Norway.

11. Cummings interview, p. 3. See also Will Barnet, "Artist in the Library," *The Quarterly Journal of the Library of Congress* 40 (Summer 1983): 180.

12. Barnet quoted in Michael Culver, "Will Barnet: Works of Six Decades," *Will Barnet: Works of Six Decades* (Ogunquit, Maine: Ogunquit Museum of American Art, 1994), 8. See also Baker interview, Reel 1, p. 90, Reel 2, p. 11 and Gelhorn interview, pp. 84-87.

13. Culver, op cit, p. 8. See also Baker interview, Reel 1, pp. 32, 94.

14. Stavitsky interview, December 7, 1999, op cit and Elie Faure, *History of Art-Modern Art* (New York and London: Harper & Brothers Publishers, 1924), xxi, copy courtesy of Beverly Public Library. For the Watteau drawing in the collection of the Louvre, see p. 205. All translated by Walter Pach, the other Faure volumes read by Barnet are: *History of Art-Ancient Art* (New York and London: Harper & Brothers Publishers, 1921); *History of Art-Medieval Art* (New York and London: Harper & Row Publishers, 1922), and *History of Art-Renaissance Art* (New York and London: Harper & Brothers Publishers, 1923). See especially the volume on ancient art, p. xix-xx (Art "recounts man to us, and through him, the universe. It goes beyond the moment. It lengthens the duration of time....It fixes moving eternity in its momentary form" and p. xxii: "Art is always 'a system of relations,' and a synthetic system.") See also Cummings interview, pp. 2,4 and Baker interview, Reel 2, p. 11.

15. Interview with Stavitsky and Twig Johnson, December 10, 1999 and Baker interview, Reel 2, p. 6. See also Peter Barnet, op cit, pp. 128-9. One of the oldest collections of Native American art, the Peabody's works will be the subject of a travelling show and catalogue organized by the American Federation of the Arts and Peabody Essex Museum in 2001, "A Rare and Admirable Collection": Native American Arts from The Peabody Essex Museum as described in the catalogue *90th Anniversary The American Federation of Arts Exhibitions Program 1999* (New York: The American Federation of the Arts, 1999), 20-23. For a history of the Peabody Essex Museum and its collections, see Walter Muir Whitehill, *The East India Marine Society and the Peabody Museum of Salem-A Sesquicentennial History* (Salem: Peabody Museum, 1949).

16. Barnet quoted in Michael Flack, "Searching for Structure," *Drawing* XIX (Summer 1997): 7. See also "The Synthesis of Idea and Technique in Art Today," Four O'Clock Forum transcript, December 5, 1954, pp. 5-6, copy courtesy of Will Barnet. For more information on the collection of the Museum of Fine Arts in the 1920s, see *Handbooks of the Museum of Fine Arts, Boston*, October 1920 and February 1927.

17. Baker interview, Reel 2, p. 21, Cummings interview, p. 21, and Gelhorn interview, p. 115.

18. Flack, 1997, op cit, p. 7, Barnet diss., 1975, op cit, pp. 118-9. See also his academic transcript, October 1, 1928, copy courtesy of the Library of the School of the Museum of Fine Arts, Boston.

19. Baker interview, Reel 2, pp. 57, 59. See also Cummings interview, pp. 13,16. For more information on Philip Hale, see Roberta A. Sheehan, *Boston Museum School: A Centennial History: 1876-1976*, Boston College, Ph.D. diss., 1983, pp. 49, 78 ,100-1, 117 and Lisa N. Peters et al, *Visions of Home: American Impressionist Images of Suburban Leisure and Country Comfort*, (Carlisle, PA.: The Trout Gallery, Dickinson College, 1997), 76.

20. See Philip L. Hale, *Vermeer* (Boston & New York: Hale, Cushman, & Flint, 1937 ed.), 9, 68, 72, 80-94. See also Baker interview, Reel 2, p. 48 and Will Barnet, "Remarks in Acceptance of the Medal of Honor presented to me by the President of the National Arts Club," January 17, 1990, transcript, p. 2, copy courtesy of the artist.

21. Cummings interview, pp. 9, 11, 12, 16, 18, 22.

22. Stavitsky interview, January 13, 2000. For a reproduction of Daumier's drawing *Le chanson à boire (The Drinking Song)* which may have served as the model for Barnet's work, see Bruce Laughton, *Honoré Daumier* (New Haven and London: Yale University Press, 1996), 43.

23. Ibid.

24. Stavitsky interview, December 7, 1999. See also Baker interview, Reel 2, pp. 28-29 and Cummings interview, p. 32. For more on Nietzsche and Spinoza, see *The Encyclopedia of Philosophy* (New York: MacMillan, Inc., 1967), vol. 5, pp. 506-514 and vols. 7-8, pp. 530-541.

25. Cummings interview, pp. 12, 14-15, 19-20, 23, 30 (also Beardsley); Cummings interview, Reel 2, pp. 52-53. On the House of Seven Gables, see William H. Truettner and Roger B. Stein, eds., *Picturing New England: Image and Memory* (New Haven and London: Yale University Press, 1999), 89-90.

26. Stavitsky interview, December 10, 1999.

27. Stavitsky interview, December 16, 1999 and Gelhorn interview, pp. 203-5. See also Baker interview, Reel 1, p. 20 and Reel 2, pp. 60, 72, 79-80. On Pascin, see Gelhorn interview, pp. 151-2 and "Art," *Time*, January 19, 1931, p. 30.

28. See Barnet's academic transcript, 1931-1932. He enrolled on October 28 in Davis's Life Drawing, Painting, and Composition class and switched on November 28 to Locke's Lithography class, The Art Students League Archives, copy courtesy of Pamela Koob. His registration card of October 2, 1933 indicates that he was also enrolled in courses with Picken and Sternberg until December 1, 1935, although he recalls functioning as a printer for these instructors (and Harry Wickey), rather than a student. In a fax of April 12, 2000 Pamela Koob stated that he studied with Davis, Locke, Picken, Wickey, and Eugene Fitsch from 1931-1933. For more on Locke, see Clinton Adams, *American Lithographers 1900-1960 The Artists and their Printers* (Albuquerque: The University of New Mexico Press, 1983), 50-51. See also Faye Hirsch, "Will Barnet Looks Around: Some Recently Discovered Plates," *Art on Paper* 4 (March-April 2000): 60-63.

29. Gelhorn interview, p. 242.

30. Stavitsky interview, December 16, 1999, Gelhorn interview, p. 153, Baker interview, Reel 2, p. 61, Cummings interview, p. 28.

31. Flack, 1997, op cit, p. 8 and Pamela Koob, interview with Will Barnet about the Art Students League, June 1999, p. 4, copy courtesy of Pamela Koob.

32. Baker interview, Reel 2, pp. 63 ,65, 66 and Cummings interview, p. 28.

33. Baker interview, pp. 67,70 and Gelhorn interview, p. 175.

34. Gelhorn interview, pp. 247-9 and academic transcript, "Will Barnet," dated October 2, 1933, indicates Summer 1936 as his first teaching term. The 1935-36 League catalogue, p. 15, lists Barnet as "printer for many prominent artists" who will "assist with the trial proofing and…print complete editions for the Lithography students." Copies courtesy of Pamela Koob.

35. Stavitsky interview, December 16, 1999. See also Baker interview, Reel 1, pp. 16-18 and Cummings, p. 30.

36. In 1930 Barnet saw *Mexican Arts*, a traveling exhibition organized and circulated by the American Federation of the Arts (on view at the Museum of Fine Arts, Boston from November 25 to December 16, 1930) with 8 paintings and five drawings by Orozco. The author thanks Anna Indych and Maria Balderrama for their assistance with this information on Orozco. In the 1940s Barnet made reprints of Orozco's work at the behest of Alma Reed. See also Cummings interview, pp. 28,30 and Gelhorn interview, pp. 172, 174-8. For Orozco's pervasive influence on Barnet and his contemporaries, see Reba Williams, "The Mexican Muralists and Prints," *The Mexican Muralists and Prints from the collection of Reba and Dave Williams* (New York: The Spanish Institute and Alliance Capital Management, 1990), 22-3, passim. For Barnet's comment on the similarities of his print *Conflict* to the contemporaneous work of Pollock , and Orozco as their mutual source of inspiration, see David Acton, Curator of Prints and Drawings, The Worcester Art Museum, "Will Barnet in Conversation," January 28, 1995, p. 3, copy of transcript courtesy of Jessica Nicoll. For an image of *Workers*, see Sylvan Cole, Jr., *Will Barnet etchings lithographs woodcuts serigraphs 1932-1972 catalogue raisonné* (New York: Associated American Artists, 1972): no. 19.

37. On Orozco, see Laurence P. Hurlburt, *The Mexican Muralists in the United States* (Albuquerque: The University of New Mexico Press, 1989), 26-28 and Desmond Rochfort, *Mexican Muralists Orozco, Rivera, Siqueiros* (San Francisco: Chronicle Books, 1998), 99, 137-8. On the American Artists' Congress, see Matthew Baigell, *Artists Against War and Fascism. Papers of the First American Artists' Congress* (New Brunswick, NJ: Rutgers University Press, 1986), 49, 53-4 and passim.

38. See Jacob Kainen, "The Graphic Arts Division of the WPA Federal Art Project," in Francis V. O'Connor, ed., *The New Deal Art Projects: An Anthology of Memoirs* (Washington D.C.: Smithsonian Press, 1972): 166-7; W.P.A. registration records dated from Feb. 3, 1936 to Sept. 3, 1936, copies courtesy of National Personnel Records Center, November 29, 1999. See also Cummings interview, pp. 38-9, Janet A. Flint, *Prints for the People: Selections from New Deal Graphic Projects* (Washington D.C.: National Collection of Fine Arts, Smithsonian Institution, 1979): n.p., Jacquie Saul, Interview with Will Barnet, January 27, 1982, Jacquie Saul Papers, Arch. Am. Art, Microfilm 3471, frames 926-936; as well as Marlene Park and Gerald E. Markowitz, *New Deal for Art. The Government Art Projects of the 1930s with Examples from New York City & State* (Hamilton, New York: The Gallery Association for New York State, 1977), 19,62, 86.

39. Stavitsky interview, January 13, 2000. See also Cummings interview, p. 26 and Baker interview, Reel 2, pp. 87,88, 92. Barnet appreciated Solman's "sense of lyrical abstraction and cultivated, lower East side subject matter," as well as his interest in Georges Rouault. He also knew other members of The Ten, including Lee Gatch, Ilya Bolotowsky, Ben Zion, Adolph Gottlieb, and Mark Rothko. For more on The Ten, see Isabelle Dervaux, "The Ten: An Avant-garde Group in the 1930s," *Archives of American Art Journal* 31 (1991): 14-20. For a recent publication on the American Abstract Artists, see Sandra Kraskin, "American Abstract Artists: Pioneers of Abstract Art," *Pioneers of Abstract Art American Abstract Artists 1936-1996* (Sidney Mishkin Gallery/Baruch College, New York, 1996): 5-27.

40. Stavitsky interview, December 16, 1999.

41. See David Acton, "The Prints of Will Barnet: An Addendum," *Second Impressions. Modern Prints & Printmakers Reconsidered* (Volume Sixteen of The Tamarind Papers, Albuquerque: University of New Mexico Press, 1996): 84

42. Cummings interview, p. 26.

43. Gelhorn interview, pp. 415-7. See also Cummings interview, p. 31 and Acton interview, 1995, op cit, pp. 3,7. For Modigliani in the 1930s in New York, see *The Art Index*, (January 1929-September 1932): 964-965, (October 1932-September 1935): 839 and (October 1935-September 1938): 920. See also "Demotte Holds Modigliani Show, *The Art News* XXX(November 7, 1931): 5.

44. Cummings interview, p. 35. See also Gelhorn interview, p. 164, Acton interview, pp. 2-3, and David Acton, "The Prints of Will Barnet...," op cit, p. 85.

45. For a reference to the Vuillard as in the Modern's collection, see *Modern Works of Art. Fifth Anniversary Exhibition* (New York: The Museum of Modern Art, 1934), Cat. No. 151, p. 34.

46. Cummings interview, p. 27 and Gelhorn interview, p. 167. Barnet destroyed most of his early paintings which were small industrial scenes.

47. Stavitsky interview, December 23, 1999.

48. Ibid and Cummings interview, p. 28. For a press release and reviews of this show, none of which mention Barnet, see The Downtown Gallery Papers, Arch. Am. Art, Microfilm ND/38, frames 601-3 and ND/39, frames 81-92.

49. Emily Genauer, "Art in Village," *New York World Telegram* (31 August 1935): 24.

50. Ibid. For another review, see "In the New York Field," *The New York Times* (25 August 1935), Sec. X, p. 7. For Mary Sinclair's impressions of her husband, see Barnet diss., pp. 18-19.

51. Jerry Kirk, "Art That's Not For Art's Sake Alone. Will Barnet is Doing His Share to Make Life Better for Slum Dwellers," *Herald Magazine* (31 July 1938): 4.

52. Ibid and Baigell, *Artists Against War...*, op cit., pp. 224-5, 281-2.

53. "Barnet Preaches No 'Angry Propaganda,'" *The Art Digest* XIII (15 December 1938): 17. See also Howard Devree, "A Reviewer's Notebook," *The New York Times* (11 December 1938): 12X and Melville Upton, "Other Group and Solo Shows," *The New York Sun* (10 December 1938): 11.

54. *The Art Students League Summer Session* (June 1 to August 26 1938), n.p. and telephone conversation with Dr. Carmen Hendershott, Reference Librarian, New School for Social Research, March 20, 2000.

55. See fn. 34, Koob interview, p. 11, and catalog brochure for *Printed by Will Barnet* (New York: Susan Teller Gallery, 1999), n.p., prints by these and other artists from Barnet's "printer's proof" collection of the 1930s and 1940s. Leonard Pytlak has recalled that he and other artists registered for courses at the League just to have access to the printing of Barnet.

56. Cummings interview, pp. 37,41.

57. Ibid, p. 31. See also Gelhorn interview, pp. 267-270.

58. Ibid, p. 29.

59. Baker interview, Reel 2, p. 81. See also Cummings, pp. 33,40 (Barnet continued to appreciate Modigliani's "purity and sense of form" like that of Seurat.)

60. On the Gallery of Living Art, the Picasso retrospective and his influence, see Gail Stavitsky, *The Development, Institutionalization, and Impact of the A.E. Gallatin Collection of Modern Art* (New York: Institute of Fine Arts-New York University, 1990): 384-5, 514-580 and Gail Stavitsky, "The A.E. Gallatin Collection: An Early Adventure in Modern Art," *Philadelphia Museum of Art Bulletin* 89 (Winter/Spring 1994): 1-47.

61. Stavitsky interview, December 23, 1999.

62. Ibid. See Will Barnet, "The Resurrection of Block Print Making," *The League* (April 1944): 7, on his awareness of German Expressionism, Gauguin, and such Japanese masters as Utamaro and Sharaku. See also *American Color Woodcuts. Bounty from the Block, 1890s-1990s* (Madison: Elvehjem Museum of Art, University of Wisconsin-Madison, 1993): 10, 108.

63. "In Short...Barnet-Saturday," *The League* (April 1944): 10.

64. "Aims in Teaching," Will Barnet Papers, Arch. Am. Art, Microfilm N68-35, frame 43. See also Gelhorn interview, p. 252.

65. Ibid, frame 23.

66. Will Barnet, "Lithography as an Art," *The League* 9 (November 1937): [3]. See also "Aims in Teaching," op cit, frame 44, Cummings interview, p. 43, Barnet diss., pp. 133, 117-175, e-mail from Tom Clyde, December 2, 1999 confirming Barnet as instructor at PAFA from 1967-68 until 1992, e-mail from Carol Salomon, November 18, 1999, confirming Barnet as instructor there from 1945-1946 to 1966-67.

67. Cummings interview, p. 66. See also Barnet diss., p. 147.

68. [Morse, John D.?], "Will Barnet," *Art Students League News* 2 (April 1, 1949): [6-7].

69. Ibid.

70. Ibid. See also Cummings interview, p. 29, Barnet diss., pp. 137, 143 and Sarah Lansdell, "Strip art of its junk, Will Barnet urges," *The Courier Journal* (6 October 1977): C6.

71. Quoted in Linda S. Price, "Points of Perspective," *American Artist* 61 (November 1997): 28 (in reference to *Madonna and Child*, ca. 1228-1236 by Berlinghiero, in the Collection of The Metropolitan Museum of Art.)

72. Quoted in Susan Larsen, *The American Abstract Artists Group: A History and Evaluation of Its Impact Upon American Art* (Northwestern University, Ph.D. diss., 1975), 601. See also Cummings interview, p. 49.

73. "Writings, c. 1950-1965,", Will Barnet Papers, op cit, N68-35, frames 18, 30-31. For the passages that Barnet copied, see Paul Guillaume and Thomas Munro, *Primitive Negro Sculpture* (New York: Hacker Books reprint, 1968), 42-43, 126.

74. Cummings interview, pp. 49-50.

75. Quoted in Dorothy Seckler, "Can painting be taught? Barnet answers," *Art News* 49 (November 1950): 44. See also Will Barnet Papers, op cit, N68-35, frame 44, Barnet diss., pp. 122, 125, and Will Barnet, "Painting without Illusion," *The League Quarterly* 22 (Spring 1950): 8-9.

76. Linda Price, "Points of Perspective," 1997, op cit, p. 35.

77. Will Barnet, "The Plastic Approach To The Model," *The League Quarterly* (Winter 1947): 8.

78. Ibid.

79. See Will Barnet Papers, op cit, N68-35, frame 89 and Cummings interview, pp. 65-6. Barnet lectured often on Raphael, Memling as well as Vermeer who, he told his classes, "could take a corner of a room and make it into a whole world."

80. Will Barnet Papers, op cit, N68-35, frame 29, also frame 89: Barnet analyzed "the shift of the entire right side to the left [which] creates the necessary opposition to the vertical format and forms the dynamics of opposition." See also Dorothy Seckler, "Can painting be taught?", 1950, op cit, p. 64.

81. Cathy Barnett interview with Will Barnet, August 19, 1988, p. 5, copy courtesy of Will Barnet.

82. Ibid, p. 8.

83. Juan Gris, "On the Possibilities of Painting" (1924), reprinted in Daniel-Henry Kahnweiler, *Juan Gris, His Life and Work* (New York: Curt Valentin, 1947), 143-4.

84. Gail Stavitsky, *The Development, Institutionalization...*, 1990, op cit , p. 525. For Kahnweiler's lecture to Barnet's class, see his letter of October 26, 1949 to Will Barnet, Will Barnet Papers, Arch. Am. Art.

85. Cummings interview, pp. 35, 39, Will Barnet, "Painting without Illusion," 1950, op cit, p. 9, Barnet diss. pp. 120-1, 127, 137.

86. Barnet diss., p. 121.

87. Ibid.

88. Ibid, pp. 122.

89. Barnet diss, p. 133.

90. Will Barnet Papers, op cit, N68-35, frame 44.

91. Will Barnet, "The Plastic Approach...," 1947, op cit, p. 8.

92. Will Barnet, "Painting Without Illusion," 1950, op cit, p. 8. See also Barnet diss., p. 141 and Will Barnet, undated notes on drawing from the object, pp. 1-2, copy courtesy of the artist.

93. Will Barnet papers, op cit, N68-35, frame 43.

94. Will Barnet, "Painting Without Illusion," 1950, op cit, pp. 8-9.

95. Will Barnet, "Will Barnet Session-Philosophy of Teaching," Famous Artists School, November 14, 1956, p. 4, copy courtesy of the artist. See also Barnet diss., pp. 36-41.

96. Barnet diss, pp. 138, 141, 146, Cummings interview, pp. 50-51. See also "Independent Art Schools: Traditions and Departures/Reflections on Fifty Years of Teaching: An Interview with Will Barnet by Ed Colker, *Art Journal* 42 (Spring 1982): 24-27. Barnet taught Mark Rothko how to create etchings. For more on Barnet's relationship with Robert Blackburn whose Workshop he helped to establish in 1948, see Trudy V. Hanson et al, *Printmaking in America Collaborative Prints and Presses 1960-1990* (New York: Harry N. Abrams, Inc., 1995), 23, 24,100 and Barbara Lekatsas, *Will Barnet Bob Blackburn An Artistic Friendship in Relief* (Lagrange, Georgia: Cochran Collection, 1997.

97. Cummings interview, p. 41.

98. Linda S. Price, "Points of Perspective," 1997, op cit, p. 31. On *The Cupboard*, see *American Paintings and Sculpture in The University Art Museum Collection* (Minneapolis: University of Minnesota, 1986): 21.

99. Cummings interview, p. 41.

100. Alonzo Lansford, "Childlike, Not Childish," *The Art Digest* 21 (1 February 1947): 16. On Picasso and Barnet, see Gail Stavitsky, *The Development, Institutionalization...*, 1990, op cit, pp. 590, 538. On the development of *Soft Boiled Eggs*, see Robert Doty, *Will Barnet* (New York: Harry N. Abrams, Inc., 1984), 35-37, Barnet diss., pp. 58-63, and Melvin L. Alexenberg, *Aesthetic Experience in Creative Process* (Ramat Gan, Israel: Bar-Ilan University Press, 1981), 72-73.

101. Stavitsky interview, December 23, 1999.

102. Ibid and Klee quoted in Jean Laude, "Paul Klee," *"Primitivism" in Twentieth Century Art: Affinity of the Tribal and the Modern* (New York: The Museum of Modern Art, 1984): 487. On Goldwater's popularity, see Ann Gibson, "Painting Outside the Paradigm: Indian Space," *Arts Magazine* 57 (February 1983): 101.

103. Will Barnet, "Chardin," *The League* XIV (November 1942): 5. See also Barnet diss, p. 143.

104. See Gail Stavitsky et al, *Steve Wheeler: The Oracle Visiting The Twentieth Century* (Montclair, NJ: The Montclair Art Museum, 1997), 9,23. On Barnet and Wheeler, see pp. 15-17.

105. Maude Riley, "Will Barnet Now Paints," *The Art Digest* 18 (1 October 1943): 19.

106. "The Passing Shows," *Art News* 42 (15 October 1943): 24.

107. Ibid.

108. Margaret Breuning, "Will Barnet Gains," *The Art Digest* 20 (1 February 1946): 19. For reviews of Barnet's show with Cameron Booth in 1945, see *The Art Digest* 19 (15 January 1945): 23 and *The Art News* 43 (15 January 1945): 26. The author extends her gratitude to Suzanne H. Freeman for sending information about the Barnet retrospective at the Virginia Museum of Fine Arts. See "Will Barnet," *Museum Bulletin* 3 (November 1942): 1-2—"one of America's outstanding artists."

109. Ibid.

110. *The New York Times*, October 23, [1946] and Howard Devree, "Exhibition Tide Rises to A Flood," unidentified clipping, February 10, 1946, Will Barnet Papers, op cit, N69-126, frame 760. For a discussion and reproduction of *Boy with Corn* (no longer extant), see W. Jackson Rushing, *Native American Art and the New York Avant-Garde* (Austin: University of Texas Press, 1995): 147-8.

111. R.A., "Barnet Turns Children into Vital Design," *Art News* 44 (February 1946): 101.

112. Ibid.

113. Organized by Jacob Kainen, Curator, Division of Graphic Arts, this ten year print retrospective was regarded by him as "the first show of fresh prints we have had in twenty-five years." (Letter of March 5, 1947, copy courtesy of Will Barnet). The author extends her gratitude to Helena E. Wright, Curator of Graphic Arts, Smithsonian Museum of Natural History, for sending information about the show.

114. Gibson, "Painting Outside the Paradigm...," op cit, 1983, pp. 98, 101-2.

115. Cummings interview, p. 49.

116. Susan Larsen, *The American Abstract Artists Group...*, 1975, op cit, p. 601.

117. See Gibson, "Painting Outside the Paradigm..." and Rushing, *Native American Art...*op cit, passim and Cathy Barnett interview, op cit, p. 5. See also Ann Eden Gibson, *Issues in Abstract Expressionism The Artist-Run Periodicals* (Ann Arbor: UMI Research Press, 1990), 5 and Stephen Polcari, *Abstract Expressionism and the Modern Experience* (New York: Cambridge University Press, 1991).

118. Barbara Delatiner, "Artist Explains His Indian Inspiration," *The New York Times*, April 28, 1996, p. 14. For more, see Twig Johnson's essay in this volume and Stephan Policari's interview with Oscar Collier, June 22, 1994, Arch. Am. Art, pp. 19, 41-2.

119. Cummings interview, p. 48. See also Doty, *Will Barnet*, op cit, p. 40 and Rushing, *Native American Art...*, op cit, p. 148.

120. Stavitsky interview, December 23, 1999.

121. Ibid.

122. Stavitsky interview, December 10, 1999. On *Family and Pink Table*, see Barnet diss., pp. 63-66.

123. Stavitsky interview, December 23, 1999, Cummings interview, p. 48, and Barnet diss., p. 69.

124. Rushing, *Native American Art...*, op cit, p. 149.

125. Dorothy Seckler, *Selected Work by Will Barnet* (New York: The Bertha Schaefer Gallery, 1948), n.p. *The Cupboard* (Cat. No. 19) was exhibited.

126. M.B., "Barnet More Abstract," *The Art Digest* 22 (1 March 1948): 23, Sam Hunter, "Modernism by Four," *The New York Times* (29 February 1948), Will Barnet Papers, N69-126, frame 222 (see also frame 223). See also "Will Barnet," *The Art News* 47 (March 1948): 49.

127. J.K.R., "World of Childhood," *The Art Digest* 24 (1 November 1949): 19 and D.S., "Will Barnet," 48 (October 1949): 47.

128. James Farrell, "Introduction," *The Paintings of Will Barnet* (New York: Press Eight, 1950), n.p. On Press Eight, see Stavitsky, *Steve Wheeler...*, op cit, p. 17.

129. Ibid. See also Dore Ashton's book review, "Will Barnet, Humanist," *The Art Digest* 26 (15 January 1952): 22.

130. Cummings interview, pp. 43,54.

131. Dorothy Seckler, "Can Painting be Taught?..." op cit, p. 44.

132. Ibid.

133. Ibid.

134. See Bradford R. Collins, "*Life* Magazine and the Abstract Expressionists, 1948-1951: A Historiographic Study of a Late Bohemian Enterprise," *The Art Bulletin* LXXIII (June 1991): 292ff.

135. Stavitsky interview, January 13, 2000.

136. Cummings interview, p. 44.

137. Gordon Brown, "New Tendencies in American Art," *College Art Journal* XI (Winter 1951-2): 103-9. For Barnet's close involvement with Brown, see his working notes, Will Barnet Papers, op cit, N68-35, frame 51.

138. Ibid, pp. 105-6.

139. Ibid, p. 107.

140. Ibid, pp. 105-6.

141. Ibid, p. 108.

142. Ibid, p. 106.

143. Will Barnet, "Painting Without Illusion," op cit, p. 8.

144. Sponsoring Artists of The Four O'Clock Forums, "The Problem of Modern Art," announcement card for "The Crisis of Form in Modern Art," March 14, 1954. On the Four O'Clock Forums, see Gail Stavitsky, *Steve Wheeler...*, op cit, p. 17.

145. Transcript for "The Crisis of Form in Modern Art," op cit, p. 3, copy courtesy of the artist.

146. Ibid.

147. Ibid, p. 14.

148. Ibid, p. 23.

149. Transcript for "The Synthesis of Idea and Technique in Art Today," December 5, 1954, p. 16. Copy courtesy of the artist.

150. Ibid, p. 14.

151. Ibid, p. 15.

152. Ibid, p. 16.

153. Barnet quoted in Stavitsky, *The Development, Institutionalization...*, op cit, p. 409. See also Larsen, *The American Abstract Artists...*, op cit, p. 602 and Cummings interview, p. 46. For Barnet joining the AAA, see AAA Papers, Arch. Am. Art, Microfilm N169-97, frame 78. George L.K. Morris taught at the League from 1944 to 1945, as per Pamela Koob, Archivist.

154. George L.K. Morris, "The Quest for an Abstract Tradition," *American Abstract Artists* (New York, 1938), n.p. On Morris, see Debra Bricker Balken & Deborah Menaker Rothschild, *Suzy Frelinghuysen & George L.K. Morris*

(Williamstown, Mass.: Williams College Museum of Art, 1992) and Melinda Lorenz, *George L.K. Morris, Artist and Critic* (Ann Arbor: UMI Research Press, 1982).

155. Will Barnet, "Aspects of American Abstract Painting," *The World of Abstract Art* (New York: George Wittenborn Inc., 1957), 105.

156. Ibid.

157. Ibid, p. 106.

158. Ibid.

159. Ibid.

160. Ibid, p. 109.

161. Ibid.

162. Ibid. See also Larsen, *American Abstract Artists...*,op cit, p. 409.

163. Ibid, p. 109.

164. Baker interview, Reel 2, p. 96. See also Cummings interview, p. 65.

165. Will Barnet, "Aspects of American Abstract Painting," op cit, p. 109.

166. Ibid, p. 111. For Barnet's discussion of Mondrian, see pp. 109, 111.

167. Ibid.

168. Ibid.

169. Ibid, p. 112.

170. Ibid.

171. Ibid.

172. This painting has been variously published as dating from 1948-1949 (see *Will Barnet: The Abstract Work* (New York: Tibor de Nagy Gallery, 1999), n.p.), 1953 (see Sandra Kraskin, "The Indian Space Painters: Native American Sources for American Abstract Art," *The Indian Space Painters: Native American Sources for American Abstract Art* (New York: The Sidney Mishkin Gallery, 1991), 11, 15 (fn 25), and 1954 (see Robert Doty, *Will Barnet* op cit, p. 53.) For a photograph of this work in progress, see the cover of the *Munson-Williams-Proctor Institute Bulletin* (February 1954) and Fig. 18. For a discussion of all the Indian Space paintings in this show, see Twig Johnson's essay in this volume. See also Sergio B. Allan, *The Indian Space Painters*, Masters of Arts thesis, Hunter College of the City University of New York, pp. 63-66.

173. Stavitsky interview, January 6, 2000. See also Barnet diss., pp. 94-5 and W. Jackson Rushing III, "Will Barnet's 'True Freedom:' Abstraction in Theory and Practice," *Will Barnet: The Abstract Work*, op cit, n.p.

174. Stavitsky interview, January 6, 2000.

175. Stavitsky interview, January 13, 2000. See also Cummings interview, p. 54, David Acton, "The Prints of Will Barnet," op cit, p. 89, and David Acton *A Spectrum of Innovation Color in American Printmaking 1890-1960* (Worcester, Mass: Worcester Art Museum, 1990), 184, 249-250.

176. See Dorothy Seckler, "Will Barnet makes a lithograph," *Art News* 51 (April 1952): 38-41, 62-64. See also John Gordon and Una Johnson *14 Painter-Printmakers* (Brooklyn: The Brooklyn Museum, 1955) and James Watrous, *A Century of American Printmaking, 1880-1980* (Madison: The University of Wisconsin Press, 1984), 193 (see also pp. 97,102,131,170-1,174-8,182,192,224,287-9, 291.

177. See Cummings interview, pp. 51-2, Stavitsky interview, January 6, 2000, Barnet diss., p. 72, W. Jackson Rushing, *Native American Art...,* op cit, p. 149.

178. For reproductions and a discussion of these works, see Sandra Kraskin, *Life Colors Art: Fifty Years of Painting by Peter Busa* (Provincetown, Mass.: Provincetown Art Association & Museum, 1992), 6,15, 16, 24 and W. Jackson Rushing, *Native American Art...,* op cit, pp. 143-5.

179. Stavitsky interview, January 27, 2000.

180. Stavitsky interview, January 6, 2000 and Cummings interview, p. 53.

181. Interview with Cathy Barnett, op cit, p. 7.

182. Stavitsky interview, January 6, 2000 and W. Jackson Rushing III, "Will Barnet's 'True Freedom'...," op cit, n.p.

183. Ibid and Robert Doty, *Will Barnet,* op cit, p. 53.

184. Robert Doty, *Will Barnet,* op cit, p. 53.

185. Ibid, p. 54.

186. Promotional flyer for *The Paintings of Will Barnet,* with an introduction by James T. Farrell, op cit, c. 1950, copy courtesy of the artist.

187. Lawrence Campbell, "Will Barnet," *Art News* 54 (April 1955): 47.

188. Ibid.

189. Ibid. See also Lawrence Campbell, "Will Barnet," *Pen & Brush* III (July-August 1955): 8, 12-14 and Will Barnet Papers, op cit, N69-126, frame 642.

190. Robert Rosenblum, *Arts Digest* 29 (15 April 1955): 22.

191. Ibid.

192. Ibid.

193. Stavitsky interview, January 6, 2000 and Cummings interview, p. 52.

194. Emily Goldstein, "A Conversation with Will Barnet," *Will Barnet: Early Works on Paper* (East Hampton, NY: Glenn Horowitz Bookseller, Inc., 1997), 15.

195. Letter of December 11, 1998 from Philippe Alexandre, Tibor de Nagy Gallery, New York stating that the card announces a 1954 reception for an exhibition by the "League of Present day Artists."

196. Thomas M. Messer, "Will Barnet," *Will Barnet: Early Works on Paper,* op cit, pp. 10-11.

197. Irving Sandler, "Will Barnet," *Art News* 56 (April 1957): 55.

198. Stavitsky interview, January 13, 2000.

199. Emily Goldstein, "A Conversation with Will Barnet," op cit, p. 13.

200. Jack Massard, " Even Abstract Foes May Admire Barnet," *Los Angeles Examiner* (12 October 1957): Sec. 8, p. 6, Will Barnet Papers, op cit, N69-126, frame 251.

201. Margaret Breuning, "...retrospective of Will Barnet," *Arts* 33 (October 1958): 51.

202. J[ames] S[chuyler], "Will Barnet," *Art News* 57 (October 1958): 14.

203. O[razio] Fumagalli, "Will Barnet," *Will Barnet: A Retrospective Exhibition* (Duluth: Tweed Gallery, University of Minnesota, 1958), n.p.

204. Ibid.

205. Stavitsky interview, January 13, 2000 and Robert Doty, *Will Barnet,* op cit, p. 57. In Provincetown, Barnet also knew David Smith, Peter Busa, Richard Stankiewicz, and Myron Stout. He was also involved in the formation of Gallery 256.

206. Cummings interview, p. 56.

207. Ibid, pp. 57-8 and Baker interview, pp. 100-1.

208. Barnet diss., p. 86.

209. Stavitsky interview, January 27, 2000 and W. Jackson Rushing, "Will Barnet's 'True Freedom,'..." op cit, n.p. compares this work with Matisse's late cut outs.

210. Stavitsky interview, January 27, 2000 and Baker interview, p. 97.

211. W. Jackson Rushing, "Will Barnet's 'True Freedom,' " op cit, n.p. and Stavitsky interview, January 13, 2000.

212. Barnet diss., p. 91.

213. Stavitsky interview, January 27, 2000

214. Ibid.

215. Stavitsky interview, January 27, 2000. On Hartley and Dove, see W. Jackson Rushing, "Will Barnet's 'True Freedom,'..." op cit, n.p. and also Robert Doty, "Will Barnet: Selected Abstract Work 1940-1960," *Will Barnet: Selected Abstract Work 1940-1960,"* (New York: Kennedy Galleries, Inc., 1988), n.p.

216. Will Barnet, "A Personal Reflection on the Spiritual Aspects in American Art," Prepared for the Vatican Art Seminar on *Influence of Spiritual Inspiration on American Art*, Rome, July 1976, p. 7, copy courtesy of the artist.

217. See Susan Larsen, *The American Abstract Artists Group...* op cit, p. 604 and Michael Auping, *Abstraction Geometry Painting: Selected Geometric Abstract Painting since 1945* (New York: Harry N. Abrams, Inc. in association with the Albright-Knox Art Gallery, 1989). Barnet is excluded from this survey as well as Irving Sandler's *The New York School: The Painters and Sculptors of the Fifties* (New York: Harper & Row Publishers, Inc., 1978) and *American Art of the 1960s* (New York: Harper & Row Publishers, Inc.,

1988). His work was also excluded from the landmark survey *Abstract Painting and Sculpture in America* in 1951 at The Museum of Modern Art.

218. John Gordon, "Geometric Abstraction in America," *Geometric Abstraction in America* (New York: Whitney Museum of American Art, 1962), n.p. Barnet's work was not discussed in the publicity for this show. See exhibition file 10, Whitney Museum of American Art Archives in the museum's library.

219. Cummings interview, p. 45. He was also referring to the primary structures of Minimalism.

220. Susan Larsen, *The American Abstract Artists Group...*, op cit, p. 604 and Cummings interview, p. 76: "The 'happening' idea is too fragmented and it is too momentary. I feel there is a hostility in the world towards painting....the idea of the hatred for beauty is another problem today." See also p. 78.

221. Dorothy Adlow, clipping from *The Christian Science Monitor* (5 March 1960), Will Barnet Papers, op cit, N69-126, frame 483.

222. Bennett Schiff, "In the Art Galleries," *New York Post*, February 14, 1960, Will Barnet Papers, N69-126, frame 516.

223. James R. Mellow, "Will Barnet," *Arts* 34 (February 1960): 59.

224. Lawrence Campbell, "Will Barnet," *Art News* 58 (February 1960): 13.

225. Francois Hertel, "Will Barnet," *Rythmes et Couleurs* (September-October 1960): 25. For the exhibition catalogue see Will Barnet Papers, N69-126, frame 407.

226 Cummings interview, p. 63.

227. Thomas M. Messer, introduction to *Will Barnet* (Boston: Institute of Contemporary Art, 1961), n.p.

228. Ibid.

229. Ibid.

230. Ibid.

231. Ibid.

232. Ibid.

233. Barnet in Ibid.

234. Emily Goldstein, "A Conversation with Will Barnet," op cit, p. 17.

235. Stavitsky interview, January 13, 2000.

236. Cummings interview, p. 68.

237. Ibid, p. 70. See also Gelhorn interview, p. 224.

238. Ibid, p. 71.

239. Quoted in Johanna Garfield, "Will Barnet and the Family," *American Art* 9 (Spring 1995): 112. See also Robert Doty, *Will Barnet*, op cit, p. 72.

240. Quoted in Michael Culver, "Will Barnet: Works of Six Decades," op cit, p. 13.

241. Stavitsky interview, January 13, 2000.

242. Ibid.

243. Will Barnet, "The Resurrection of Block Print Making," op cit, p. 7. See also Cummings interview, p. 72.

244. Reproduced in Sylvan Cole, *Will Barnet etchings lithographs woodcuts...op* cit, no. 125.

245. Ibid, no. 137.

246. Robert Doty, *Will Barnet*, op cit, p. 86 and Barnet diss., p. 95.

247. Stavitsky interview, January 13, 2000 and Cummings interview, p. 71.

248. Cummings interview, p. 72. On Neuberger and Barnet's portraits of him, see Michael Caiati, "Roy Neuberger: The Art of Living," *Spotlight* (December 1988): 110, Neuberger's autobiography with this painting on cover,, *So Far, So Good: The First 94 Years* by Roy Neuberger with Alfred and Roma Connable (New York: John Wiley and Sons, Inc., 1997), and Catherine Barnett, "Striking Poses," *Art & Antiques* (March 1987): 88,90.

249. Catherine Barnett, "Striking Poses...," op cit, p. 85.

250. Will Barnet, "My Self-Portrait," Will Barnet Papers, Arch. Am. Art, p. 1.

251. Ibid.

252. Ibid. See also Robert Henke, *Themes in American Painting* (Jefferson, NC: McFarland & Company, Inc., 1993), 13,15,234.

253. Catherine Barnett, "Striking Poses...," op cit, p. 86. For a discussion of this work, see Jessica Nicoll's essay in this volume.

254. For Barnet's discussion of the Greenwood portrait, see his lecture "A Personal Reflection on the Spiritual Aspects in American Art," op cit, p. 3. For comments on Barnet's portraits in relation to the colonial American limner tradition, see Michael Florescu, "The Portraiture of Will Barnet," *Arts* 57 (April 1983): 120-1 and Gerrit Henry, "Will Barnet at Dintenfass," *Art in America* 71 (March 1983): 54.

255. Indeed one critic has commented on the "poetic stylization" of Barnet's work "unlike ...the more prosaic flatness of Alex Katz's figuration." See Edgar Allen Beem, "Will Barnet and the gray lady," *Maine Times* (18 January 1991): 36. On Pearlstein, Flack, and Katz, see Frank H. Goodyear, Jr., *Contemporary American Realism since 1960* (Boston: New York Graphic Society, in association with the Pennsylvania Academy of the Fine Arts, 1981): 64, 69, 72. Surprisingly Barnet is not even mentioned in this catalogue. For a contrasting comparison of Barnet and Jack Beal's work, see William Kloss, "The Sara Roby Foundation Collection: Varieties of American Realism," *Modern American Realism The Sara Roby Foundation Collection* (Washington D.C.: National Museum of American Art, 1998): 19-20.

256. Felice T. Ross, "Gallery Previews in New York: Will Barnet," *Pictures on Exhibit* XXV (February 1962): 10,12. For the accompanying press release, see Will Barnet Papers, N69-126, frame 457, in which he states that the "same consider-

ations which impelled me to work abstractly for the past ten years are present, though with a shift of focal reference, in this new group of [portraits]. There is no ambivalence for me in the fact that the figure has been profoundly transformed or transposed, with closer reference to its original structure. Nor are there any so-called 'humanistic' rationalizations for the present shift in my work. My interest has been in developing further the plastic convictions which have been evolving in my abstract work; so that a portrait, while remaining a portrait, should become in this sense an abstraction: the idea of a person in its most intense and essential aspect."

257. Brian O'Doherty, "Art: Painting and Sculpture Displays: Works by Barnet, Gat, and Decker Shown," *The New York Times* (31 (January 1962): 23 and Natalie Edgaa, "Will Barnet," *Art News* 60 (February 1962): 19. See also S.T., "Will Barnet," *Arts* 36 (March 1962): 54.

258. See W[orden] .D[ay]., "Will Barnet," *Art News* 61 (February 1963): 10-11 and V[ivien] R[aynor], "New York Exhibitions: In the Galleries," *Arts* 37 (March 1963): 72-3.

259. J[acqueline] B[arnitz], "Will Barnet," *Arts Magazine* 39 (May-June 1965): 61. See also R[osalind] B[rowne}, "Will Barnet..," *Art News* 64 (May 1965): 15 and Will Barnet Papers, N69-126, frame 144.

260. "Will Barnet's Abstract Portraits," *Arts Magazine* 40 (April 1966): 48. See also M.T., "Will Barnet," *Art News* 64 (February 1966): 13 and P.S., "Will Barnet," *Art News* 65 (October 1966): 10. For Glenn A. Krimsky's 1966 Brooklyn College thesis on Barnet, see Will Barnet Papers, N69-126, frames 336-348.

261. Grace Glueck, "New York Gallery Notes: Who's Minding the Easel?," *Art in America* 56 (January-February 1968): 111 2 and Grace Glueck, "Tony Smith Displays Some Departures—New Portraits by Will Barnet," *The New York Times*, (10 February 1968): 28.

262. G[ordon] Br[own], "Will Barnet," *Arts Magazine* 42 (March 1968): 64. See also R[osalind] B[rowne], "Will Barnet," *Art News* 67 (March 1968): 11.

263. Richard J. Boyle, "Will Barnet in the Sixties," *Will Barnet in the Sixties* (Philadelphia: Pennsylvania Academy of the Fine Arts, 1969), n.p.

264. Ibid. For a review, see "Barnet's 'Corner of World,'" *The Philadelphia Inquirer* (21 December 1969), copy courtesy of the artist.

265. Richard J. Boyle, "Will Barnet: An Appreciation," *Recent paintings by Will Barnet* (New York: Hirschl & Adler Galleries, Inc., 1973), n.p.

266. Will Barnet, "Maine and Its Influence On My Art," *Will Barnet recent paintings & drawings* (Rockland, Maine: William A. Farnsworth Library and Art Museum, 1985), n.p. For Barnet in the context of Maine art, see Margot Brown McWilliams, "Maine Coast Artists emphasizes younger artists 'on the edge,'" *Casco Bay Weekly* (27 August 1992): 27.

267. Ibid.

268. Stavitsky interview, January 27, 2000. Created in the second half of the 1st century B.C., these frescoes featured life-size figures, depicting Dionysiac initiation rites and the prenuptial ordeals of a bride. See Amedeo Maiuri (trans. By Stuart Gilbert), *The Great Centuries of Painting: Roman Painting* (Cleveland: World Publishing Company, 1953), 58-63. For a discussion of Barnet's work in relationship to ancient Greek art, see Howard Wooden, "Introduction," *Will Barnet Paintings and Prints 1932-1982* (Wichita, Kansas: Wichita Art Museum, 1983), 11-12.

269. Quoted in Richard J. Boyle, "Will Barnet: An Appreciation," op cit, n.p.

270. For Barnet's discussion of Seurat's significance, see Patrick Pacheco, "Point Counterpoint," *Art & Antiques* (October 1991): 74-75.

271. See Bennett Schiff, "Martin Johnson Heade: An American Original," *Smithsonian*, 30 (January 2000): 70, copy courtesy of Will Barnet. On Luminism and Barnet, see also Richard J. Boyle, "Will Barnet: An Appreciation," op cit, n.p. and Robert Doty, *Will Barnet*, op cit, p. 122.

272. Stavitsky interview, January 27, 2000.

273. See Richard J. Boyle, "Will Barnet: An Appreciation," op cit, n.p. and "Will Barnet-the survival of an individualist," *Art News* 72 (October 1973): 83 ,Will Barnet, "Maine and Its Influence On My Art," op cit, n.p., Robert Doty, *Will Barnet*, op cit, p. 125, Howard Wooden, "Introduction," op cit, p. 13, Michael Culver, "Will Barnet: Works of Six Decades," op cit, p. 14, and Frank Getlein, introduction to *Will Barnet Retrospective 1931-1987* (Naples, Florida: Harmon-Meek Gallery, 1990), 3—refers to the women as Penelope figures waiting for Odysseus. See also Avis Berman, "Artist's Dialogue: Will Barnet, From Maine to Infinity," *Architectural Digest* 43(March 1986): 62,66,70,72,74.

274. Will Barnet, "Maine and Its Influence On My Art," op cit, n.p.

275. Quoted in Terry Trucco, "Will Barnet: A Part of and Apart From His Times," *Art News* 81 (December 1982): 98.

276. See discussion by Jessica. Nicoll in this book and also Joseph J. Kwiat, "Robert Henri and The Emerson-Whitman Tradition," *Publications of the Modern Languages Association* 52 (September 1956): 617-636 for Henri's indebtedness to this tradition in terms of self-reliance, reverence for great art of the past as the foundation for the new, dissatisfaction with mere technical facility as opposed to genuine insight, respect for one's individuality, humanism, and the drive towards finding universal meaning in life while recognizing the essential beauty of America and expressing an American point of view—convictions embraced by Barnet as well.

277. Will Barnet, "A Personal Reflection on the Spiritual Aspects in American Art," op cit, pp. 6-7.

278. For an interpretation of Barnet's relationship to American transcendentalism, see Cliff McMahon, "The Sublime is How: Philip Taafe and Will Barnet," *Art & Design,* (1995): 29-33. See especially p. 30: "In his strong, silent, intellectually brooding women we should see not just the fierce, isolated and confident individualism of Emerson and Thoreau, but also the powerful and intellectual Hester Prynne of *The Scarlet Letter,* as well as the powerful, secretive and enduring mind of Emily Dickinson."

279. For the widespread impact of his posters, see Linda Southworth, "Profile—Will Barnet, Visual Virtuoso," *Midtown Resident* (October 29- November 12, 1993) and William Zimmer, "Decades of Work from the Elusive Will Barnet," *The New York Times* (28 March 1999): 16.

280. Katherine Kuh, "Will Barnet: An Appreciation," *Will Barnet: Twenty Years of Painting and Drawing* (Purchase, New York: Neuberger Museum, 1980), 30. See also Sylvan Cole, *Will Barnet…catalogue raisonné* op cit , Susan Meyer, intro., *Will Barnet 27 Master Prints* (New York: Harry N. Abrams, Inc., 1979), and David Acton, "The Prints of Will Barnet," op cit, p. 90. For an interview on Barnet's prints, see "Will Barnet: Five Decades in Printmaking," *Newsletter from Jane Haslem Gallery*, Washington D.C. , 1977, n.p.

281. Winthrop Nielson, "The Complete Individualist: Will Barnet," *American Artist* 37 (June 1973): 38- 45, 72.

282. Daniel Catton Rich, introduction to *Will Barnet New Paintings (1974-1976)* (New York: Hirschl & Adler Galleries, Inc., 1976), n.p.

283. Ibid. For a review, see Margaret Betz, "Will Barnet," *Art News* 75 (December 1976): 114.

284. Bert Chernow, "Will Barnet: An Introduction," *Will Barnet: Twenty Years…* op cit, p. 7.

285. Ibid, p., 16.

286. Ibid, p. 7. For Barnet's feeling that the pluralist decade of the 70s was a more receptive period, see also Susan Larsen, *The American Abstract Artists Group…*op cit, p. 604 and Terry Trucco, "Will Barnet…" op cit, p. 95.

287. Richard J. Boyle, "Will Barnet: Artist/Teacher," *Will Barnet: Twenty Years…*op cit, p. 21 placing him in the great tradition of artist/teacher which includes Thomas Eakins (a favorite of Barnet), William Meritt Chase, and Hans Hofmann.

288. Katherine Kuh, "Will Barnet: An Appreciation," op cit, p. 29.

289. Ibid.

290. Katherine Kuh, "Sitting for Will," *Sittings: Portraits by Will Barnet* (New York: Terry Dintenfass Gallery, 1982), n.p.

291. Ibid.

292. Ibid.

293. Stavitsky interview, January 27, 2000.

294. Katherine Kuh, "Sitting for Will," op cit, n.p. See also Barbara Gallati, "Will Barnet," *Arts Magazine* 57 (February 1983): 34.

295. Stavitsky interview, January 13, 2000.

296. For more on the Vogels, see Cathy Barnett, "Striking Poses…," op cit, p. 90, Michael Flack, "The Vogel Collection: A Sense of Ordered Purposefulness," *Drawing* XVIII (Spring 1997): 97- 100 (*The Collectors* ill. p. 98) and Ruth E. Fine and John T. Paoletti, *From Minimal to Conceptual Art: Works from The Dorothy and Herbert Vogel Collection* (Washington D.C.: National Gallery of Art, 1994).

297. John Russell, "Art: Library Shows Treasury of 19th-century Prints," *The New York Times* (28 December 1979): C15. See also Kathie Beals, "Art is heaven to talented Will Barnet," *Gannett West-chester Newspapers* (5 November 1979): B1.

298. Marcia Corbino, "The Gentle, Sovereign World of Will Barnet," *Sarasota Herald-Tribune* (13 April 1980): 13. For reviews of Robert Doty's monograph, no longer in print, see John Russell, "Christmas Books," *The New York Times Book Review* (2 December 1984): 11-12 and "Books: A Library to Celebrate the Holidays," *Time* (10 December 1984): 95.

299. Bob Katz, "His goal was always to paint," *North Shore* (21 September 1980): 4.

300. See Johanna Garfield, "Will Barnet and the Family," op cit and Caril Dreyfuss McHugh, "Will Barnet," *Arts Magazine* 59 (December 1984): 15 which refers to Barnet's painting *New England Family* (1983-4, Collection of Will and Elena Barnet).

301. Lawrence Campbell, "Will Barnet at Kennedy Galleries," *Art in America* 76 (February 1988): 143, compared the figures to the empress Theodora and her retinue on the walls of San Vitale in Ravenna. He also discussed how influences of Indian Space, Ingres, Byzantine, and 18th century Japanese prints have commingled to produce an extremely personal style. (p. 144)

302. Robert M. Doty, introduction to *Will Barnet New Paintings* (New York: Kennedy Galleries, Inc., 1987), n.p.

303. John Russell, "Will Barnet," *The New York Times* (9 October 1987): C30.

304. Stavitsky interview, January 27, 2000. See also Nicoll essay in this book, Michael Culver, "Will Barnet: Works of Six Decades," op cit, p. 14. Barnet's Archives contain a profusion of clippings attesting to his strong, ongoing ties with Beverly, its public library, and local Montserrat College of Art, e.g. John Novack, "'A World I had never known before," Library names lecture hall for Will Barnet," *Salem Times* (June 1987).

305. See Robert M. Doty, introduction to *Will Barnet: Drawings from The Emily Dickinson Series* (Rockland, Maine:Farnsworth Museum, 1991), n.p., Maryanne Garbowsky, "Will Barnet Meets Emily Dickinson," *Emily Dickinson International Society Bulletin* (November-December 1994): 8,9,18, and Stanley Marcus, "A Certain Slant of Light: Drawings by Will Barnet, Poems by Emily Dickinson," *American Artist* 53(November 1989): 56-61.

306. Quoted in Susan Danly, ed., *Language as Object: Emily Dickinson and Contemporary Art* (Amherst, Mass.: Mead Art Museum, Amherst College, 1997): 69. On Barnet, see also pp. 18, 19, 68,97.

307. See Robert Doty, *Will Barnet*, op cit, p. 86, Carter Ratcliff, "New York...Will Barnet," *Art International* XIV (May 1970): 78, and R[osalind] B[rowne], "Reviews and Previews," *Art News* 69 (May 1970): 20.

308. John Updike, "Foreword," *Centennial Portfolio* (New York: American Academy of Arts and Letters, 1998), n.p. See also David Kiehl, "Paper Trail," *On Paper* 1 (November-December 1996): 4. In a letter of December 14, 1999, Kathleen Kienholz, Archivist, confirmed Barnet's very active AAAL membership.

309. Michael A. Tomor and Lisa M. Davis, *Will Barnet: An American Master Print Retrospective* (Loretto, PA: The Southern Alleghenies Museum, of Art, 1998).

310. Townsend Wolfe, "Foreword," *Will Barnet Drawings 1930-1990* (Little Rock: The Arkansas Arts Center, 1992): 9.

311. Theodore Wolff, "Will Barnet," *Will Barnet* (New York: Terry Dintenfass Gallery, 1994), n.p.

312. Grace Glueck, "Will Barnet: 'The Abstract Work,'" *The New York Times* (30 October1998): E38.

313. Ibid. For a brief discussion of the connections between the abstract and figurative work in the exhibition catalogue, see W. Jackson Rushing, "Will Barnet's 'True Freedom'..." op cit, n.p.

314. Hilton Kramer, "Will Barnet in the Abstract," *Art & Antiques* (January 1999): 98-9. See also Mario Naves, "Steve Wheeler's Stubborn, Riddled Pictures," *The New York Observer*, (18 October 1999): 19 and for the rarity of exposure of the abstract works, see also Eleanor Heartney, "Will Barnet-Kennedy," *Art News* 87 (December 1988): 158).

315. Ibid.

316. Will Barnet, "Portraits," *The Artist's Eye: Will Barnet Selects from the Permanent Collection* (New York: National Academy Museum and School of Fine Arts, 1997), n.p. and letter from David Dearinger, February 10, 2000.

317. Ibid.

318. Linda S. Price, "Points of Perspective," op cit, p. 28.

319. *World Artists At The Millennium*, presented in celebration of The International Year of Older Persons (New York: The United Nations, 1999), n.p.

Will Barnet and
Native American Art

by Twig Johnson

Will Barnet has long been interested in American Indian art, especially in how it relates to his intention to create "real American art." Barnet was ahead of his time in recognizing American Indian art as art. Unlike many of his colleagues, Barnet realized that each Native American group produced its own unique art forms, and understood that "art" itself is a European term whose definition has continuously changed through time. The "discovery" of Indian art was really a realignment in thinking about the definition of art. Native Americans and other tribal people have artistic traditions that are thousands of years old.

In Barnet's search for "real American values" he was struck by the strength of American Indian Art and the ability of Native American artists to use abstract designs that projected dynamic movement, balance, and emotion in positive space. Inspired by Native American art, Barnet's art moved in the direction where his visual vocabulary became simpler, straightforward, more telling in their imagery. By eliminating line, and emphasizing the integration of form and ground, he was able to synthesize classical values, aboriginal concepts, and personal experience in his work.

As a teacher at the Art Students League, Barnet often lectured about various tribal arts and aesthetics and organized field trips to The Museum of Natural History and The

Fig. 11

Bowl from Four Mile Ruin, a prehistoric Hopi site in Arizona. Illustrated in *Bureau of American Ethnology*, Twenty-second Annual Report, 1900-1901, Part 1, Plate XXV, No. B177110.

Museum of the American Indian (Heye Foundation, now The National Museum of the American Indian, Smithsonian). Barnet would emphasize the importance of the design shapes that were found in aboriginal art, all of which had positive and negative identities that balanced to create an all-over positive form with dynamic movement. He recognized early on that these images were a pictorial language that spoke volumes about the societies that created them. By looking at both Northwest Coast and Southwestern Indian art, his own creative process was forever changed. However, according to Barnet, the Northwest Coast was not as seminal an influence for him as the work of the ancient Pueblo people in the Southwest. Barnet was captivated by the ceramic art from Four Mile Ruin, a prehistoric Hopi site in Northeastern Arizona. Like many artists, he shared the common belief that the art of early cultures, especially the American Indian, exhibited formal power and profound insights, both psychological and conceptual which should be studied. Barnet viewed native arts as a way to understand human nature and the environment. Thus Barnet began to eliminate line from his work and instead to emphasize shapes. These shapes never overlapped, but expanded and contracted, pushing, pulling and interacting with each other. This dynamic interaction of positive and negative form and surrounding space were central features of a style that would come to be known as Indian Space Painting.

Fig. 12
Bowl from Four Mile Ruin, a prehistoric Hopi site in Arizona. Illustrated in *Bureau of American Ethnology*, Twenty-second Annual Report, 1900-1901, Part 1, Plate XXVI, No. 177203.

Indian Space Painting was a style developed by an informal group of artists working in New York in the 1940's. This group included Robert Barrell, Gertrude Barrer, Peter Busa, Howard Daum, Helen DeMott, and Ruth Lewin. Daum, Lewin, and Barrer were students of Barnet's at the Art Students League. Steve Wheeler, a close friend of Barnet, was regarded as the progenitor of this movement, a role he deplored as confining. Indian Space refers to the flat, all-over, non-illusionistic designs that balance organic and geometric forms. On these flat surfaces, intellectual, sensory, and emotional experiences come together to form the meaning or essence of the work. Color and form are used to show depth and time, forming pictures of ideas. In a sense, the works were experiments in a new pictorial language. Will Barnet and the other Indian Space Painters were looking for a way to equal, if not surpass, Picasso's Cubism in forging a new American modern art. The journal *Iconograph*, published by Gallery Neuf owner Peter Beaudoin, featured many examples of Indian Space paintings as well as articles dealing with Northwest Coast mythology, and primitive art. This journal was instrumental in encouraging an awareness and understanding of Native American art and its influence on artists in the 1940's. *Iconograph* and Barnet both recognized that Native American art was an influential and inspirational art source.

The focal point of the "Indian Space" group was the exhibition entitled *Semeiology* or *8*

and a Totem Pole at Gallery Neuf in New York in 1946. However, neither Barnet nor Wheeler took part in this exhibition. Wheeler declined to participate, attempting to distance himself from this group. Barnet's work was absent because he was concentrating on his family, teaching, and finalizing his work for a exhibition at the Bertha Schaefer Gallery. He was still experimenting with and synthesizing the concepts of "Indian Space" with his own thoughts and emotions to create a unique visual language.

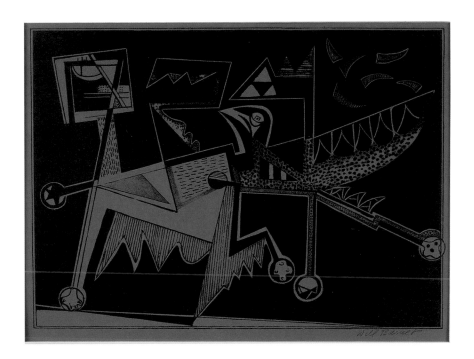

By the late 1940's Barnet began to incorporate the use of positive space in his own work. The native art forms he saw at the museums, and especially the objects illustrated in the Smithsonian Institution's Bureau of American Ethnology volumes he collected, became his dominant influence. The ceramic works from Four Mile Ruin in Arizona enlightened him to the use of form over line (figs. 11, 12, 14). These works were particularly important in Barnet's work and overshadowed the Northwest Coast iconography that influenced most of the other Indian Space painters. In these aboriginal works he saw representational life forms within an architectonically controlled field. Most of these forms usually occur framed on bowl interiors so that the entire composition can be seen at once. Mass and three-dimensional space are implicit even though the figures are flatly painted silhouettes. There is a focus on large, single motifs, and many often lack bilateral symmetry. The strength of the ideographic unity and structure of these compositions were driving forces in Barnet's work. The ability to create mass and scale by using forms became pivotal.

In his lithograph, *Strange Birds* (Cat. No. 10), Barnet blends the imagery of the prehistoric Hopi work from Four Mile Ruin and his own observations of animals, in this case, a chicken and a cat from his family's farm in upstate New York. The works from Four Mile Ruin in Arizona that influenced much of Barnet's work often depict animals especially birds and supernatural beings. These works are illustrated in the Bureau of American Ethnology volumes in Barnet's collection. The images piqued his interest and imagination. He felt these images were "fantastic." Barnet was excited by the way the prehistoric Hopi artisans handled their forms. This manipulation of form and space influenced Barnet for at least 15 years. To this day, he feels the Hopi are among the most wonderful artists he has ever encountered. He worked for years to understand how they "can take a bird and make it into a kind of monumental object that takes up positive space, and makes it all seem as if it's bursting with energy." This is exactly what Barnet was attempting to do with his use of forms, to imbue them with a sense of life and

Cat. No. 10
Strange Birds, 1947
Lithograph
9 3/4 x 13 in.
Collection of The Montclair Art Museum, Museum purchase; Acquisition Fund, 1994.42
Photo by: Peter Jacobs

energy, to enable them to explode off the canvas. In *Strange Birds*, Barnet is analyzing the behavior and relationship between the bird and the cat. By using a combination of geometry and imagery, Barnet was able to focus on the spirit of the image. Bird imagery is found throughout Native American art. Because of their ability to exist in the sky, on land, and in some cases in water, birds are frequently linked to the supernatural and secular worlds. Many historic Southwest ceramics depict chickens and other animals associated with European contact.

By assimilating native art ideas into his own work, Barnet was able to explore everyday life and relationships in a new positive manner. Concentrating on the rectangle, he focused on the vertical and horizontal expansion of forms. As Barnet researched the prehistoric Hopi work, it continued to stir his imagination. "What really happened in my work, in relationship to their work, is how they [the Hopi] depicted people in their imagery…. I began to take things around me, like my children, and I would use them as a take-off because they were in their primitive stage and it interested me a great deal." Barnet was struck by the scale of an object. When looking at the ceramics from Four Mile Ruin he was enchanted with the manner in which the Hopi used rounded forms with a sense of great scale, resulting in the feeling that the images are hovering above the surface of the object. Barnet

Fig. 13
Bowl from Chavez Pass, a prehistoric Hopi site in Arizona. Illustrated in *Bureau of American Ethnology*, Twenty-second Annual Report, 1900-1901, Part 1, Plate XL, A177219.

strove to understand the way they manipulated simple forms to create such a feeling of space and expansion. He sees this relationship between simple forms and mass as an almost miraculous synthesis.

In his work *Self Portrait,* (1953-54, Cat. No. 25, see cover), Barnet eliminates realistic space and renders only details, a dissection or dismemberment of the human face. Forms, not line, become the dominant elements. As Barnet commented," I don't work in a lineal sense, I work with mass." Much like Northwest Coast art, this work seems to utilize the idea of schematic characterization through the exaggeration of certain anatomic features, the dislocation of split details to other parts of the decorated surface, and the illogical transformation of details into new representations. But unlike Northwest Coast art, there is no formline. Formline delineates design units; it is what gives Northwest Coast art its fluidity. *Self Portrait* is contained by the limits of the canvas, yet has mass and depth. Like the ceramics from Four Mile Ruin, *Self Portrait* uses large single motifs and internal hatched elements. The geometric forms in *Self Portrait* are treated as biomorphic forms, with the shoulders, arm, hand and nose becoming apparent. Barnet, like the ancient artisans of the Southwest, has in this work rearranged and reduced the subject to its most essential structure. This is another parallel with Native American art, the idea of expressing nature

symbolically by using geometry and imagery together to visually express important emotions.

Barnet continued to experiment with Indian symbols to create his own personal "American" visual language with *The Cave*, (1953, Cat. No.26, see page 87). In this painting, he experimented with compressing pictorial space. Barnett uses shapes that swell and push against each other in a tight flat design, derived from the ancient works from Four Mile Ruin. *The Cave* visually explores the relationship between parents and children. The larger figure is a portrait of his son Todd. The smaller figure is Barnet, the adult, watching the larger figure who appears to be ready to explode from the canvas. This use of forms to denote motion and mass is directly related to the early Hopi ceramics that were found at Four Mile Ruin. The size and form of the child also conveys the complexities of childhood emotions and the promise of the future, while the adult is "caged" or held hostage by the cave. The cave in this instance can be understood to be the environment or rules governing the society in which we live. The child is pushing those limits and challenging them as he grows. The adult is offering a helping hand to the child who will not be constrained by the rules governing his parent's life. By using these strong forms in a combination of geometry and imagery, Barnet was able to convey the complex psychological relationships shared by families.

Fourth of July (1954, Cat. No.28, see page 88) continued Barnet's work with reducing images to their most essential positive form and rearranging them to create a visual language capable of expressing emotions and nature. *Fourth of July* is a portrait of Barnet's three sons.

Family groups are often the themes in his work. Here he has simplified and unified form in positive space. Figure and background are part of each other, just as family members are related. Barnet was taking the human form and changing it, abstracting and stretching it so that it possessed power, movement, change. These abstract figures are created as symbols for all of humanity. This same power can be seen in the ceramics from Four Mile Ruin that had originally influenced Barnet's work. The forms are abstracted and possess a power that makes the observer feel the image is about to leap off the page (see fig. 11). Because of his play with rearranging and reducing the images, and the geometric forms that may be related to skeletal imagery, some influence from Northwest coast art is also evident. There is a feeling of totemic structures in the life forms that have been rendered within rectangles concentrating on the vertical expansion of the forms. The energy in this work translates into a metaphor for life and celebration of the future.

Fig. 14
Bowl from Four Mile Ruin, a prehistoric Hopi site in Arizona. Illustrated in *Bureau of American Ethnology*, Twenty-second Annual Report, 1900-1901, Part 1, Plate B177086.

Creation (1954-55, Cat. No.27, see page 85) is an emotional response to his wife Elena's pregnancy with their daughter Ona. Two forms, one male and one female sit in the hand of God. Again, Barnet has used pared down abstract imagery to show equilibrium between forces, the pushing and pulling of shapes in positive space. The figures of the children are pictographic in nature and resemble the many petroglyphs and pictographs found among Native American cultures. These geometric forms become symbols for all of humanity. This somewhat totemic work is imbued with emotion and demonstrates the power of shapes to tell a visual story of emotions and beliefs. Like the ancient artisans in Native America, Barnet captures human thought and feelings with uncomplicated forms. This image explores the idea of "art being almost a religious experience because you are creating something." This is another analogy with Native American art. All of indigenous art had a spirit that made the object a living thing.

In *Janus and the White Vertebra*, (1955, Cat. No.29, see page 89) Barnet explores the role of duality in human nature. This work displays many influences from Native American art, including the x-ray like quality of the main figure, the elimination of unnecessary detail, the use of positive space and forms, and the concept of duality. Another possible link to Native American art can be found in the title. There is a group of Inuit carvers, known as the Clyde River Artists, in the Mary River area of Northern Baffin Island, Canada, that carve whale vertebrae with Janus faces to best utilize the natural shapes of the bones. Skeletal imagery in art is an ancient concept that probably began with the Upper Paleolithic hunter-gatherers around 15,000 B.C. to 10,000 B.C. and is now found worldwide and in many Native American cultures including Inuit, Woodlands, Northwest Coast, Plains, and the Southwest.[1] Skeletal imagery is often linked with religious ideas including transformation, death, rebirth, and the ability of the invisible to become visible. The divided figure speaks of duality of persona, which in turn relates to the dualism and complexities of life. Again, Barnet has been able to evoke human thought and emotion. Although he was influenced by Native American art, Barnet did not merely incorporate Indian designs but rather reinvented and synthesized them into his own unique visual language of human emotions.

Unlike many of his colleagues, Barnet recognized the powerful cultural metaphors found in the geometric forms that abound in native art. Barnet understood the artistic motivations of native people. He found that native art could serve as an intellectual forum for his need to create a uniquely American art form. By using his own visual vocabulary and manipulating form, Barnet gave his work a history and a life. All of his art is personal and

Fig. 15
Will Barnet, *Untitled*, c. 1948/completed 2000, oil on burlap, 46 x 30 in. Collection of Will and Elena Barnet, promised gift to The Montclair Art Museum. Barnet's use of stylized bird imagery to complement landscape symbols reflects his appreciation of the Native American art at Four Mile Ruin. Photo credit: Greg Kitchen

deals with the universality of human experiences. He connected with ancient native artists because of the underlying themes of environment and the universality of humanity's spiritual emotions that are found in his work. Barnet and Native American artists shared a common bond within the iconography they used. Both incorporate iconography that represents emotions, spiritual essences, and unseen forces experienced in dreams and thoughts. Barnet and native artists share the idea that art as a whole reaffirms a belief system that values creative adaptation as a means of expression. Their art reveals a progression in response to environmental, social, and economic influences. Both view their art as living, spiritual expressions of the integrated forces that tie together and unify all aspects of life.

FOOTNOTES:

All quotations are from the author's interviews with Will Barnet on December 10,1999 and January 6, 2000.

1. Dubin, Lois Sherr. *North American Indian Jewelry and Adornment* (New York: Harry N. Abrams. Inc.,1999.)

"A Certain Slant of Light":
Will Barnet and New England

by Jessica Nicoll

Will Barnet has been an active participant in the New York art world for seventy years, yet he describes himself as a "New Englander in New York."[1] The distinction is important, for it speaks to an identity and a set of values that have consistently informed his work. Raised in coastal Beverly, Massachusetts and educated in Boston, Barnet was molded by New England. He describes the region's character, and his own, as defined by stoic independence, persevering strength, and a transcendental affinity with nature. Over the decades he has developed those qualities into themes explored with ever-increasing resonance in his paintings, drawings, and prints.

Barnet's conception of New England was formed by the distinctive circumstances of his youth in the first decades of the 20th century. He was born in 1911 in his family's home in Beverly. Eleven years separated him from the youngest of his three older siblings, and he was the only American-born member of his immediate family. His parents, his brother, and his sisters had emigrated from Russia to Canada in 1906. His father, drawn by the prospect of work in the factories that dotted Massachusetts' north shore, moved the family to the seaside town of Beverly where he found employment as a mechanic with The United Shoe Company.[2]

Barnet's family was part of a wave of immigrants that was transforming New England at the turn of the century by fueling the growth

Fig. 16

Summer Idyll, 1976
Color serigraph
29 3/4 x 37 3/4 in.
Courtesy of Tibor de Nagy Gallery, New York and Sylvan Cole Gallery, New York

of industrial manufacturing and by diversifying what had been a largely Anglo-American culture. Recent scholarship has suggested that it was precisely this phenomenon that inspired the codification of a mythology of old New England. As the region was metamorphosing, a vision of its past emerged that emphasized its Puritan and Yankee heritage.[3] Barnet's childhood was steeped in that history. Beverly is situated across the harbor from Salem, site of the 17th-century witch trials and an active and prosperous seaport in the Colonial and Federal eras. The evidence of those histories was, and is, omnipresent in the community—in the House of Seven Gables,[4] in the Federal mansions of wealthy sea captains and merchants, and in the historical collections of what is now the Peabody Essex Museum. Among the earliest paintings to capture Barnet's imagination were stern 18th-century portraits in the Peabody's collection. The young boy was acutely aware of remnants of the past around him. As he recalls, "the last of the clipperships were still sailing into Beverly port when I was a boy…The feeling of lingering history was everywhere, and I suppose I daydreamed a lot…Beverly and Salem were both well past their prime as great whaling and trading ports but the memory of the great sea-captains, fearsome monsters of the sea, and far-off places lingered on."[5]

Barnet's awareness of New England's history was reinforced by his parents' focus on becoming American. They placed so little emphasis on their European heritage that when asked to discuss their origins, the artist can only offer that his mother was Czechoslovakian and his father a Russian who had fought in the Czar's army during the Russo-Japanese War.[6] His parents raised him to absorb the lessons of American history and to embrace the New England ethic of reserve, practicality, and diligence.[7]

The other leitmotif of Barnet's childhood was loneliness. His father was a driven working man who had little time for his children. When he was not working long hours at the factory, he toiled at home, single-handedly building the house the family occupied for most of their years in Beverly. By the time Barnet was a child his brother had moved out and his sisters were already working, first in factories and then in a local millinery shop. His mother was in her forties when Will was born, and although they had a close relationship, a pall was cast over it by her melancholy disposition.

Barnet describes an independent childhood spent largely in solitary activities—reading the stories of Robert Louis Stevenson and Nathaniel Hawthorne, studying books on art at the local library, and exploring the rocky shore in Beverly and neighboring towns. He cannot remember a time when he did not want to be an artist, an ambition that was neither encouraged nor discouraged by his family; as he recalls, "no one paid attention."[8] He developed his skills by scrutinizing reproductions of great artworks and sketching in a studio set up in the basement. As he grew he embraced a profound humanism (tinged with socialism) informed by his reading of Spinoza, his study of Rembrandt and Daumier, and his awareness of the social inequity evident in the disparity between Beverly's working class and the affluent residents of Massachusetts' north shore.

In 1927, Barnet left high school in his junior year to begin his formal artistic education at the Boston Museum School. He rode the train daily from Beverly to Boston to attend classes at the prestigious school then under the direction of the painter Philip Hale. The conservative curriculum was modeled on the French academic system, with stress placed on the study of perspective, anatomy, and the history of art. Although he was already interested in more contemporary themes and formal issues, Barnet "respected and followed Mr. Hale," valuing the solid foundation he was gaining.[9]

For his qualifying paper, Barnet was required to analyze a portrait by John Singer Sargent, but in addition he elected to study El Greco's portrait of *Fray Hortensio Felix Paravicino* (Fig. 17) in the collection of the Museum of Fine Arts. It was a choice that signaled the qualities he admired, and aspired to, in figurative painting. The El Greco is rendered with a vital immediacy and a focus on the sitter's penetrating gaze, sensitive mouth, and attenuated fingers, which create a compelling physical presence. The stark severity of the painting and its overwhelming evocation of the life of its subject attracted Barnet, as had the early 18th-century portraits by John Greenwood and others at the Peabody Museum. In these artists' portraits, as well as those of others including Rembrandt and Eakins, he was impressed by the clarity and the degree to which "the seriousness of life is present." This stood in contrast to what he saw as superficiality in Sargent's portraits, an "awareness of the material and clothing that a figure is wearing, and the objects in the room."[10]

Barnet's attraction to portraiture is a distinctly New England affinity. It was the dominant artistic tradition in the region through the colonial era, setting the standard for American portraiture, and it enjoyed continued distinction through the 19th century and into the 20th. Barnet gained an appreciation early on for the power portraits have to distill the essence of an individual's character and their historical moment. He has extended this tradition in his own portraits which, like the early portraits he admired and studied, convey their subjects' strength, their individuality, and a sense of their inner lives. The formative influence of such works as John Greenwood's portrait of Abigail Gerrish (Fig. 18) or the El Greco can be seen in Barnet's striking portrait of art historian Ruth Bowman (1967, Cat. No. 42, see page 100). Although it is a painting entirely consistent with its time and the

artist's mature painting style, it shares with the earlier works a pronounced verticality (indeed, Barnet's portrait has virtually the same dimensions as the El Greco), a spare palette marked by sharp contrast, and the sitter's erect, frontal posture and direct gaze. And, as in early portraits, the details are carefully chosen for their significance. The apple that Ruth Bowman has cut open is more than a decorative device. It describes her method for instructing her students about symmetry and design in nature, and thus is a potent symbol of her vocation and gifts as a teacher.

In 1931, Barnet left Boston for New York. Although he maintained strong ties to New England through his family, it would be decades before he returned to the region in his art. Nevertheless, he carried the imprint of New England with him to New York and his early experiences there. His first decade in the City was one of focused dedication to his art as he completed his education at the progressive Art Students League, supported

Fig. 17

El Greco (Domenikos Theotocopoulos), Greek (worked in Spain), 1541-1614, *Fray Hortensio Félix Paravicino,* **1609,** oil on canvas, 44 1/8 x 33 7/8 in., Isaac Sweetser Fund Courtesy, Museum of Fine Arts, Boston © 2000. Museum of Fine Arts, Boston. All rights reserved.

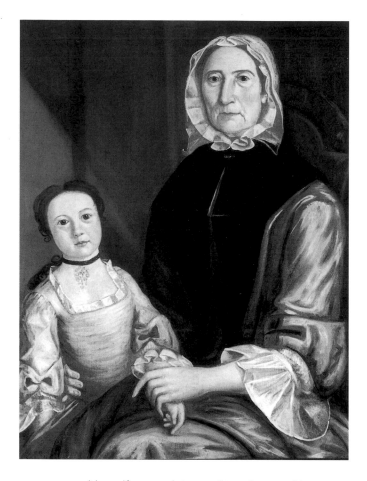

Fig. 18
John Greenwood,
*Portrait of Abigail
Gerrish with her
grandmother*,
c. 1750, oil on
canvas,
28 1/2 x 27 1/2 in.,
Courtesy, Peabody
Essex Museum,
Salem, MA

himself as a printer and teacher, and began to develop a significant body of work. Underlying these experiences was a commitment to education, a fierce work ethic, and an independent spirit, all of which derived from his childhood. His art of this period also bore the imprint of an idealism and social consciousness developed in New England. These were expressed both in the themes he addressed and in his choice of printmaking, a medium for the masses, as the vehicle for their expression.

It was not until 1956, during a summer stay in Provincetown, Massachusetts, that the New England landscape became a subject for his art. Although the visit yielded relatively few paintings, it marked an important turning point for the artist. At the time he had been working with abstraction for several years, focusing primarily on space, form, and color, and had only recently begun to reintroduce shapes evocative of the figure into his work. Returning to the New England shore and

experiencing the limitless expanse of sea and sky prompted him to begin to work with forms in nature. The result was a group of abstract paintings that set up a tension between the solidity of figures and the land and the openness of the ocean and the sky. These were Barnet's first serious paintings directly inspired by nature. His communion with his native landscape led to the abstract paintings of the late 1950s and early 60s, such as *Big Duluth* (1960, Cat. No. 33, see page 91), which powerfully express the fundamental elements that shape and define the natural world.

While Provincetown had provided a springboard for a new direction in Barnet's art, the coast of Maine would spark the creation of an important group of paintings whose inspiration, formal concerns, and subject matter are entirely rooted in New England. The *Women and the Sea* series was conceived in 1971 during a summer spent in Chamberlain on Maine's midcoast. For more than a decade, Barnet had been working in a figurative idiom informed by his earlier abstract investigations of distilled forms and compressed space. This period had seen the creation of some of his finest portraits and a large body of work focused on his family in interior settings. Chamberlain opened the door for a return to painting the landscape and a new way of approaching human experience that moved away from specific personal histories and toward more universal statements.

That summer and for several years to follow, Barnet rented a house set amidst soaring pines on a promontory overlooking the ocean. The elements of that distinctive landscape haunted the artist. As he has written, "Maine with its monumental primordial rocky coastline—its tall pine trees silhouetted against a vast luminous sky and ocean—its deep harbours and ancient piers caught my visual imagination."[11] He began sketching that environment and meditating on the sense of

time that it evoked. For Barnet the passing of centuries was made palpable by the primitive forms he was exploring and by the spirit of endurance embodied by trees and rocks continually battered by wind and sea. The idea for how to begin to translate those ideas into paintings came one evening when, as the artist remembers, "I saw my wife standing alone on our porch…It was dusk and her figure was silhouetted against the sea. It was a moment to remember."[12]

From that moment came *Woman and the Sea* (1972, Cat. No. 44, see page 105),[13] the first of the series of paintings of women keeping silent vigil by the sea. When Barnet discusses this work he emphasizes the formal challenges contained within it: establishing a dynamic balance between the verticals of the porch and the strong horizon line, creating a feeling of infinite space while maintaining the two-dimensional picture plane, and conveying the figure's volume and weight within this flatness. He achieved a dramatic tension between those oppositions both by synthesizing the lessons of his earlier abstract and figurative work and by adopting new techniques. Notably, his palette changed almost overnight, becoming very cool in response to Maine's distinctive light. The use of color in the *Women and the Sea* paintings is key to their strength. The dominant tones are gray, but they are grays built of thin, layered applications of rich color. The gradated colors that result have a depth and density that create an impression of expansive space without violating the surface flatness. Furthermore, Barnet's focus on light in transition—on dawns and dusks—imbues his canvases with movement, preventing them from becoming static despite the stillness of their compositions.

Barnet's cogent design and prodigious technique transcend mere formal mastery to create works resonant with meaning. With virtually no specific narrative detail, the *Women and the Sea* paintings powerfully evoke New England's history and the essential attributes that define the region's character. In these paintings every element—form, color, and execution—serves the larger message. The infinite space becomes a metaphor for infinite time. The complete integration of figure and setting transforms the women into elements in the landscape, a part of the natural world. Like the rocks on which they stand, the limitless ocean on which they gaze, and the weathered trees on which they lean, they embody strength, endurance, and survival.

The artist's choice to populate these paintings only with women consciously evokes the history of New England women left behind by men gone to sea. In all of the paintings, the women's long gowns and shawls link them to past centuries, but the simplified design of their clothing resists specifying a precise time period or a distinct personality. In works like *Early Morning* (1972, Cat. No. 45, see page 102) the architecture signals a coastal New England setting, while in *Vigil* (1974-75, Cat. No. 47, see page 104) the placement of the three women atop a widow's walk makes explicit both the locale and the subject. Nevertheless, Barnet avoids providing details that would transform his images into specific narratives. His purpose in conjuring the history of women in New England's seafaring past is to use their collective experience to symbolize the persistence of the human spirit. Barnet offers the patience, faith, and fortitude personified by his women as the foundation of our past and the key to our future. As he has said, "I select subjects that are not only introspective, but also retrospective. Then I go into the future. I'm trying to create a contemporary mythology of New England."[14]

While inspired by Maine, the *Women and the Sea* paintings are derived equally from the sense of history that Barnet absorbed during his childhood and the personal ideology that

he evolved as a young man. His essentially humanist interpretation of the past departs materially from the religious beliefs at the core of early New England's history. His emphasis on self-reliance allies him more with the philosophy of the American Transcendentalists and their belief that the dictates of social custom and religious doctrine must be resisted by the individual if he is to arrive at a personal understanding of what is right and true. In Transcendentalism it is the ability to reason, to intuit absolute truth, that is key to understanding the world of the spirit. Similarly, the profound spirituality in the *Women and the Sea* paintings comes not from an assertion of divine providence but from an affirmation of human potential. The cathedrals Barnet's women inhabit are vaulted groves of pines, spaces made sacred by the enduring strength of nature and the human soul.

The portrayals of humans in harmony with nature in the *Women and the Sea* paintings mirror the writings of Henry David Thoreau, one of the most important exponents of American Transcendentalism. Indeed, the series affirms Thoreau's conviction that communion with nature is a spiritual pursuit. Barnet's depictions of women contemplating the dawn in *Early Morning* (1972, Cat. No. 45, see page 102) and *Eos* (1973, Cat. No. 48, see page 38) evoke the concluding lines of *Walden*: "The light which puts out our eyes is darkness to us. Only that day dawns to which we are awake. There is more day to dawn. The sun is but a morning star."[15] Barnet, like Thoreau, presents the natural world as a source of inspiration in the introspective search for self-knowledge and uses light as a metaphor for the Inner Light, the world within. And, like Thoreau, the artist draws on classical sources in developing this theme of spiritual birth or renewal, as the title *Eos*, the name of the Greek goddess of the dawn, indicates. Classicism also informs

the cool, orderly, rational style of Barnet's works, underscoring the idealism of their message of faith in humanity.

As he completed the *Women and the Sea* series, Barnet transmuted his anonymous, archetypal females into a specific individual for a new body of work inspired by Emily Dickinson's poetry. In the mid-1980s, publisher George Braziller invited the artist to work on a holiday gift book of Dickinson's love poems. Barnet, an admirer of the poet's work, accepted, but quickly persuaded Braziller to expand the project into an illustrated edition of Dickinson's poems. *The World in a Frame*, featuring forty-six poems accompanied by twenty-four drawings, was published in 1989. To prepare for the project, Barnet spent two years reading and re-reading all of Dickinson's 1,775 poems and making sketches in the search for visual analogues to the emotional tone of the poems. The process yielded not only hundreds of sketches and the finished drawings for the book, but also a series of oil paintings and prints.

Barnet recognized in Dickinson's poetry the stamp of New England that his own work bears. He felt an affinity with her reverence for nature, her emphasis on introspection and the life of the mind, and her meditations on the metaphysical.[16] On the order and restraint that characterize both artists' work, Barnet has observed,

> Dickinson's poetry was…very hard-edged, very concise, very contained. Emily Dickinson's verse was framed, like a great painting, and that's why I feel close to her. In literature, she was a hard-edged painter. In painting, I'm a hard-edged poet. The architecture of a picture is what really fascinates me.[17]

The sympathies between the artists made it natural for Barnet to project Dickinson into the world of his paintings. She comfortably wears

the mantle of his powerful, isolated, enduring women. The convergence between the two series is explicit in works like *This is my letter to the World*, which depicts Dickinson confronting the world from atop a widow's walk. Here, and throughout the Dickinson series, a portrait of the poet has replaced the anonymous features of the *Women and the Sea*. Barnet based his likeness of Dickinson on the only known image of her, a daguerreotype taken in her late teens. *What mystery pervades a well!* and other representations of the poet's strong features framed by hair pulled tightly off her face are also informed by Dickinson's own self-description: "I had no portrait, now, but am small, like the Wren, and my Hair is bold, like the Chestnut Bur— and my eyes, like the Sherry in the Glass that the Guest leaves—"[18]

In the Dickinson works Barnet also departed from his earlier New England paintings by returning to the treatment of the figure in interior settings. *Unto my Books—so good to turn*, an image of Dickinson in her library, directly quotes the composition of his *Silent Seasons* series (1967, Whitney Museum of American Art) and joins dozens of other depictions of women enjoying the quiet contemplation of books. However, in drawings like *The Wind begun to rock the Grass* and *The Loneliness One dare not sound* a new tone entered the work. In these representations of a figure separated from the world by a window or tightly constrained by the architecture of the image and the room, the interior setting conveys a claustrophobic isolation. Here Barnet began an investigation of a darker side of solitude that would culminate in his most personal series of paintings inspired by his New England origins.

Barnet credits Dickinson's evocations of loneliness, fear, and the lingering presence of the departed with prompting a body of work, begun in 1990, set in his family's Beverly home. The central character in these interior dramas is his sister Eva, the artist's last surviving family member, depicted in anxious old age. Unlike their brothers, Eva and her sister Jeanette never left their father's home, becoming increasingly reclusive as they aged. Barnet has described his sisters' story of spinsterhood and solitude as "like an early New England saga."[19] The Beverly paintings were inspired by Eva's illness-induced hallucinations of her deceased parents and siblings. His sister's fright was made palpable for Barnet when she mistook him for one of the ghosts that was haunting her. That experience crystallized for the artist the terror of time, of things disappearing. He has called these "an old man's pictures," observing, "I wanted to say something about how life just simply evaporates….When you are young, you always think things are ahead of you. You get older, you realize there's not so much ahead; it's all in the past. I wanted to capture that."[20]

In *The Three Windows* (1992, Cat. No. 50, see page 44) Barnet portrays Eva standing in their childhood home, her head caught in profile with her hand held to her face in a gesture of anxiety. She is silhouetted against one of three blank windows that fill the composition, their shades drawn to shut the world out. As in all of Barnet's work, the form of this painting is completely integrated with its content. The flatness of the image and the pronounced verticals created by the windows communicate Eva's confinement, the narrowness of her world. Amidst the darkness of the room she is dramatically lit by an unseen source, but it is not a light of hope or optimism; rather, it illuminates her fear. The image summons Emily Dickinson's lines:

> *There's a certain Slant of light,*
> *Winter Afternoons—*
> *That oppresses, like the Heft*
> *Of Cathedral Tunes—*[21]

Other works in the series populate the interior of the house with the shadowy figures of

departed family members. They share the same spaces yet exist in total isolation, no one interacting with another. Time is compressed in these paintings, uniting in one image the family at different stages of their lives. One of the most poignant is *The Mother* (1992, Collection of the artist) in which the artist simultaneously portrays himself as a young man sketching the seated figure of his mother and as an older man standing beside her but looking away to the world outside. It is Barnet's homage to his origins— to the time, place, and people that left their impress indelibly upon him and his life's work.

For Barnet, New England has been a nearly continual source of inspiration and renewal. The region's stark light and austere landscape have fed the development of his spare, crisp, harmonious style. In its history he has found a poetic vehicle for his celebration of the sublimity of human experience. By combining a respect for tradition with a modern sensibility he has achieved his "contemporary mythology of New England," creating an art of relevance, resonance, and grace.

ENDNOTES:

1. Interview with Will Barnet by the author, 11 August 1999, Sebasco, Maine.

2. Peter Barnet, *Will Barnet: Artist and Teacher* (New York University, Ed. D, 1975): p. 1; Barnet interview, op. cit.

3. This idea is developed in Dona Brown and Stephen Nissenbaum, "Changing New England: 1865-1945," in William H. Truettner and Roger B. Stein, eds., *Picturing Old New England: Image and Memory* (New Haven: Yale University Press, 1999).

4. The House of Seven Gables is the eponymous setting of Nathaniel Hawthorne's 1851 novel which tells the story of a curse placed on the House of Pyncheon by Matthew Maule, a victim of the Salem witchcraft trials. In the early 20th century it was a settlement house where Barnet, at the age of fourteen, taught his first art classes.

5. Quoted in Barnet, *Will Barnet*, p. 8.

6. Barnet interview, op. cit.

7. In a 1976 lecture delivered at the Vatican, Barnet implicitly articulated the importance of these experiences in shaping his world view, stating: "We Americans often say we are of varying ethnic groups, but actually, over a period of time we have become homogenized, a melting pot, but always retaining that strong drive of individual freedom. This freedom is perhaps clouded, and surely influenced by what I would call severity of Puritanism as it affects everything we do,—indeed it has affected everything I have done in my lifetime." Will Barnet, "A Personal Reflection on the Spiritual Aspects in American Art" (unpublished manuscript, 1976): 1.

8. Barnet interview, op. cit.

9. Ibid.

10. Barnet, "Spiritual Aspects in American Art," p. 9.

11. Will Barnet, "Maine and its Influence on My Art" (March 10, 1985). *Will Barnet recent paintings and drawings* (Rockland, Maine): William A. Fransworth Library and Art Museum, 1985), n.p.

12. Ibid.

13. *Woman and the Sea* was translated into a lithograph in 1973, as many of the other *Women and the Sea* images subsequently were.

14. Marsha Howland, "Artweek honors Will Barnet; Fish Flake Hill still calls the artist home," *The Salem Mass. Evening News* (October 24, 1980).

15. Henry David Thoreau, "18. Conclusion," *Walden* (1854).

16. This discussion is informed by Maryanne Grabowsky, "Dickinson and the Visual Arts: Will Barnet Meets Emily Dickinson," *Emily Dickinson International Society Bulletin*, vol. 6, no. 2 (November/ December 1994): 8-9, 18.

17. Quoted in Roy Proctor, "Will Barnet draws on his Yankee heritage," *The Richmond News Leader* (May 11, 1991): A-42.

18. Quoted in Susan Danly and David Porter, "Emily Dickinson's Impact on Contemporary Art," *Language as Object: Emily Dickinson and Contemporary Art* (Amherst, Mass.: Mead Art Museum, Amherst College, 1997): 68.

19. Barnet interview, op. cit.

20. Ibid.

21. Emily Dickinson, "There's a certain Slant of light," poem no. 258, in *The World in a Frame* (New York: George Braziller, Inc., 1989): 34.

PLATES

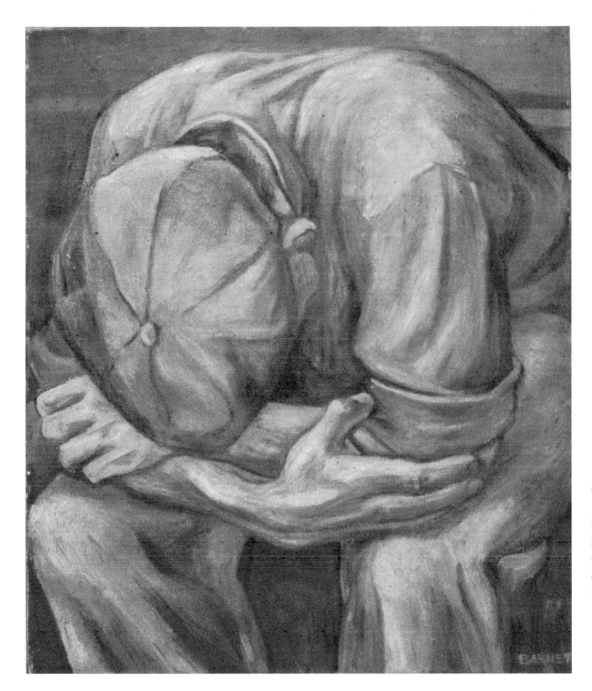

Cat. No. 18

Idle Hands, 1935
Oil on canvas
25 x 21 in.
Collection of Mr.
and Mrs. Woody
Klein

Cat. No. 20.

Soft Boiled Eggs,
1946
Oil on canvas
36 x 42 in.
Collection of Will
and Elena Barnet

My early work, which has recognizable images, actually contains most of the ideas that I am working with today. My paintings of the children were very searching in terms of exact characterizations of a particular child or a particular relationship. I sketched for months before I started painting until I arrived at the most symbolic gesture. 'Soft Boiled Eggs' came as a summation of a feeling about something in terms of the family itself and the atmosphere of a ritual. It has a sense of icon, of religious painting. (quoted in *Will Barnet*, Boston: Institute of Contemporary Art, 1961, n.p.)

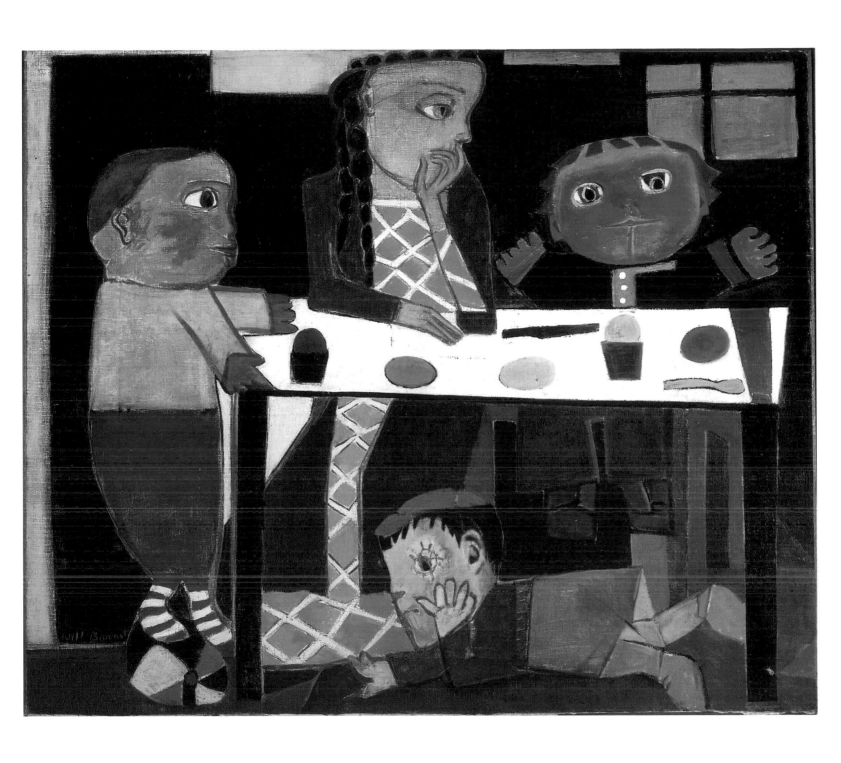

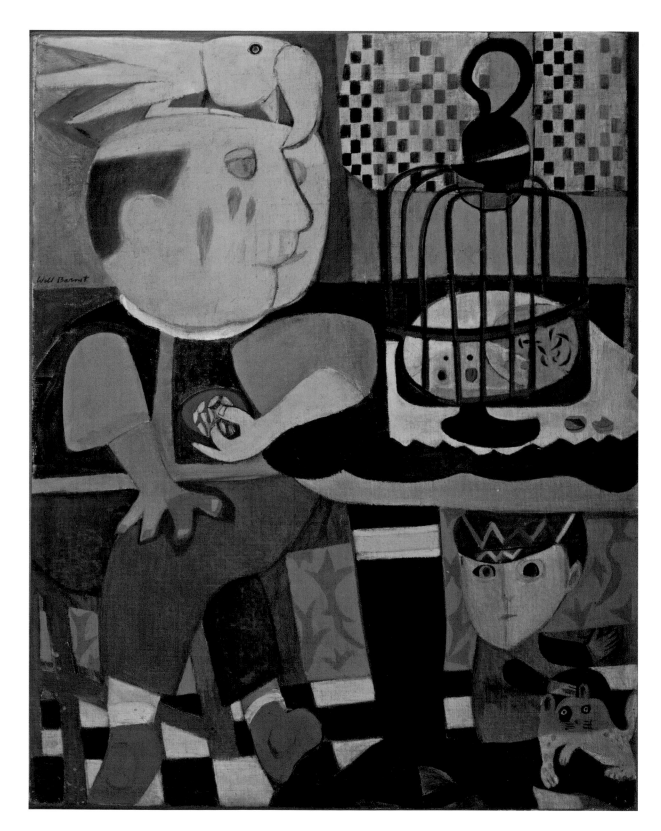

Cat. No. 21.

*Old Man's
Afternoon*, 1947
Oil on canvas
28 x 22 in.
Collection of
Irene and Philip
Clark

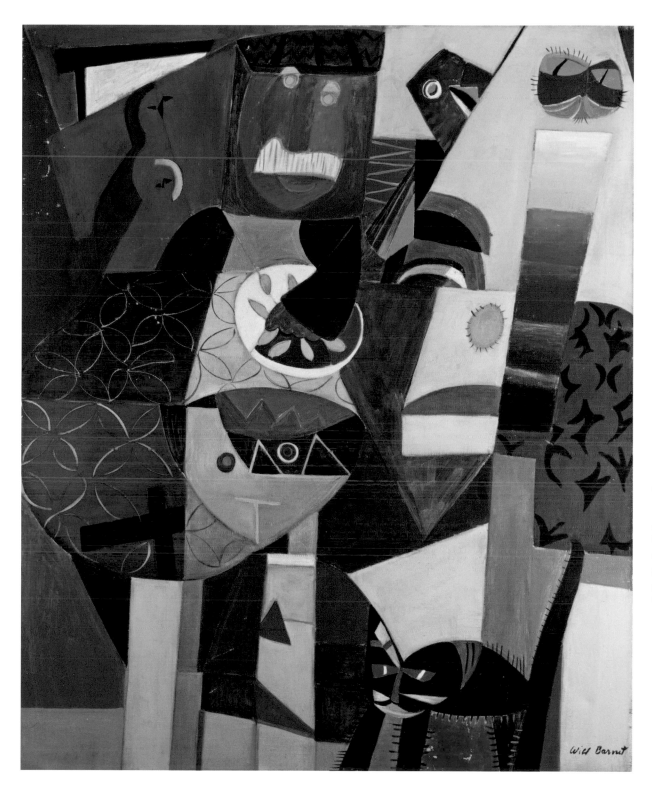

Cat. No. 22.
*Old Man's
Afternoon*, 1947
Oil on canvas
47 x 36 in.
Collection of Mr.
and Mrs. William
Y. Hutchinson

Cat. No. 24.

Summer Family,
1948
Oil on canvas
34 x 44 in.
The Samuel S.
Fleisher Art
Memorial,
Philadelphia

My Search in the late forties was to find forms that belonged to the pure matter of painting itself but which were equivalent to the substance and the forces that I felt in nature. I eliminated realistic space and substituted a painting space based purely on the rectangle: the vertical and horizontal expansion of forms. (Quoted in *Will Barnet*, Boston: Institute of Contemporary Art, 1961, n.p.)

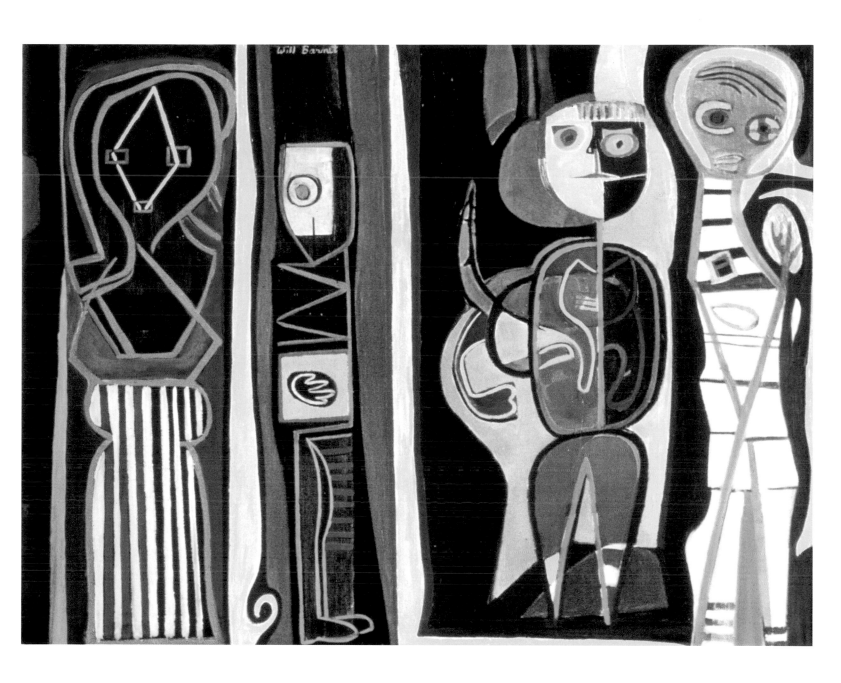

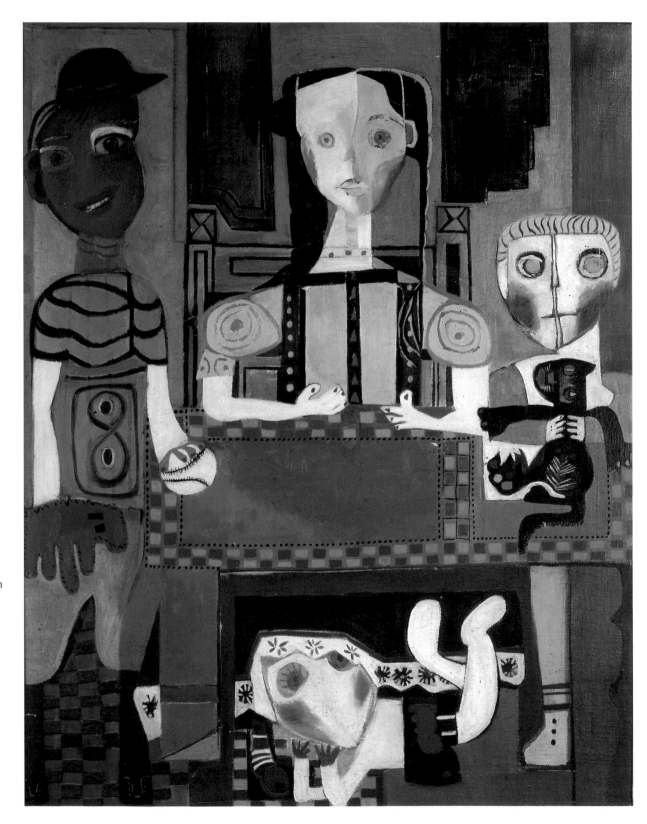

Cat. No. 23.

Family and Pink Table (Mary and Sons), 1948
Oil on canvas
36 x 28 in.
Private Collection

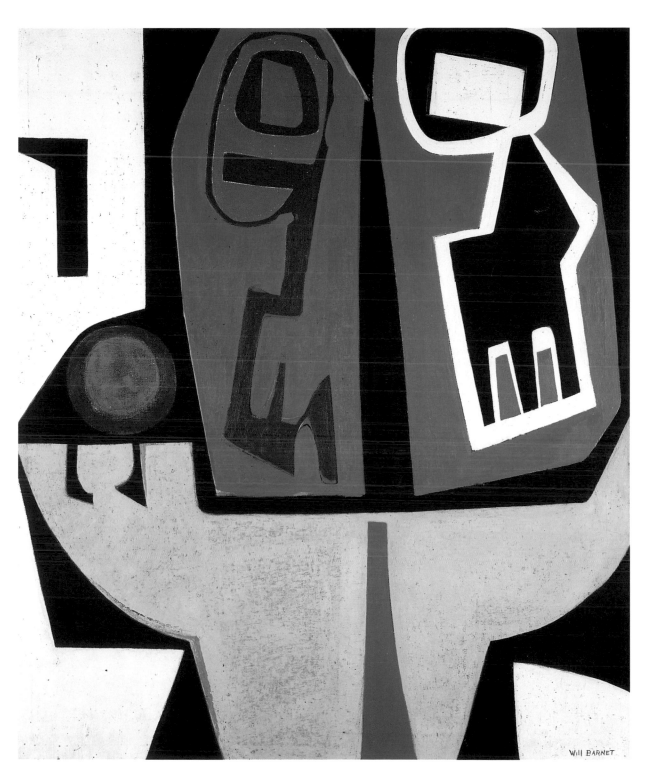

Cat. No. 27.

Creation,
1954-55
Oil on canvas
44 1/8 x
36 3/4 in.
Gift of Mr. Will
Barnet, The Snite
Museum of Art,
University of
Notre Dame,
Indiana

The Cave, 1953
Oil on canvas
36 x 47 3/4 in.
Collection of
Neuberger
Museum of Art,
Purchase
College, State
University of
New York,
Gift of Henry
Pearson
Photo credit: Jim
Frank, 1994

Although the creation of subjective images no longer depends on direct observation, my work is constantly revitalized by direct contact with reality. The abstract work is never concerned with amorphous feelings but always with visual images of very real experiences which demand, as did the more recognizable imagery of the earlier work, that each form exist in its own sharply defined character. (Quoted in *Will Barnet*, Boston: Institute of Contemporary Art, 1961, n.p.)

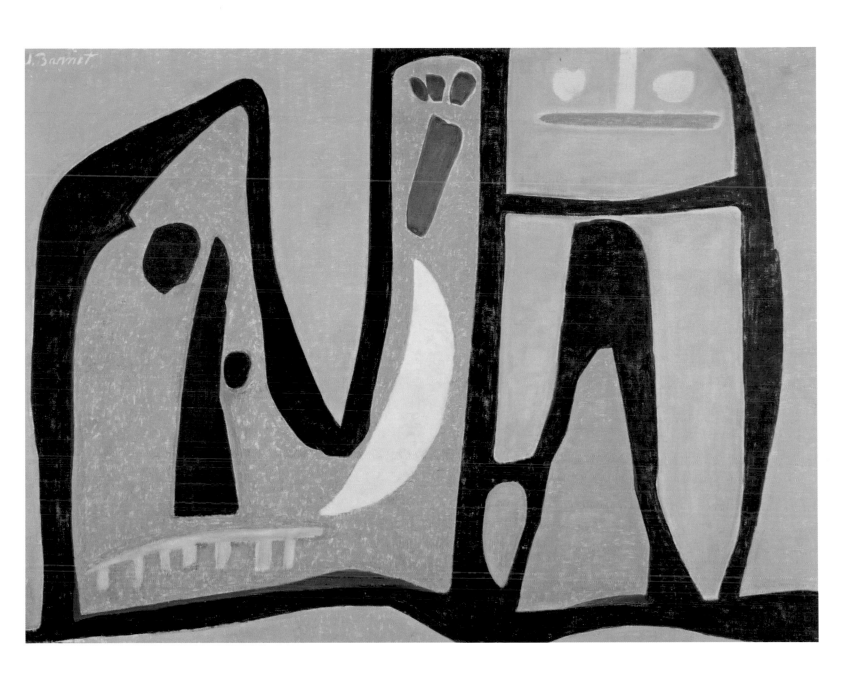

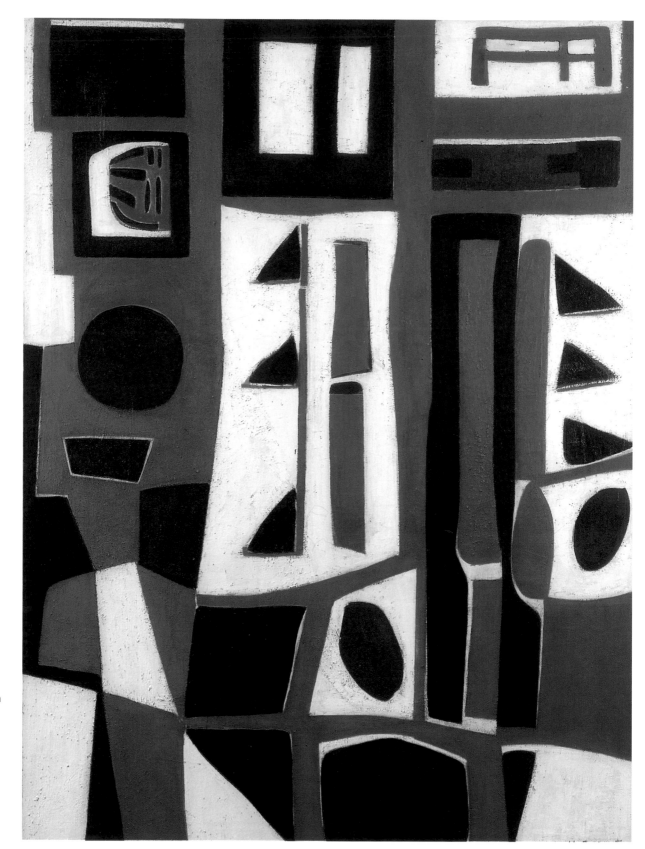

Cat. No. 28.
Fourth of July,
1954
Oil on canvas
51 3/4 x
37 3/4 in.
Private Collection

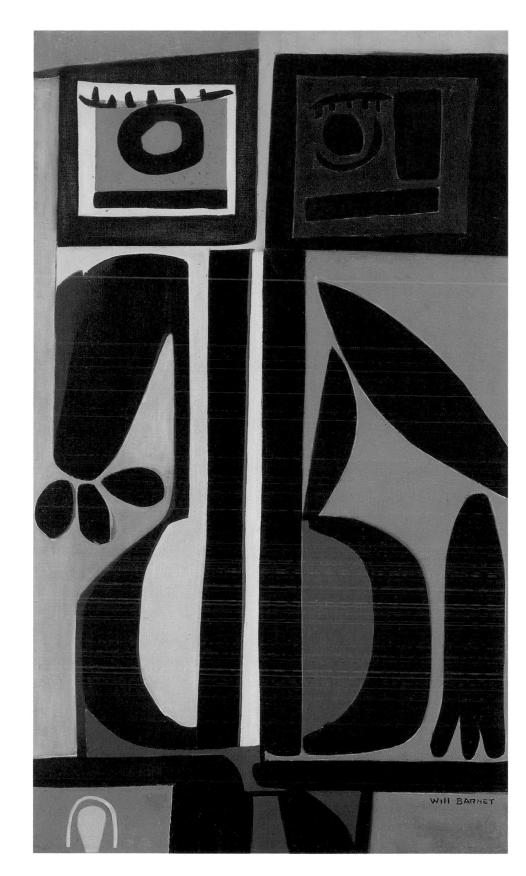

Cat. No. 29.

Janus and the Whito Vortebra, 1955
Oil on canvas
41 1/8 x 23 7/8 in.
National Museum of American Art, Smithsonian Institution, Gift of Mr. Wreatham E. Gathright

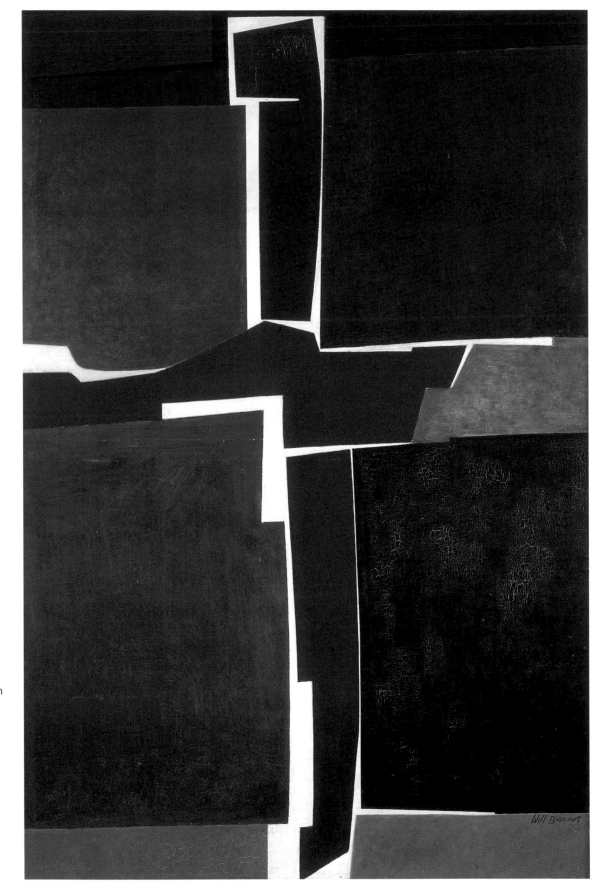

Cat. No. 31.

Singular Image,
1959
Oil on canvas
68 1/2 x
46 in.
Private Collection

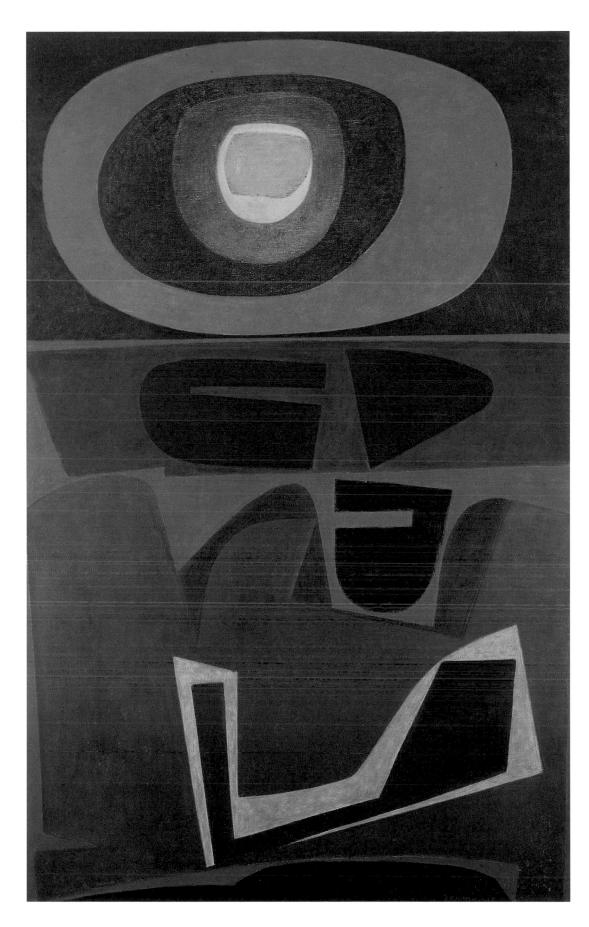

Cat. No. 32.

Big Duluth, 1960
Oil on canvas
85 x 52 1/2 in.
Tweed Museum
of Art, University
of Minnesota
Duluth,
Patrons and
Subscribers Fund
Purchase

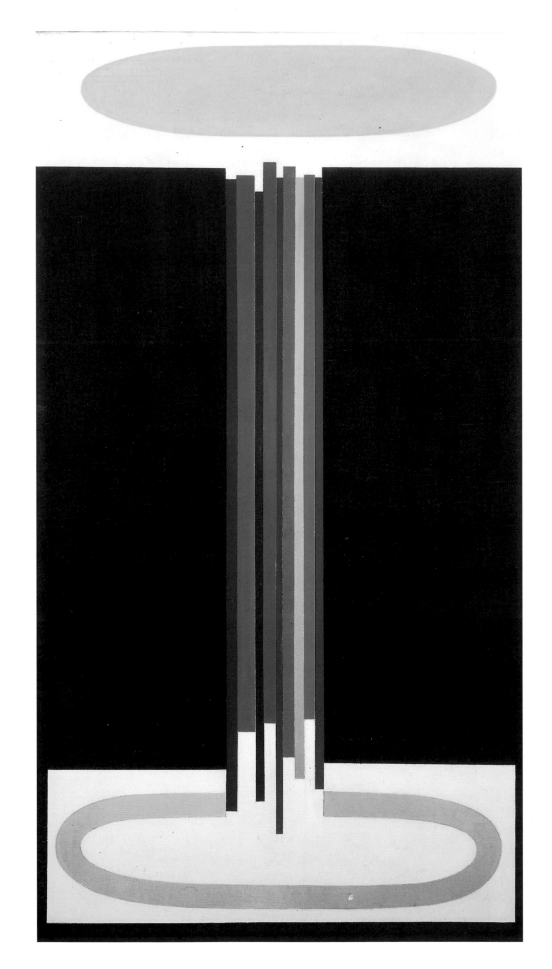

Cat. No. 33.
Impulse, 1964
Oil on canvas
70 1/2 x 37 3/4 in.
Collection of Mr.
and Mrs. Frank
Martucci

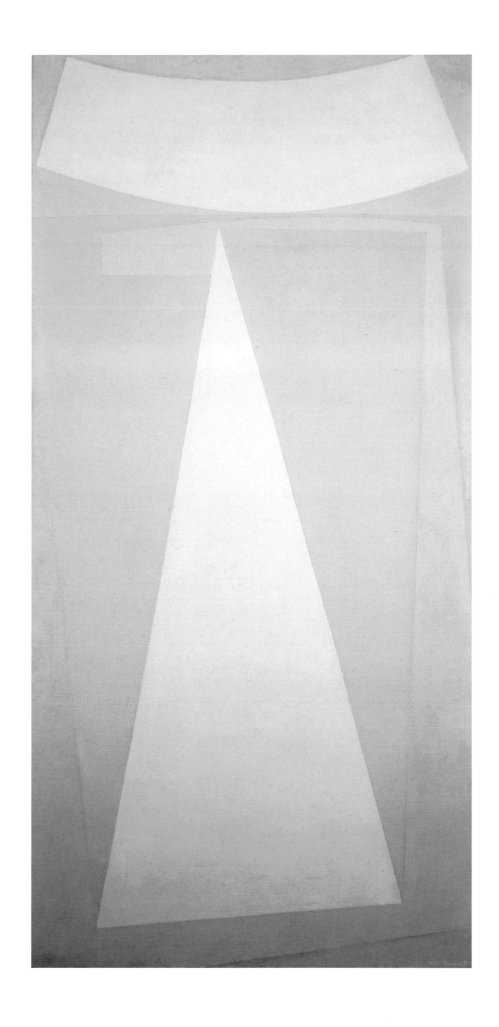

Cat. No. 34.

Eden, 1964-65
Oil on canvas
88 x 43 in.

Courtesy of Tibor
de Nagy Gallery,
New York

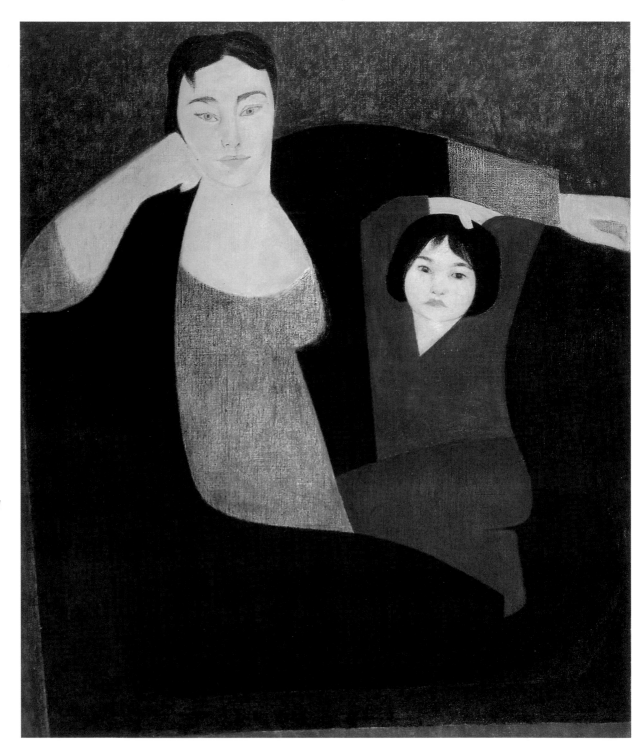

Cat. No. 35.

*Mother and Child
(Elena and Ona)*,
1961
Oil on canvas
46 x 39 in.
Collection of Will
and Elena Barnet

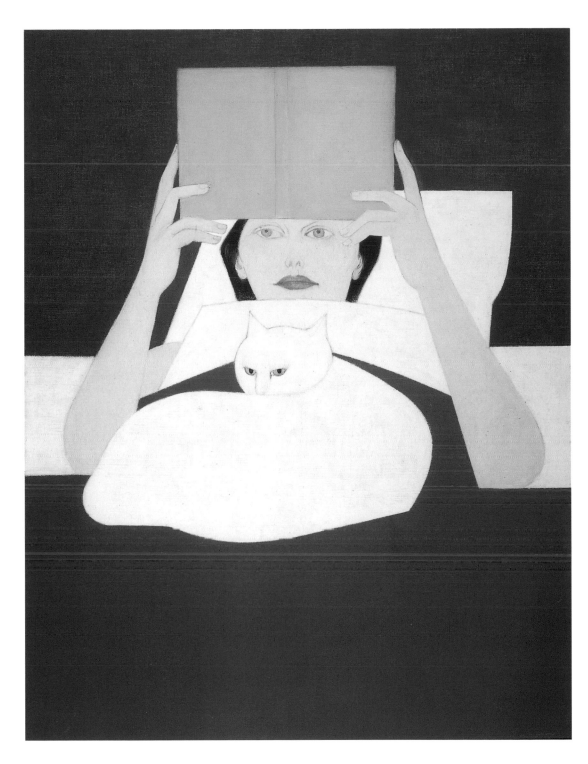

Cat. No. 37.

Woman Reading,
1965
Oil on canvas
45 x 35 in.
Collection of Will
and Elena Barnet

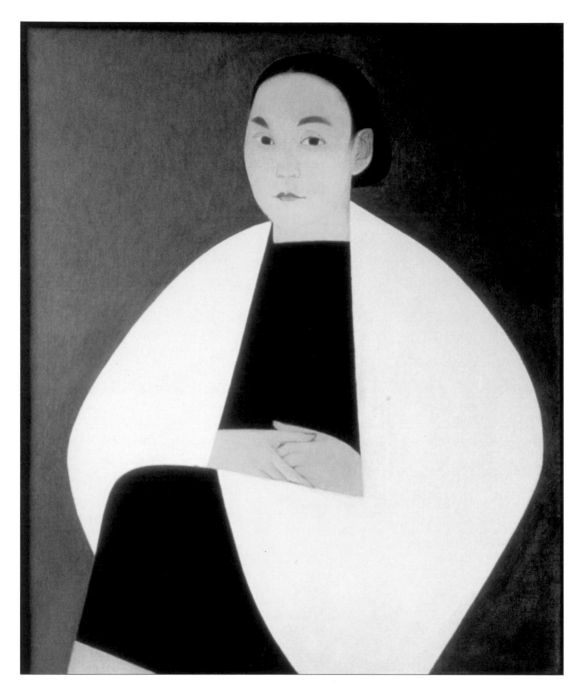

Cat. No. 38.

Remi, 1962
Oil on canvas
31 x 26 in.
Collection of Tom
and Remi Messer

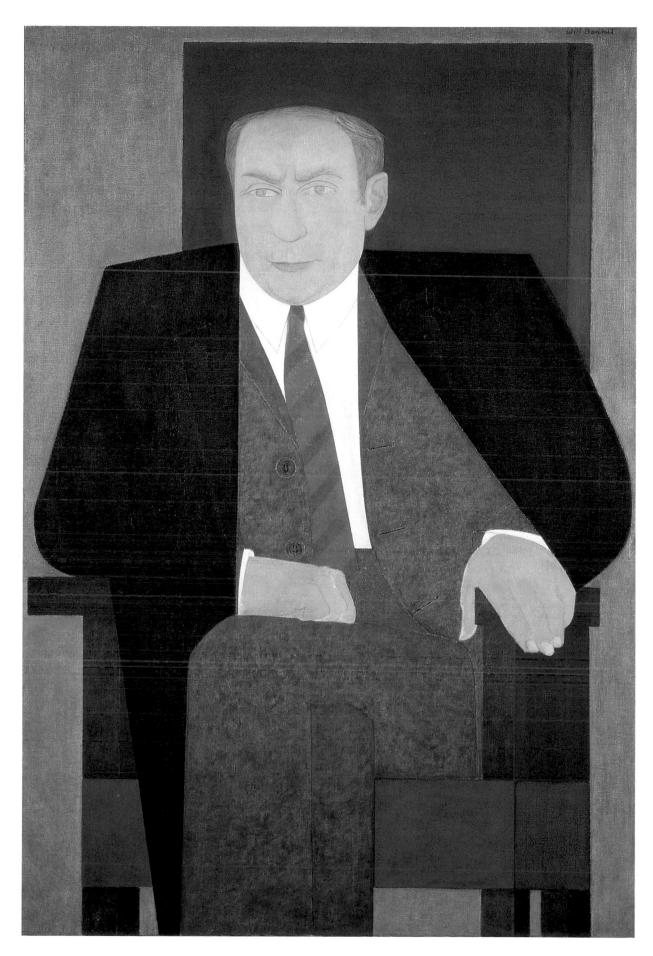

Cat. No. 39.

Portrait of R.N.N.,
1965
Oil on canvas
67 x 43 in.
Grey Art Gallery
& Study Center,
New York
University Art
Collection,
Gift of Roy
Neuberger, 1966
Photo credit: Jim
Frank

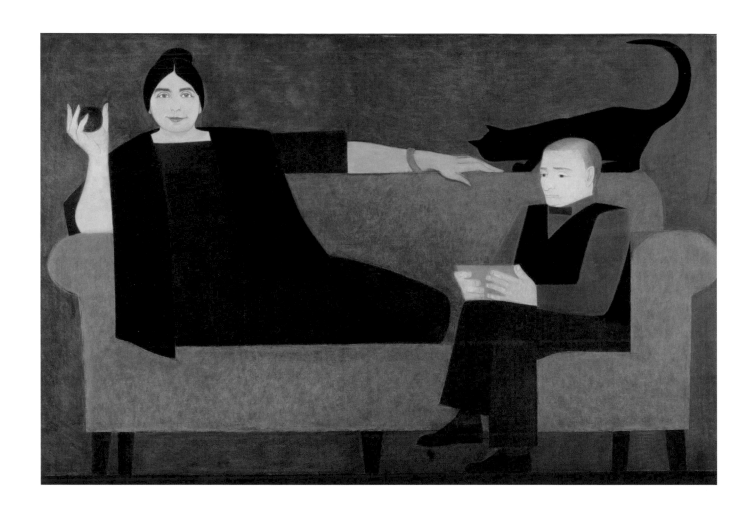

Cat. No. 40.
Kiesler and Wife,
1963-1965
Oil on canvas
48 x 71 1/2 in.
The Metropolitan
Museum of Art
Purchase, Roy R.
and Marie S.
Neuberger
Foundation Inc.
Gift and George
A. Hearn Fund,
1966.
Photograph ©
1981 The
Metropolitan
Museum of Art

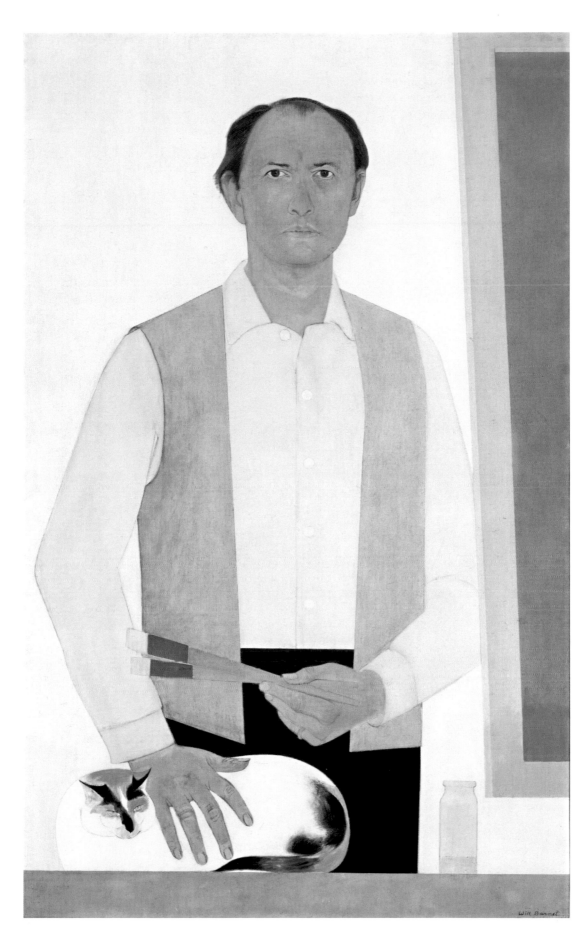

Cat. No. 41.
Self Portrait,
1907
Oil on canvas
62 x 38 in.
Courtesy of
Museum of Fine
Arts, Boston,
Anonymous Gift
through the
Waddell Gallery

68.143

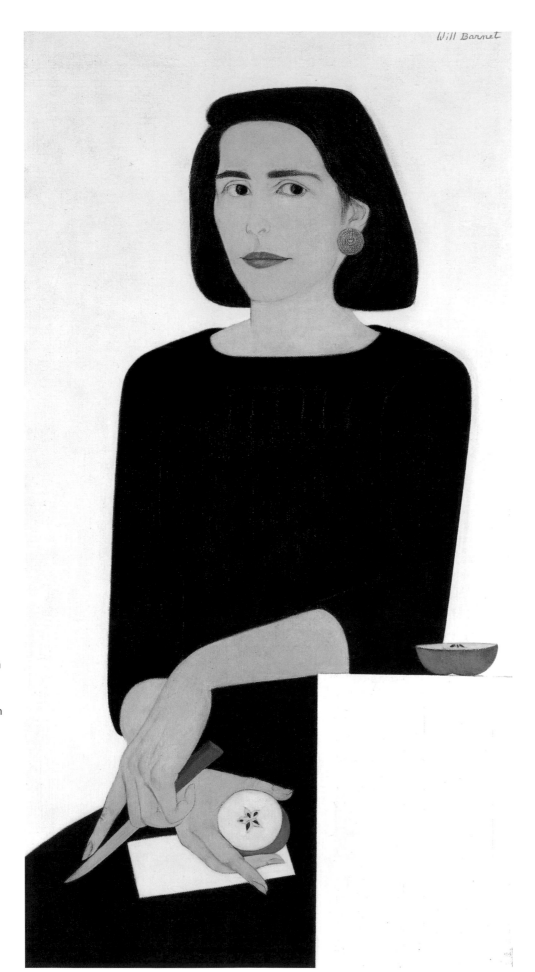

Cat. No. 42

Ruth Bowman,
1967
Oil and pencil on
canvas
45 x 23 3/4 in.
The Metropolitan
Museum of Art
Gift of Ruth and
R. Wallace
Bowman, 1998
Photograph
©1998 The
Metropolitan
Museum of Art

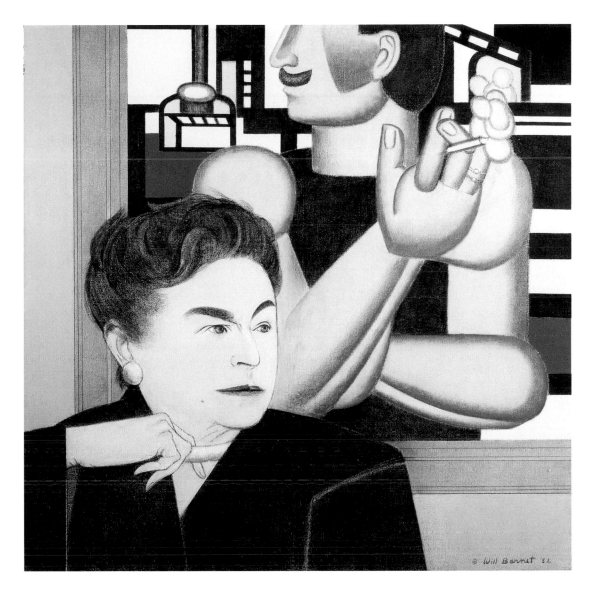

Cat. No. 43.

Homage to Léger, with K.K., 1982
Oil on canvas
39 1/2 x 39 1/2 in.
Collection of Mr. and Mrs. William Y. Hutchinson

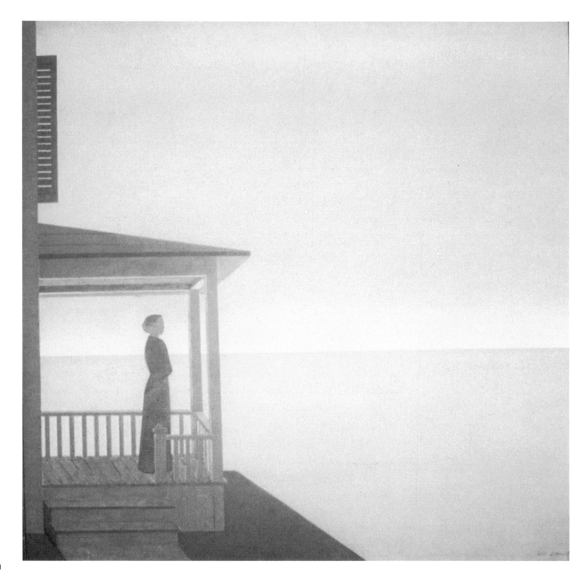

Cat. No. 45.

Early Morning ,
1972
Oil on canvas
57 3/4 x 57 1/2 in.
Private Collection

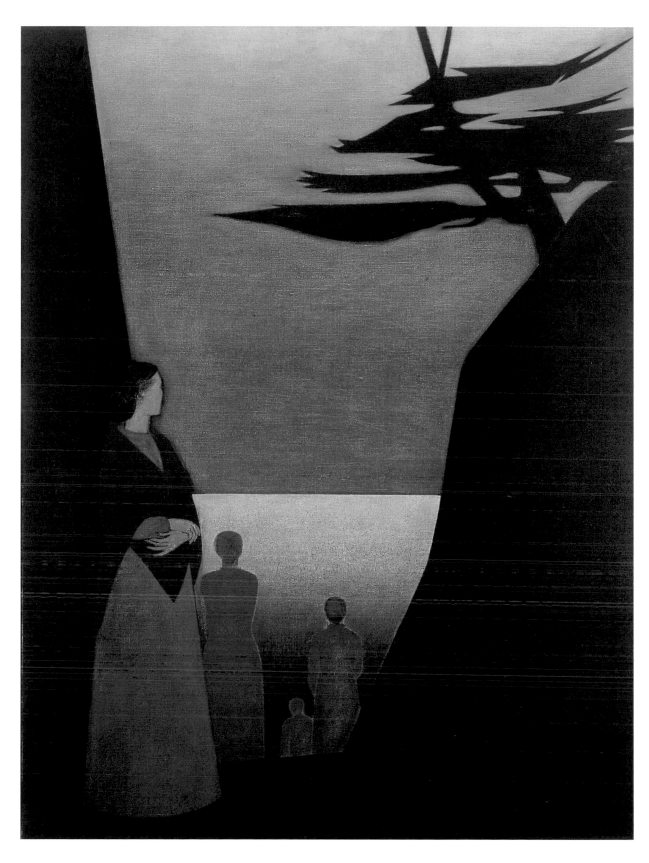

Cat. No. 46.

Infinite, 1974
Oil on canvas
63 1/2 x 47 1/2 in.
Farnsworth Art
Museum, Gift of
Maurine and
Robert
Rothschild

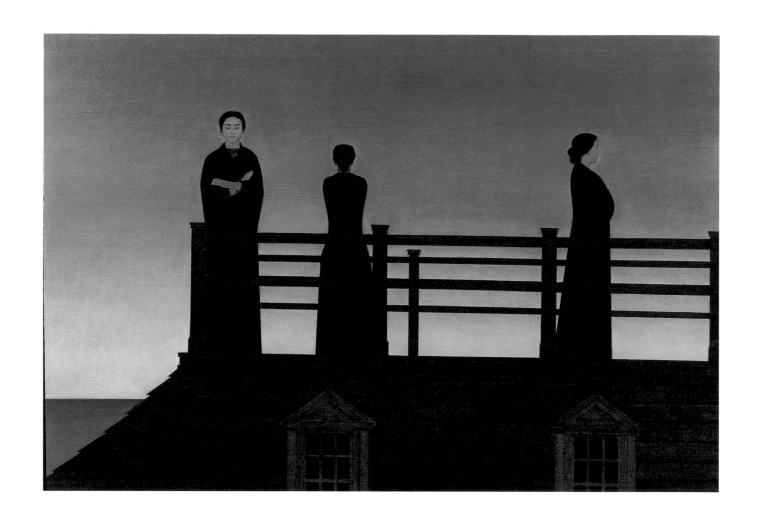

Cat. No. 47.

Vigil, 1974-75
Oil on canvas
48 x 67 1/2 in.
Collection of Liza
and Michael
Moses

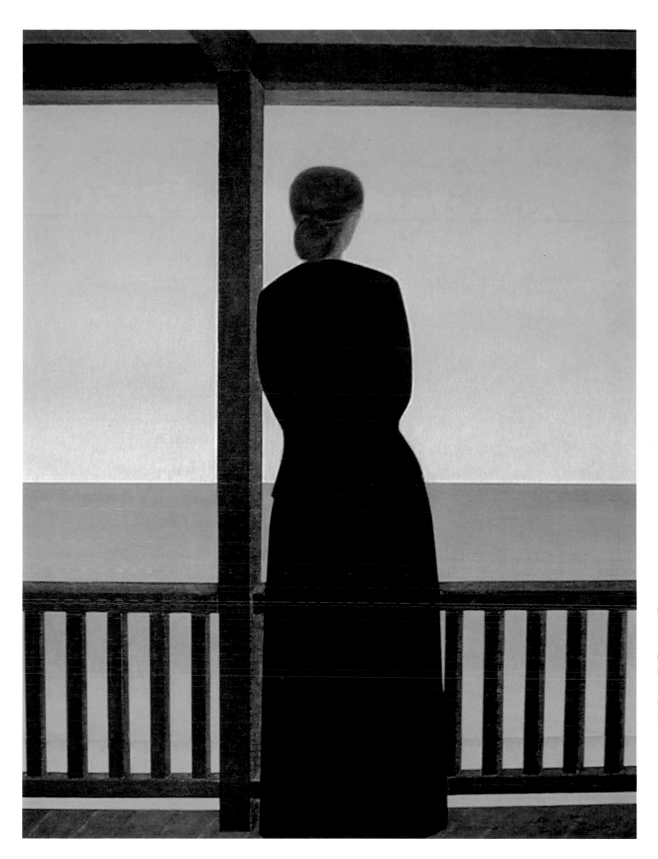

Cat. No. 44.
Woman and the Sea, 1972
Oil on canvas
51 3/4 × 41 in
David David
Gallery,
Philadelphia

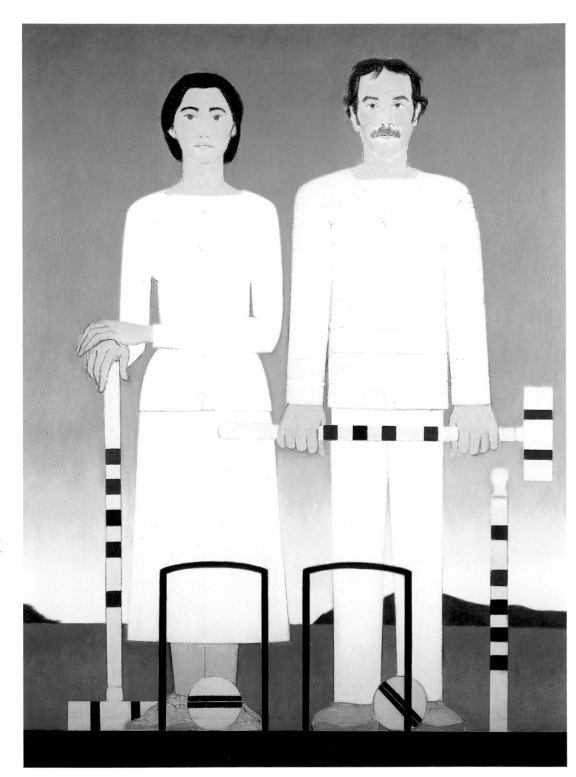

Cat. No. 49.

Croquet, 1985
Oil on canvas
65 1/4 x 48 1/2 in.
Courtesy of Tibor
de Nagy Gallery,
New York

Cat. No. 51.

The Grandmother, 1992
Oil on canvas
49 1/4 x 55 3/4 in.
Collection of Mary Ann and Bruno A. Quinson

Cat. No. 52.
*The Purple
Bottle,* 1989-1999
Oil on canvas
34 x 38 1/2 in.
Private Collection

SELECTED BIBLIOGRAPHY

(For additional citations, see Robert Doty, Will Barnet (New York: Harry N. Abrams, Inc., 1984), 157-162).

Writings by the Artist

"Lithography as an Art," *The League*, IX (November 1937): [6-7].

"Technical Supplement" (with Harry Sternberg). In Andre Smith, *Concerning the Education of a Print Collector*, New York: Harlow, Keppel & Co., 1941.

"Chardin," *The League* XIV (November 1942): 4-5.

"The Resurrection of Block Print Making," *The League* (April 1944): 7.

"The Plastic Approach to the Model," *The League Quarterly* (Winter 1947): 8-9.

Statement, *Exhibition of Drawings. Peter Barnet, Dickie Barnet*, New York: Carlebach Gallery, 1947, n.p.

"Painting without Illusion," *The League Quarterly* 22 (Spring 1950): 8-9.

"Aspects of American Abstract Painting," *The World of Abstract Art*, New York: George Wittenborn, Inc., 1957.

Statements in *Will Barnet*, Boston: Institute of Contemporary Art, 1961, n.p.

"Unique Images," *Art in America* 51 (December 1963): 70-71.

Statement in *Will Barnet: New Paintings*, New York: Grippi and Waddell, 1966, p. 2.

"A Personal Reflection on the Spiritual Aspects in American Art," unpublished manuscript prepared for the Vatican Art Seminar on *Influence of Spiritual Inspiration on American Art*, Rome, July 1976.

"Artist in the Library," *The Quarterly Journal of the Library of Congress* 40 (Summer 1983): 180-87.

"Maine and its Influence on My Art," *Will Barnet recent paintings & drawings*, Rockland, Maine: William A. Farnsworth Library and Art Museum, 1985, n.p.

Statement in *Artists Observed. Photographs by Harvey Stein*, New York, Harry N. Abrams, Inc., 1986, p. 147.

"Romare Bearden 1912-1988," *Proceedings of the American Academy and Institute of Arts and Letters*, Second Series, Number Forty, New York, 1989, pp. 81-83.

"Portraits," *The Artist's Eye: Will Barnet Selects Portraits from the Permanent Collection*, New York: National Academy Museum and School of Fine Arts, 1997, n.p.

"Foreword," *Centennial Portfolio*, New York: American Academy of Arts and Letters, 1998, n.p.

Transcribed Interviews with the Artist, Archival and Unpublished Sources

Richard Brown Baker, interview with Will Barnet, January 20 and 29, 1964, Archives of American Art, Smithsonian Institution, Reel 1, pp. 1-108 and Reel 2, pp. 1-108.

Anne Parsons, interview with Will Barnet, November 22, 1967.

Peter Barnet, *Will Barnet: Artist and Teacher. A Study of Will Barnet as Painter and Teacher*, New York University, Ed.D., 1975.

Will Barnet Papers, Archives of American Art, Smithsonian Institution, Microfilm reels N68-22, N68-35, N69-46, N69-126, N70-48, and 98. See also unmicrofilmed materials.

Paul Cummings interview with Will Barnet, January 15, 1968, Archives of American Art, Smithsonian Institution, pp. 1-78.

Kitty Gelhorn, interviews with Will Barnet, October 1975 to June 1976, Oral History Research Office, Columbia University, pp. 1-524.

Jacquie Saul, interview with Will Barnet, January 27, 1982, Jacquie Saul Papers, Archives of American Art, Smithsonian Institution, Microfilm Reel 3471, frames 926-936.

Cathy Barnett, interview with Will Barnet, August 19, 1988.

Stephen Polcari, interview with Will Barnet, April 9, 1993, Archives of American Art, Smithsonian Institution.

David Acton, public discussion with Will Barnet at the Worcester Art Museum, January 28, 1995.

Pamela Koob, interview with Will Barnet concerning the Art Students League, June 1999.

Published Writings about the Artist
(in chronological order)

[Morse, John D.?], "Will Barnet," *Art Students League News* II (April 1, 1949), pp. [6-7].

Farrell, James T., intro. to *The Paintings of Will Barnet* (New York: Press Eight, 1950), n.p.

Seckler, Dorothy, "Can Painting Be Taught? Barnet Answers," *Art News* 49 (November 1950), pp. 44-45, 64.

Seckler, Dorothy, "Will Barnet makes a lithograph," *Art News* 51 (April 1952), pp. 38-41, 62-64.

Brown, Gordon, "New Tendencies in American Art," *College Art Journal* XI (Winter 1951-52), pp. 103-9.

Campbell, Lawrence, "Will Barnet," *Pen & Brush* III (July-August 1955), pp. 8, 12-14.

Fumagalli, Orazio, "Will Barnet," *Will Barnet: A Retrospective Exhibition*, Duluth: Tweed Gallery, University of Minnesota, 1958, n.p.

Messer, Thomas M., intro. to *Will Barnet*, Boston: Institute of Contemporary Art, 1961, n.p.

Guitar, Mary Anne, *22 Famous Painters and Illustrators Tell How They Work*, New York: David McKay Company, Inc., 1964, pp. 3-11.

Johnson, Una, *Will Barnet Prints 1932-1964*, Brooklyn: The Brooklyn Museum, 1965.

"Will Barnet's Abstract Portraits," *Arts* 40 (April 1966), p. 48.

Robert Beverly Hale, intro. to *Will Barnet. Twenty-Seven Paintings Completed During the Period 1960-1968*, New York: The Ram Press, 1968, n.p.

Boyle, Richard, "Will Barnet in the Sixties," *Will Barnet in the Sixties*, Philadelphia, Pennsylvania Academy of the Fine Arts, 1969, n.p.

Boyle, Richard, "The World of Will Barnet," *Famous Artists Magazine* 19 (1971), pp. 12-17.

Cole, Sylvan, *Will Barnet etchings, lithographs, woodcuts, serigraphs 1932-1972 catalogue raisonné*, New York: Associated American Artists Gallery , 1972, and *Supplement, 1973-1979*, New York: Associated American Artists Gallery, 1979.

Jacobs, Jay, "Will Barnet," *The Art Gallery Magazine* 16 (October 1972), pp. 9-10.

Neilson, Winthrop, "The Complete Individualist: Will Barnet," *American Artist* 37 (June 1973), pp. 38-44, 72.

Boyle, Richard, "Will Barnet: An Appreciation," *Recent Paintings by Will Barnet*, New York: Hirschl & Adler Galleries, Inc., 1973, n.p.

Boyle, Richard, "Will Barnet-the survival of an individualist," *Art News* 72 (October 1973), pp. 81-83.

Rich, Daniel Catton, intro. to *Will Barnet New Paintings 1974-1976*, New York: Hirschl & Adler Galleries, 1976, n.p.

Chernow, Burt et al, *Will Barnet: Twenty Years of Painting and Drawing*, Purchase, New York: Neuberger Museum, 1979.

Meyer, Susan E., intro. to *Will Barnet. 27 Master Prints*, New York: Harry N. Abrams, Inc., 1979.

Alexenberg, Melvin L., *Aesthetic Experience in Creative Process*, Ramat Gan, Israel: Bar-ilan University Press, 1981, pp. 71-78.

Schutz, Prescott, intro. to *Will Barnet. New Paintings*. New York: Hirschl & Adler Galleries, Inc., 1981, n.p.

O'Beil, Hedy, "Will Barnet," *Arts* 55 (May 1981), p. 15.

Colker, Ed, "Reflections on Fifty Years of Teaching: An Interview with Will Barnet," *Art Journal* 42 (Spring 1982), pp. 24-27.

Trucco, Terry, "Will Barnet: A Part of and Apart From His Times," *Art News* 81 (December 1982), pp. 94-98.

Florescu, Michael, "The Portraiture of Will Barnet," *Arts* 57 (April 1983), pp. 120-1.

Wooden, Howard E., *Will Barnet. Paintings and Prints 1932-1982*, Wichita, Kansas: Wichita Art Museum, 1983.

Doty, Robert, *Will Barnet*, New York: Harry N. Abrams, Inc., 1984.

Doty, Robert, intro. to *Will Barnet at Kennedy Galleries*, New York: Kennedy Galleries, 1984, n.p.

McHugh, Caril Dreyfuss, "Will Barnet," *Arts* 59 (December 1984), p. 15.

Watrous, James, *A Century of American Printmaking*, Madison: The University of Wisconsin Press, 1984, pp. 97, 102, 131, 170, 171, 174-178, 192, 224, 287, 288, 289, 291.

Moritz, Charles, ed., "Will Barnet," *Current Biography* 46 (June 1985), pp. 3-5.

Wolff, Theodore F., "Stylization: avoiding a shortcut to disaster," *The Christian Science Monitor*, August 22, 1985, p. 30.

Berman, Avis, "Artist's Dialogue: Will Barnet," *Architectural Digest* 43 (March 1986), pp. 62, 66, 70, 72, 74.

Barnett, Catherine, "Striking Poses," *Art & Antiques*, (March 1987), pp. 85-90.

Doty, Robert M., intro. to *Will Barnet New Paintings*, New York: Kennedy Galleries, Inc., 1987, n.p.

Steiner, Raymond J., "Will Barnet," *Art Times*, July 1987, pp. 12-13.

Doty, Robert M., "Will Barnet: Selected Abstract Work 1940-1960," *Will Barnet: Selected Abstract Work 1940-1960*, New York: Kennedy Galleries, Inc., 1988, n.p.

"The New York Newsday Interview with Will Barnet: Why Artists Are Getting the Brush-Off," *New York Newsday*, October 5, 1988, p. 69.

Benfrey, Christopher, intro. to *The World in a Frame. Drawings by Will Barnet. Poems by Emily Dickinson*, New York: George Braziller, Inc., 1989.

Marcus, Stanley, "A Certain Slant of Light," *American Artist* 53 (November 1989), pp. 56-61.

Acton, David, *A Spectrum of Innovation. Color in American Printmaking 1860-1960*, Worcester, Massachusetts: Worcester Art Museum, 1991, pp. 184, 249-250.

Getlein, Frank, intro. to *Will Barnet Retrospective 1931-1987*, Naples, Florida: Harmon-Meek Gallery, 1990, pp. 3-7.

Castro, Jan Garden, intro. to *Will Barnet Master Prints 1979-1991*, St. Louis, Missouri: Jo Ann Perse Gallery, 1991.

Doty, Robert M., intro. to *Will Barnet. Drawings from The Emily Dickinson Series*, Rockland, Maine: William A. Farnsworth Library and Art Museum, 1991, n.p.

Wolfe, Townsend, *Will Barnet Drawings 1930-1990*, Little Rock: The Arkansas Arts Center, 1991.

Culver, Michael, "Will Barnet. Works of Six Decades," *Will Barnet: Works of Six Decades*, Ogunquit, Maine: Ogunquit Museum of American Art, 1994, pp. 8-15.

Garbowsky, Maryanne, "Will Barnet Meets Emily Dickinson," *Emily Dickinson International Society Bulletin*, 6 (November/December 1994), pp. 7-9, 18.

Nadel, Norman, intro. to *Will Barnet "Then, and Now,"* Naples, Florida: Philharmonic Center for the Arts, 1994, pp. 2, 7.

Wolff, Theodore F., "Will Barnet," *Will Barnet. Five Major Paintings and Related Works on Paper*, New York: Terry Dintenfass Gallery, 1994, n.p.

Garfield, Johanna, "Will Barnet and the Family," *American Art* 9 (Spring 1995), pp. 110-115.

McMahon, Cliff, "The Sublime is How: Philip Taaffe and Will Barnet," *Art & Design* (1995), pp. 19-33.

Rushing, W. Jackson, *Native American Art and the New York Avant-Garde*, Austin: University of Texas Press, 1995, pp. 147-152.

Acton, David, "The Prints of Will Barnet: An Addendum," *Second Impressions. Modern Prints & Printmakers Reconsidered*, Volume Sixteen of the Tamarind Papers, Albuquerque: University of New Mexico Press, 1996, pp. 83-92.

Stavitsky, Gail, "Will Barnet: New Paintings," *Will Barnet New Paintings*, New York: Terry Dintenfass in association with Salander O'Reilly Galleries, 1996, n.p.

Danly Susan, ed., *Language as Object: Emily Dickinson and Contemporary Art*, Amherst, Massachusetts: Mead Art Museum, 1997, pp. 18-19, 68-69.

Flack, Michael, "Will Barnet: Searching for Structure," *Drawing* XIX (Summer 1997), pp. 7-10.

Goldstein, Emily and Messer, Thomas M., *Will Barnet: Early Works on Paper*, East Hampton, New York: Glenn Horowitz Bookseller, Inc., 1997.

Lekatsas, Barbara, *Will Barnet, Bob Blackburn: An Artistic Friendship in Relief*, Lagrange, Georgia: Cochran Collection, 1997, pp. 4-14.

Price, Linda S., "Points of Perspective," *American Artist* 61 (November 1997), pp. 27-35.

Rushing, W. Jackson, "Will Barnet's 'True Freedom, ': Abstraction in Theory and Practice," *Will Barnet: The Abstract Work*, New York: Tibor de Nagy Gallery, 1998, n.p.

Tomor, Michael A. and Davis, Lisa A., *Will Barnet: An American Master. Print Retrospective*, Loretto, Pennsylvania: The Southern Alleghenies Museum of Art, 1998.

Kramer, Hilton, "Will Barnet in the Abstract," *Art & Antiques* (January 1999), pp. 98-9.

Hirsh, Faye, "Will Barnet Looks Around: Some Recently Discovered Plates," *Art on Paper* 4 (March-April 2000), pp. 60-63.

SELECTIVE CHRONOLOGY AND EXHIBITION HISTORY

(For additional citations, see Robert Doty, Will Barnet (New York: Harry N. Abrams, Inc., 1984): 147-8, 152-6)

1911

Born May 25 in Beverly, Massachusetts to Noah and Sarahdina (née Toahnick).

Youngest of four children. Siblings: Jeannette, Eva, Benjamin.

1928-1931

Studied at the Boston Museum School with Philip Hale.

1931-1933

Studied at the Art Students League of New York with Stuart Davis, Charles Locke, and others.

1935

Became professional printer for the Art Students League. First one-man exhibition at the Eighth Street Playhouse, New York. Married Mary Sinclair.

1941

Son Richard Sinclair born January 17. Represented in the Whitney Annual exhibition (also in 1952, 1953, 1957, 1961, 1965). Appointed Instructor at the Art Students League; taught graphic arts and composition.

1942

First solo museum exhibition at the Virginia Museum of Fine Arts. Wins Mildred Boericke Prize, and three Honorable Mentions, the Print Club, Philadelphia.

Included in *Between Two Wars: Prints by American Artists 1914-1941*, The Whitney Museum of American Art and *Artists for Victory*, The Metropolitan Museum of Art.

1943

One-man show at Galerie St. Etienne, New York.

1944

Son Todd Williams born May 10.

1936

Served as technical advisor and printer for the Graphic Arts Division of the Works Progress Administration. As the League printer, began conducting workshops in graphic arts.

1938

Second solo exhibition at the Hudson Walker Gallery, New York.

Became instructor in printmaking at the New School for Social Research (until 1941). Included in the Fifth International Exhibition, *Etching and Engraving*, The Art Institute of Chicago.

1939

Son Peter George born September 11. Exhibited in the *American Art Today* exhibition at the World's Fair.

1940

Exhibited in the Annual Exhibition of Watercolors, Prints, and Drawings at the Pennsylvania Academy of the Fine Arts (1940-1953 and 1969)

1945

Began teaching graphic arts and, later, painting, at Cooper Union, New New York, through 1966-67).

Resides at 50 W. 106 Street. Two-man show with Cameron Booth at Bertha Schaefer Gallery, New York.

1946

One-man show, Bertha Schaefer Gallery, New York (also in 1947, 1948, 1949, 1951, 1952, 1953, 1955, 1961, 1962). Print retrospective at U.S. National Museum, Smithsonian Institution in Washington D.C.

Taught painting and graphic arts at the Art Students League from 1946-47 until 1953-54.

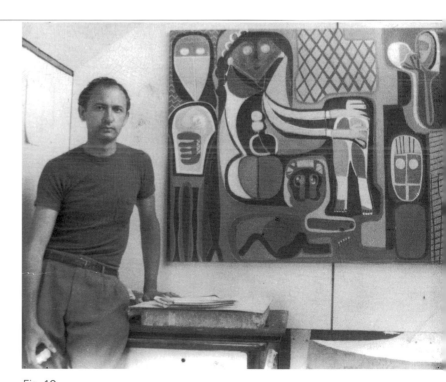

Fig. 19

**Will Barnet with his painting *Awakening*
(1949, Private Collection)**

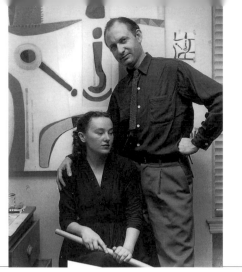

1947-48

Spent summers in the countryside in Webatuck, New York and near Danbury, Connecticut. Showed in Annual Exhibition of Oils and Sculptures at the Pennsylvania Academy of the Fine Arts (1947-60).

1950

Dallas Museum of Fine Arts, solo print exhibition. Represented in *American Painting Today*, The Metropolitan Museum of Art.

1952-1953

Visiting critic, Yale University, New Haven, Connecticut. *Will Barnet Makes a Color Lithograph*, traveling exhibition organized by the American Federation of the Arts.

1953

Married Elena Ciurlys. Travels abroad for his honeymoon to France, Italy, Greece, Morocco, and Spain. Taught Life Drawing, Painting, and Composition at the Art Students League (until 1979).

1960

One-man exhibition at the Institute of Contemporary Art, Boston. Travels to Europe.

1961

Solo exhibition at the Galleria Trastevere, Rome. Moved to 439 E. 87 Street. Received Third William A. Clark Prize and Corcoran Bronze Medal when represented in *The Twenty-Seventh Biennial Exhibition of Contemporary American Painting*, Corcoran Museum, Washington, D.C.

1962

One-man exhibition at the Albany Institute of History and Art.

Represented in *Geometric Abstraction in America*, Whitney Museum of American Art.

1963

Appointed Visiting Instructor in Advanced Painting, Boston Museum School (also teaches there in 1965 and 1968). Taught in summer session, Washington State University, Spokane. Solo exhibition, Peter H. Deitsch Gallery, New York. *Mother and Child in Modern Art*, traveling exhibition circulated by the American Federation of Arts (1963-1964). Moves to 43 West 90th Street.

Fig. 21
Will and Todd Barnet, 1952.
© Alfred Gescheidt

1954

Daughter Ona born.
Visiting artist, Munson-
Williams-Proctor Institute,
Utica, New York.

1955

Included in *14 Painter-
Printmakers*, The Brooklyn
Museum.

1958

First comprehensive retro-
spective at Tweed
Museum of Art, University
of Minnesota, Duluth
where he taught.
Retrospective exhibition at
the Oscar Krasner Gallery,
New York.

1959

Moved to 60 East End
Avenue.

1964

Ford Foundation Grant,
Artist-in-Residence and
solo exhibition, Virginia
Museum of Fine Arts.

1965

Solo exhibitions at the
Grippi Waddell Gallery,
New York (also 1966,
1968, and 1970) and Des
Moines Art Center.

Fig. 22
Will, Elena, and Ona Barnet, early 1960s

1967

Appointed as instructor in painting and general critic at the Pennsylvania Academy of the Fine Arts (until 1988, thereafter he worked primarily as a critic until 1992).

1968

Received the Walter Lippincott Prize for the best figure painting in oil by an American artist, Pennsylvania Academy of the Fine Arts

1969

Pennsylvania Academy of the Fine Arts, solo exhibition, *Will Barnet in the Sixties*.

Early 1970s

Trip to Italy. Begins spending summers in Chamberlain, Maine.

1977

Benjamin Altman Prize, National Academy of Design.

1979-80

Traveling retrospective organized by the Neuberger Museum, Purchase, New York.

1980

Retrospective at the Essex Institute, Salem, Massachusetts.

1981

Childe Hassam Award, American Academy and Institute of Arts and Letters.

1972

Chairman of the Committee on Instruction (until 1977-78) at the Pennsylvania Academy of the Fine Arts). Solo exhibition at David David Gallery, Philadelphia. Print retrospective at Associated American Artists, New York.

1973

Hirschl & Adler Galleries, New York, solo exhibition (also 1976, 1981).

1974

Elected to Associate Membership in the National Academy of Design, New York.

1976

Lectured at the Vatican Museum, Rome on "A Personal Reflection on the Spiritual Aspects in American Art."

1982

Election to full membership in the National Academy of Design and the American Academy and Institute of Arts and Letters. Solo exhibition at the Terry Dintenfass Gallery, New York (also 1994, 1996). Moved to the National Arts Club, Gramercy Park. Print retrospective at the Associated American Artists.

1983

Retrospective exhibition at the Wichita Art Museum, Kansas.

1984

Publication of monograph by Robert Doty. Solo exhibition at Kennedy Galleries, New York (also 1987, 1988). Traveling retrospective organized by The Currier Gallery of Art, Manchester, New Hampshire.

1985

Retrospective of recent work at the William A. Farnsworth Library and Museum, Rockland, Maine.

1988

Sylvan Cole Gallery, New York, solo exhibition.

1987

Included in *A Quiet Revolution: American Art from the Solomon R. Guggenheim Museum*, Columbia Museum, South Carolina.

1989

Awarded Honorary Doctorate of Fine Arts, Massachusetts College of Art, Boston.

1990

Gold Medal of Honor, National Arts Club. Retrospective at the Harmon-Meek Gallery, Naples, Florida (also 1995). First Vice-President, National Academy of Design (until 2000).

1994

One-man show at the Philharmonic Center for the Arts, Naples, Florida. Retrospective at The Ogunquit Museum of American Art, Maine.

1995

Will Barnet: An Intimate View from the Museum's Collec-tion at the National Museum of American Art. *Contacting Pablo Picasso: The Influence of Picasso on American Printmakers* at The Spanish Institute, New York. Traveling exhibition *Affinities and Influences: Native American Art and American Modern-ism*, organized by The Montclair Art Museum.

1996

Included in *Powerful Expressions: Recent American Drawings*, National Academy of Design, New York. Juror of Selection (Paintings), National Academy of Design (also 2000).

1997

Included in *Language as Object: Emily Dickinson and Contemporary Art*, Mead Art Museum, Amherst College, Massachusetts. Curated *The Artist's Eye: Will Barnet Selects Portraits From the Permanent Collection*, National Academy Museum and

1991

Retrospective of works on paper of the 1950s, Arlene Bujese Gallery, Southampton, New York, 1990

Lotus Medal of Merit, Lotos Club. Traveling show, *Will Barnet Drawings: The Emily Dickinson Suite*, organized by the William A. Farnsworth Library and Art Museum. Exhibition of master prints, 1979-1991 at the Jo Ann Perse

Gallery of Fine Art, St. Louis. Included in *The Indian Space Painters: Native American Sources for American Abstract Art*, The Sidney Mishkin Gallery, Baruch College, The City University of New York.

1992

Retrospective of Barnet's drawings at The Arkansas Arts Center. Juror of Awards, National Academy of Design (also 1995).

School of Fine Arts, New York. Featured in *Will Barnet Bob Blackburn: An Artistic Friendship in Relief*, Wllmer Jennings Gallery at Kenkeleba, New York. Retrospective of works on paper, c. 1949-60, Glenn Horowitz Bookseller, Inc., East Hampton, New York.

1998

Included in *Modern American Realism. The Sara Roby Foundation Collection*, National Museum of American Art, Smithsonian Institution.

Traveling print retrospective organized by the Southern Alleghenies Museum of Art, Loretto, Pennsylvania. Publication of the American Academy of Arts and Letters Centennial Portfolio, supervised by Will Barnet. One-man show at the Century Association, New York. Retrospective of abstract work at Tibor de Nagy Gallery, New York.

1999

Print retrospective at the Portland Museum of Art, Maine.

2000

Comprehensive traveling retrospective *Will Barnet: A Timeless World* organized by The Montclair Art Museum, New Jersey. *Seven Decades of Drawing* in September at Tibor de Nagy Gallery, New York.

EXHIBITION CHECKLIST

Works on Paper

1. *Lifestudy*, Boston Museum School,
 1929
 Charcoal on paper
 25 x 19 in.
 Arkansas Arts Center Foundation
 Collection: Promised gift of Will and
 Elena Barnet, 1992

2. *Fulton Street Fish Market*, 1934
 Lithograph
 15 1/2 x 11 in.
 Collection of Will and Elena Barnet

3. *Little Joe*, 1935
 Lithograph
 16 3/8 x 9 3/4 in.
 Courtesy Tibor de Nagy Gallery, New
 York and Sylvan Cole Gallery, New York

4. *Artist's Mother*, 1934
 Watercolor on paper
 15 1/2 x 11 1/4 in.
 Collection of Will and Elena Barnet

5. *The Tailor*, 1936
 Aquatint and etching
 10 x 12 in.
 Collection of Will and Elena Barnet

6. *My Father*, 1937
 Aquatint
 11 3/4 x 14 3/4 in.
 Collection of Will and Elena Barnet

7. *The Butcher's Son*, 1939
 Woodcut
 13 3/8 x 15 in.
 Collection of Will and Elena Barnet

8. *Early Morning*, 1939
 Woodcut
 9 x 15 3/8 inches
 Collection of Will and Elena Barnet

9. *Go-Go*, 1947
 Serigraph
 12 x 9 5/8 in.
 Collection of Will and Elena Barnet

10. *Strange Birds*, 1947
 Lithograph
 9 3/4 x 13 in.
 Collection of The Montclair Art
 Museum, Museum purchase;
 Acquisition Fund, 1994.42

11. *Untitled*, c. 1954
 Watercolor and ink on postcard
 6 x 5 in.
 Collection of The Montclair Art
 Museum, 1999.6
 Gift of Cherry and Lloyd Provost
 Photo by: Peter Jacobs, 1999

12. *Untitled*, 1957
 Gouache and watercolor on paper
 7 x 4 7/8 in.
 Collection of Mr. and Mrs. Richard E.
 Salomon

13. *Study for Big Duluth*, 1960
 Gouache on paper
 7 1/2 x 4 3/4 in.
 Courtesy of Tibor de Nagy Gallery,
 New York

14. *Study for Big Duluth*, 1960
 Ink on paper
 7 3/4 x 4 3/4 in.
 Courtesy of Tibor de Nagy Gallery,
 New York

15. *The Collectors*, 1977
 Carbon pencil and conte crayon on
 paper
 28 1/2 x 41 1/4 inches
 Collection of Dorothy and Herb Vogel

16. *The Mirror*, 1996
 Woodcut
 22 x 20 in.
 Courtesy of Tibor de Nagy Gallery,
 New York and Sylvan Cole Gallery,
 New York

17. *Between Life and Life*, 1998
 Lithograph for the Print Club of New
 York, printed by Maurice Sanchez and
 James Miller, Derriere L'Etoile
 Studios,New York
 28 x 29 3/4 in.
 Courtesy of Tibor de Nagy Gallery,
 New York and Sylvan Cole Gallery,
 New York

Early Paintings

18. *Idle Hands*, 1935
 Oil on canvas
 25 x 21 in.
 Collection of Mr. and Mrs. Woody
 Klein

19. *The Cupboard*, 1944
 Oil on canvas
 18 x 24 in.
 Lent by the Frederick R. Weisman Art
 Museum, Bequest of Hudson Walker
 from the Ione and Hudson Walker
 Collection

20. *Soft Boiled Eggs*, 1946
 Oil on canvas
 36 x 42 inches
 Collection of Will and Elena Barnet

21. *Old Man's Afternoon*, 1947
 Oil on canvas
 28 x 22 in.
 Collection of Irene and Philip Clark

22. *Old Man's Afternoon*, 1947
 Oil on canvas
 47 x 36 in.
 Collection of Mr. and Mrs. William Y.
 Hutchinson

23. *Family and Pink Table (Mary and
 Sons)*, 1948
 Oil on canvas
 36 x 28 in.
 Private Collection

24. *Summer Family*, 1948
 Oil on canvas
 34 x 44 inches
 The Samuel S. Fleisher Art Memorial,
 Philadelphia

Indian Space Paintings

25. *Self-Portrait*, 1953-1954
Oil on canvas
45 x 38 in.
Anonymous lender

26. *The Cave*, 1953
Oil on canvas
36 x 47 3/4 in.
Collection of Neuberger Museum of
Art, Purchase College, State University
of New York, Gift of Henry Pearson

27. *Creation*, 1954-55
Oil on canvas
44 1/8 x 36 3/4 in.
The Snite Museum of Art, University
of Notre Dame, Indiana, Gift of Mr.
and Mrs. Will Barnet

28. *Fourth of July*, 1954
Oil on canvas
51 3/4 x 37 3/4 in.
Private Collection

29. *Janus and the White Vertebra*, 1955
Oil on canvas
41 1/8 x 23 7/8 in.
National Museum of American Art,
Smithsonian Institution,
Gift of Mr. Wreatham E. Gathright

30. *Black and Gold*, c.1955
Oil on canvas
32 1/4 x 25 1/4 in.
Collection of Brenda and Hartley
Bingham

Abstractions

31. *Singular Image*, 1959
Oil on canvas
68 1/2 x 46 in.
Private Collection

32. *Big Duluth*, 1960
Oil on canvas
85 x 52 1/2 in.
Tweed Museum of Art, University of
Minnesota Duluth,
Patrons and Subscribers Fund
Purchase

33. *Impulse*, 1964
Oil on canvas
70 1/2 x 37 3/4 in.
Collection of Mr. and Mrs. Frank
Martucci

34. *Eden*, 1964-65
Oil on canvas
88 x 43 in.
Courtesy of Tibor de Nagy Gallery,
New York

Figure Compositions of the 1960s

35. *Mother and Child (Elena and Ona)*,
1961
Oil on canvas
46 x 39 in.
Collection of Will and Elena Barnet

36. *Woman and Cats*, 1962
45 x 50 in.
Oil on canvas
Collection of Dr. and Mrs. John C.
Bullard

37. *Woman Reading*, 1965
Oil on canvas
45 x 35 in.
Collection of Will and Elena Barnet

Portraits

38. *Remi*, 1962
Oil on canvas
31 x 26 in.
Collection of Tom and Remi Messer

39. *Portrait of R.N.N.*, 1965
Oil on canvas
67 x 43 in.
Grey Art Gallery & Study Center, New
York University Art Collection,
Gift of Roy Neuberger, 1966

40. *Kiesler and Wife*, 1963-1965
Oil on canvas
48 x 71 1/2 in.
The Metropolitan Museum of Art
Purchase, Roy R. and Marie S.
Neuberger Foundation Inc. Gift and
George A. Hearn Fund, 1966.

41. *Self Portrait*, 1967
Oil on canvas
62 x 38 in.
Museum of Fine Arts, Boston
Anonymous Gift through the Waddell
Gallery 68.143

42. *Ruth Bowman*, 1967
Oil and pencil on canvas
45 x 23 3/4 in.
The Metropolitan Museum of Art
Gift of Ruth and R. Wallace Bowman,
1998

43. *Homage to Léger, with K.K.*, 1982
Oil on canvas
39 1/2 x 39 1/2 in.
Collection of Mr. and Mrs. William Y.
Hutchinson

Figure Compositions of the 1970s (Maine)

44. *Woman and the Sea*, 1972
Oil on canvas
51 3/4 x 41 in.
David David Gallery, Philadelphia

45. *Early Morning* , 1972
Oil on canvas
57 3/4 x 57 1/2 in.
Private Collection

46. *Infinite*, 1974
Oil on canvas
63 1/2 x 47 1/2 in.
Farnsworth Art Museum, Gift of
Maurine and Robert Rothschild

47. *Vigil*, 1974-75
Oil on canvas
48 x 67 1/2 in.
Collection of Liza and Michael Moses

48. *Eos*, 1973
Oil on canvas
58 x 58 in.
Collection of Frank K. Ribelin

Recent Work

49. *Croquet*, 1985
Oil on canvas
65 1/4 x 48 1/2 in.
Courtesy of Tibor de Nagy Gallery,
New York

50. *The Three Windows*, 1992
Oil on canvas
30 1/8 x 34 1/2 in.
Courtesy of Tibor de Nagy Gallery,
New York

51. *The Grandmother*, 1992
Oil on canvas
49 1/4 x 55 3/4 in.
Collection of Mary Ann and Bruno A.
Quinson

52. *The Purple Bottle*, 1989-1999
Oil on canvas
34 x 38 1/2 in.
Private Collection

The following works will be exhibited at the Arkansas Art Center:

Stairway, 1970
Pencil and watercolor on vellum
11 1/4 in. x 7 1/8 in.
Arkansas Arts Center Foundation
Collection: Promised Gift of Will and Elena
Barnet, 1992

Study for *Sanctum*, 1977
43 3/4 in. x 55 in.
Charcoal on paper
Arkansas Arts Center Foundation
Collection: Promised Gift of Will and Elena
Barnet, 1992

Wendy and Hillel, 1989
Carbon pencil on vellum
25 1/8 in. x 38 in.
Arkansas Arts Center Foundation
Collection: Promised Gift of Will and Elena
Barnet, 1992

The Mirror, 1981
Oil on vellum
41 1/2 in. x 38 in.
Arkansas Arts Center Foundation
Collection: Promised Gift of Will and Elena
Barnet, 1992

The Skaters, 1986
Carbon pencil on vellum
72 7/8 in. x 48 in.
Arkansas Arts Center Foundation
Collection: Promised Gift of Will and Elena
Barnet, 1992

Study for Elena and Ona, 1961
Pencil on paper
11 1/4 in. x 8 3/4 in.
Arkansas Arts Center Foundation
Collection: Promised Gift of Will and Elena
Barnet, 1992

Study for Great Spokane I, 1964
Pencil and watercolor on paper
10 5/8 in. x 13 7/8 in.
Arkansas Arts Center Foundation
Collection: Promised Gift of Will and Elena
Barnet, 1992

Go-Go No. 2, 1947
Watercolor on paper
9 3/4 in. x 11 3/4 in.
Arkansas Arts Center Foundation
Collection: Promised Gift of Will and Elena
Barnet, 1992

Multiple Image, 1958
Pencil and watercolor on paper
9 1/2 in. x 7 3/4 in.
Arkansas Arts Center Foundation
Collection: Promised Gift of Will and Elena
Barnet, 1992

E. D. Poem, 1989
Charcoal on paper
27 3/4 in. x 37 in.
Arkansas Arts Center Foundation
Collection: Gift of Elena Barnet, 1990.

APPENDIX

Will Barnet—Statement for Lawrence Alloway

You ask for a statement. Of course, we all wish our paintings to be their own statements, but the embattled cultural climate we are in, especially here, gives one an urge towards polemics, which I shall try to restrain.

Conceptual art has always been the closest to me. I am not interested in technique for its own sake, or form as form. I want each of my paintings to be as much a total experience as possible, but know that for me the picture becomes alive only if it is fully realized plastically. In other words, the image problem is identical with the form problem. All my paintings start from content, and while I value as much the original manifestations of the creative impulse, the final clarity of the image is for me the only honorable end to the process of fully realizing the concept in painting terms.

My paintings end up, I suppose, looking to the innocent eye of today, rather intellectual. But while the process of painting is slow— and I often work on paintings for a considerable time, it doesn't seem to cool off for me into anything intellectual. The end is not predetermined, but becomes what it is in response to the demands of the painting itself. Of course, I want to strip it to essentials, drastically, without cutting into the underlying complexity of the concept. I want emphatically to contain the emotion and the energy so that it resides entirely in the forms—their proportion, their pressure and tension, expansion, contraction, etc. I want every part of the canvas to be a constant image, with no passages, vaporous, obscure or left as ground. I think it is in this area that I go beyond much of the current painting where forms float and the surface is still there as a foil, as something, somehow, plastically inexistent.

Whereas many painters still rely on each form to have a single action— a single movement that is tied to other movements by linear means— all this I abandoned in my painting in the 1940's. The exchanges in my imagery and the use of the total ground of the canvas necessitated a more dynamic concept of form. This lead me over many years of work to the birth of forms that have a double action—a double movement that grips the entire surface and brings the whole canvas into total action. The canvas itself is action. My image and my content determines the proposition of my canvas. However, each new proportion creates challenges that are endless.

Also, the big challenge for me is still in the use of oil paint and canvas, with everything that implies what to me are welcome, usable, and the positive limitations of painting. In general, other media offer trivial distractions from the main purpose of working out new painting concepts. Of course, texture and handling are important to any experi-

enced painter, but my revulsion towards surface cleverness began at an early age and the obvious attractiveness of effects have never tempted me.

I suppose my drive towards clarity and completion has something to do with my nowadays anomalous optimism. Somehow the horrors of civilization only increase the need for mastery, order, affirmation and the full expansion of ideas. This is certainly more of a statement than I intended. But, I suppose that teaching gives one the habit of over-extending oneself. As you suggested, I am including some early work in the material that I am sending out by the same mail. I feel that I've slowly, but very consistently moved towards what I am doing now. I still feel indebted to the great classical tradition of European painting—also to Byzantine and Medieval Art, more consciously maybe than others because living in a small New England town, learning art in Boston—where the teaching and art activity were much more academic than one might suppose—I found what I cared about in books and in the museum. When I got to New York, national and social realism were beginning to come onto the scene, and although I briefly worked in the new exciting streets of the city, my great hero was Vermeer, and my great discovery was that he made the corner of a room become a whole world. At any rate, I concentrated on what was close to me, my family and the special elongated boxes of the railroad flats we lived in where the walls seemed to be closing in on the frantic activity of children. I was excited by children—they always involved problems of scale, their gestures were close to symbolic gestures, their emotions open and intense. Human beings are still the main subject and I am still concerned with specific-ness, and characterization although it obviously takes a different form.

In those days I was working to discard illusionism in all its manifestations. What attracted me in America were rather the works of the itinerant portrait painters of the 18th Century, and certain aboriginal work.

Towards the end of the 40's, the content of the paintings seemed to have come more from the inside, sometimes starting from doodles, but they were always visual images, not amorphous feelings—maybe because a lot had been stored away, or that by then the transformation from reaction to nature in subjective images had become immediate.

My titles are not to be taken literally—the red, white, and blue of the *4th of July* might make one think that I meant it to be just that. It so happened that I finished the painting on that day, and felt that the title conveyed something explosive or jubilant related to what I had felt while painting it. It actually started as an idea about three figures.

This statement was originally written for Lawrence Alloway to assist him with the preparation of an essay for the catalogue accompanying the artist's show at the Galleria Trastevere in Rome in 1960. Although the essay was never written, this statement was published as "A Letter to an English Critic," Castalia 1 (Fall 1961), pp. 66-69 and also in The Pioneer 44 (November 20, 1964), p. 4.